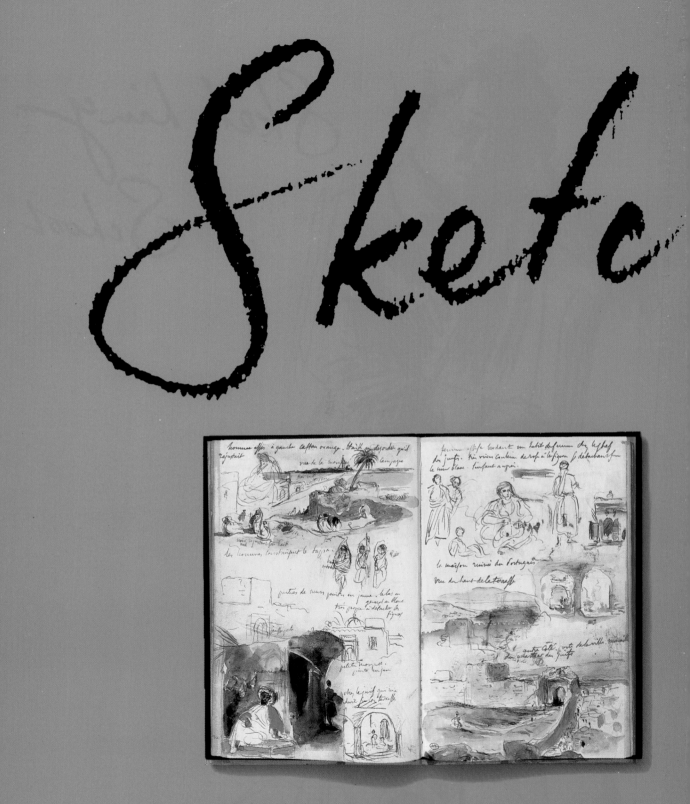

Two pages from Delacroix's travel sketchbook showing impressions of Spain, Morocco and Algeria, 1834.

Quilting School

JUDY
MARTIN

Reader's Digest

THE READER'S DIGEST ASSOCIATION, INC.
Pleasantville, New York/Montreal

A READER'S DIGEST BOOK

This book was designed and edited by
Quarto Inc.

Senior Editor *Kate Kirby*
Copy Editor *Angela Gair*
Art Editor *Nick Clark*
Designers *Daniel Evans, Steven Randall*
Picture Researcher *Angela Anderson*
Photographers *Ian Howes, Gilbert Elliot*
Art Director *Moira Clinch*
Publishing Director *Janet Slingsby*

With thanks to Sandra Miller,
Harriet Lassalle, Stefanie Foster

First published in Great Britain in 1991 as Sketching.

Library of Congress Cataloging in Publication Data
Martin, Judy (Frances Judy)
 Sketching school/Judy Martin.
 p. cm.
 ISBN 0-89577-405-4
 1. Drawing — Technique. I. Title.
 NC730.M294 1992
741.2 – dc20 91–25709

Contents

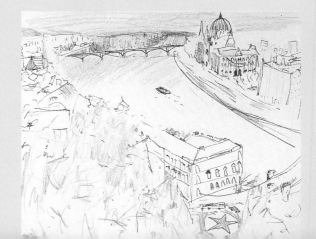

1

Getting started

La Victo

Getting started

Sketching has many different functions, and there are as many ways to sketch as there are ways of making marks on paper, as many different kinds of sketch as there are artists who make sketches. One of the most important aspects of sketching is its basic role as a method of gathering visual information from the world around you. It can be an end in itself, and part of the purpose of this book is to show that sketching is a versatile and enjoyable art accessible to everyone. But if you are also interested in making other kinds of images or objects — paintings, prints, sculptures, ceramics, textiles — sketches are a vital resource for your work. A chance observation can set off a whole train of thought and activity that may lead to unexpectedly rich results.

To begin at the beginning, the examples and projects in this chapter demonstrate various ways of becoming comfortable with the habit of sketching and making it work for you. The great value of a sketchbook is that it is a purely personal record for the artist, yet it can become a comprehensive and fascinating document of individual experience and progress. A full-scale drawing or painting can feel like a public statement — after all, the purpose of art is to be seen. But when sketching, wherever and for whatever reason you do it, you do not have to feel that anyone is looking over your shoulder, nor that you have anything to prove visually or technically. Sketches should be done solely for your own pleasure and interest, and in the way that suits you at a particular moment.

All the same, it can be frustrating when something especially takes your eye and you just cannot capture the essence of it in your sketch. There may be various factors at work causing inhibition: you may be rushed by the situation or by companions when trying to sketch while out on a visit to a special location; you may be trying to make too detailed an image when what you mainly need is an impression that will serve to call up your visual memory of the subject; you may be sketching in a public place with strangers looking at or even commenting on what you are doing. Then there is the question of your own expectations — are you so concerned with doing a good sketch that you are less focused on whatever it is you are observing? Are you inhibited because

Daphne Casdagli
Pencil
4¼″ × 5¾″

In this pencil sketch of a South American mountain village (right), the artist has quickly traced the busy pattern of shapes made by the buildings and the terracing, making a lively study in line and tone. She has added written notes that record items of interest about the particular view.

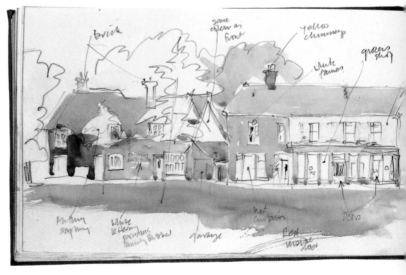

John Lidzey
Pencil and Watercolor
6″ × 18″

The full width of the open sketchbook is used here to accommodate a frontal view of the row of houses. The outlines of the architectural forms are freely sketched with active pencil lines, but the solid geometry of the buildings emerges satisfactorily. Loose watercolor washes give a broad impression of color contrasts.

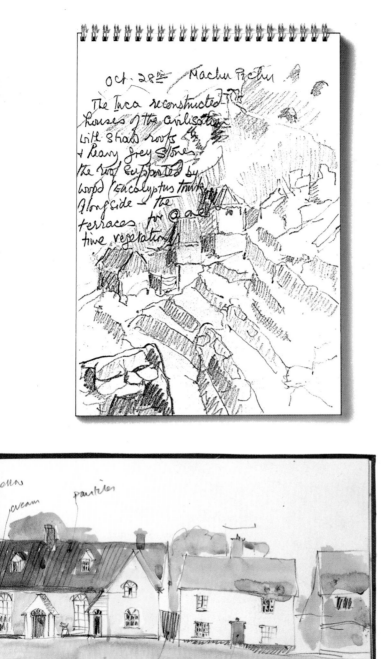

you feel you do not have the right materials — for example, are you having to draw with a black felt-tip pen when what really attracts you about your subject is its color? Do you simply suppose that your technique is lacking if a sketch doesn't turn out too well?

ACQUIRING TECHNICAL SKILLS

Technical confidence grows with experience; there is no other way to master your materials than to use them often and understand their capabilities or limitations. As to having the right materials with you at any given time, many of the sketches throughout this book will show you that monochrome sketches need not be colorless. The vitality of the subject can be conveyed with line only, or with smudges and scribbles; if "true" color is an essential factor, you can write color notes on a line and value sketch made in pencil, ink, or charcoal, to remind you of what you have observed. This underscores the fact that it is the quality of your observation, not your technique, that most contributes to your progress as an artist. When you have identified exactly what interests you about the subject, when you can analyze its properties and the combination of elements that make it what it is, then you are halfway to being able to reproduce them on paper.

Technically you need to be adaptable to your situation; you will obviously produce different kinds of results when you are standing on the street corner working with a ballpoint pen from those you achieve when you take a watercolor set into the countryside for a full day's leisurely work. Timing is an interesting aspect of sketching: The need to make visual selection and use an approximate technique when you have seconds or minutes in which to do your drawing can have a vitalizing effect — perhaps, because you must respond immediately to the circumstances, you may even make a breakthrough in technique or observation. Alternatively, you might get so bound up in the detail of the subject that a single sketch takes a long time and you may have to leave it uncompleted. But, ideally, the work does not seem labored under these circumstances — a sketch represents a very direct response, whereas a finished drawing may become more contrived and complex.

John Elliot
Pastel on Colored Paper
9″ × 12″

Using the long side of a pastel stick rather than the tip creates an atmospheric, grainy texture showing the paper color beneath, and has the practical advantage of covering the surface quickly. Linear details and flashes of brilliant color give a framework to the massed hues.

Sometimes you seem to go back before you can go forward, and even the most experienced artist has apparent failures. A sketchbook is the place where you can "think aloud" at random and without the judgment of others. Inevitably some of the work will go wrong; some may seem to have taken you up a blind alley. But in the process you will have discovered and learned a great deal. The advantage of the personal record formed by your sketches is that you can come back to it weeks, months, or even years later and find many enjoyable reminders of where you have been and what you have seen; and because you have moved on in other ways, you may then see a value in drawings that were disappointing at the time. There is no set standard, personally or professionally, for what constitutes a "good sketch."

AIMS AND INTENTIONS

It is difficult to arrive at a precise definition of a sketch; this is not really a matter of timing, technique, or degree of finish. Typically, the best sketches have a kind of immediacy that suggests rapid and uninhibited work; but equally, some highly detailed and extensive drawings that have taken quite a long time to do still appear to have the freshness often associated with much quicker, looser sketches. There is also the personal touch – only one person has seen this subject in exactly this way. A sketch says something in visual terms, of the artist's pleasures and preferences, of the ways in which that person responds both to new experiences and familiar patterns. Technical aims are important in sketching, not in terms of achieving competence or excellence, but in learning and trusting the medium, and taking risks when it is appropriate to do so. Sketching is also a testing ground for use of line, value, mass, texture, pattern, and color – the compositional devices that may later be related to other media and more ambitious projects.

A generally acceptable idea of what sketching is and what it is for is certainly secondary to your own aims in producing a

personal collection of sketch work. It helps if you have a sense of your specific intentions. Are you keeping a sort of visual diary? Does it matter if the images are recognizable, or are they private references that could be incomprehensible to someone else? What are your reasons for sketching at any given time: To record what you see? To get some practice in drawing? Or to develop ideas that may lead you on to further work? Why have you chosen a particular subject: Is it conveniently in view while you wait for a plane or train? Does it have special associations? Is your response strictly to the visual elements? Or do you regard the subject as a technical challenge?

Of course, you can also allow for the fact that a quick sketch is a first response and may go no further. But if you have longer to spend on a subject or you do a batch of three or more sketches, your interests and aims may change as you perceive more and figure out different ways of noting down the information. Sketching is about versatility, about trial and error, about serendipitous discoveries that surprise, absorb, energize, and please you. The following pages will give you plenty of ideas and inspiration, about getting started on your sketching, and how to continue once you have begun.

Stan Smith
Pencil
15″ × 20″

The expressive lines of this figure drawing create a simultaneous elegance and awkwardness that combine to form a
striking image. The shapes are loosely suggested, but a distinct mood and character emerge. Scribbled, dark shapes create focus and emphasize the openness of the composition.

There are many different reasons for developing a habit of frequent sketching: to keep journalistic reference notes on places, people, and things you have seen; to gather visual impressions that may later contribute to more finished works; to record little details of, for example, natural or architectural forms; to work out compositional ideas that are forming in your mind's eye.

When you start keeping sketchbooks,

Neil Meacher
Pencil
5¾″ × 8¼″

In the perspectives of these two drawings (right) the artist catches the character of the subject in different ways, altering its depth and focus. Soft pencil lines construct form and texture. Separate images on facing pages, like these two, can create a pleasing wholeness.

Sketching wherever you are

**GETTING
STARTED**

there are practicalities to consider. What size of sketchbook do you need? Do you want a particular quality of paper? Is the book fully bound or does it contain tear-out sheets? What sort of media can you carry with you conveniently everywhere you go?

To begin with, you can just use a simple spiral-bound notebook and a pen. The technical details hardly matter — you can develop your preferences for materials and methods as you become used to the habit of sketching. But there are other kinds of practical problems. Especially if you are just starting out, it can be embarrassing to sketch in public — people do come to look at what you are doing; if you are sketching strangers, they sometimes get uneasy when they realize that they are being studied. However, trying to sketch surreptitiously is not going to help your confidence or your technique. The only answer is to go for it — problems are best solved by working through them. But if you are sketching strangers in a strange place, just make sure that no offense can be taken.

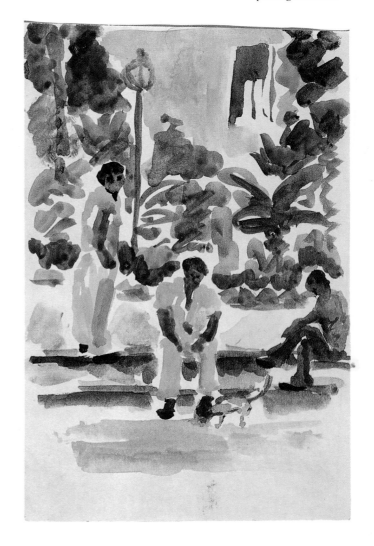

Daphne Casdagli
Watercolor
6¾″ × 4½″

A vivid sense of atmosphere is achieved in this sketch with admirable economy of means. The artist has used free, broad brushstrokes and a limited palette to overcome the problems of working quickly in watercolor, but there is a clear impression of descriptive detail in a well-organized composition.

- *Decide whether you will keep one sketchbook for all your records, or different ones for different subjects.*

- *Keep together all the materials and equipment you need, but try to keep them to a minimum. For example, if you are using pencil you don't necessarily need an eraser, as free sketches need not be clean or fully accurate, but you do need a pencil sharpener or safety knife to keep pencil points fresh.*

- *Get into the habit of working openly right from the start. If your subjects are people, make it easy for them to accept the situation, and it will be easier for you to concentrate on the work in hand. But don't persist in sketching someone who doesn't want to be included – artistic license only goes so far.*

- *Find a reasonably comfortable way to work, unless you are just doing rapid thumbnail sketches. If you need a long period of study, find somewhere to sit and something to balance your sketchbook on, so that your drawing hand can move freely and confidently.*

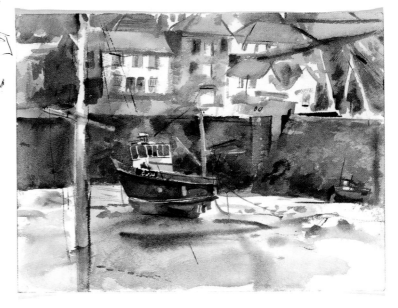

Elisabeth Harden
Pencil
14¾″ × 10¼″

Everyday occurrences provide interesting material for sketching as much as do unfamiliar locations and events.

Watching a friend at work in the yard, the artist has seen the potential for a lively image which she has rendered quickly and freely in line and tone.

Stan Smith
Watercolor
12″ × 15¾″

This brush drawing gives a detailed impression, but its apparent complexity is subtly achieved. The background is loosely washed in with broad strokes. The crisp outlines and strong colors of the boat focus the image, and the foreground plane is cleverly established by the fine lines radiating from the mast at left. Colors flooded through the range of grays representing stone and water both enliven and unify the composition.

Developing ✏️
a seeing eye

The idea of sketching conjures a vision of sitting in a sunny landscape with pencils and watercolors at hand, but it is not always possible to isolate a block of time to be devoted to sketching, nor to work on an "ideal" subject that is relatively inaccessible. However, if you become addicted to sketching, or in order to get yourself into the habit, you can pick any subject from what is immediately at hand. However mundane or familiar it may seem,

GETTING STARTED

Immediate subjects

once you consider it in terms of drawing — what material you will use, what is the exact shape, texture, or color of an object, and how you can translate this onto the page — you will find your couch cushions or your cat just as interesting as a mountain view or a caged leopard.

The advantage of doing this is that you can work at home, making use of any amount of time you happen to have to spare, and using any of the materials that you have in stock, so that you can vary between drawing and painting media, between monochrome and color images. You can also use a large sheet of paper rather than a confined sketchpad page, if you prefer. Spend some time looking around your home with an artist's eye for the potential of your everyday possessions. And don't neglect the important subject that is with you all the time: Self-portraiture can be fascinating, and you can readily make detail studies of, for example, your hands and feet — elements that most artists find difficult in figure drawing.

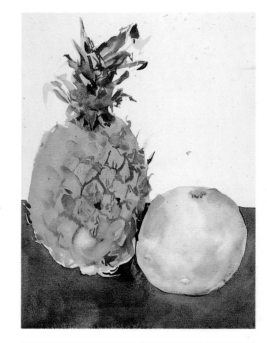

Stan Smith
Watercolor
12¼″ × 9″

Two fruits form the simplest of still lifes, but with plenty to study in the forms, colors, and textures. Here, broad watercolor washes establishing the basic color range are overlaid with brush-drawn detail.

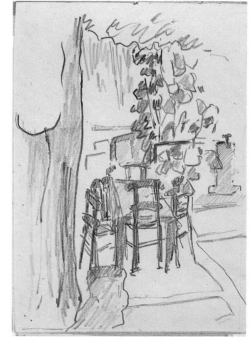

Daphne Casdagli
Colored Pencil
6¼″ × 4½″

Since we spend a lot of time indoors at home or work, we inhabit many kinds of interiors that can provide convenient, if familiar, subjects. This sketch shows how a slightly unusual perspective, a fresh, direct technical approach and attention to contrast in the range of detail can produce a strikingly original image.

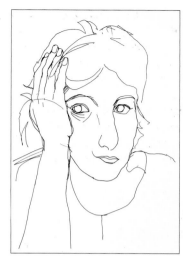

Stan Smith
Felt-tip Pen
9″ × 12″

This sketch of sleeping children contains a range of interesting visual references (below). Despite the inactivity of the subjects, the artist has chosen to use very vigorous line work to trace the children's hands and faces, the folds and patterns of the covers, and the angular grid of the bed rail. A difficult detail precisely realized here is the characteristic structure of a child's head, as distinct from an adult's — typical features are the high forehead and smallness of the nose in relation to the rest of the face.

Judy Martin
Felt-tip Pen (left and above)
11″ × 7″

Portraiture is not an easy subject for everyone. Sketched self-portraits give you an opportunity to practice in privacy. The sketches will capture a different mood and perception each time. Begin with simple line work in felt-tip pen or pencil, and as you become more at ease, you may like to move on to color work.

● *Self-portraits — try them "straight" until you get used to taking an objective view of your own face. Then, just for fun, try sketching yourself in the style of a famous artist you admire.*

● *The carpet or drapes — patterned textiles provide simple but detailed subjects that call for discipline and concentration in your drawing. Your sketches might be in line or color.*

● *Houseplants or a flower arrangement, fruits and vegetables — natural subjects are appealing for shape, texture, and color. Try fairly rapid sketches in various media, experimenting with different interpretations.*

● *The family pet — most dogs and cats spend enough time resting or fast asleep to provide an obedient and accessible artist's model, but there is also a special challenge in drawing them on the move.*

● *An unmade bed — this can become almost an alpine landscape when you examine the folds and crevasses in sheets and covers. If you like figure drawing, sketch your children or partner asleep in bed.*

● *The kitchen counter — just as it is. Don't bother to clear away the random clutter of utensils and food packages — their shapes, patterns, and textures form a fascinating still life.*

● *Broaden your scope by sketching the view from a window — the housefront opposite, the yard, stores and shoppers, passing traffic. Readily accessible subjects need not be confined in scale.*

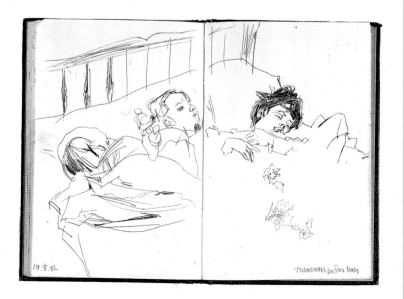

Outdoor work presents a wealth of possibilities — landscape and seascape, parks and gardens, town views with and without the day-to-day movements of their inhabitants. The drawbacks of sketching outdoors, such as they are, have a lot to do with practicalities — how to carry the materials and equipment you may need, especially for color work, and how to protect yourself against the more extreme weather conditions without handicapping your

Elisabeth Harden
Pencil, Watercolor, and
Gouache
23½″ × 16½″

Determining the ✎
subject of a sketch

Coping with ✎
the elements

How to capture ✎
atmosphere

Your outdoor sketches may include individual natural subjects and details as well as broader landscape views. Here a plum tree in blossom above a bright mass of flowers provides plenty of visual interest and captures the mood of spring. The artist went on to make a gouache painting and a collage of the same subject, using this sketch as reference.

Sketching outdoors

GETTING STARTED

sightlines and your drawing hand.

When you confront the enormous scope of the world outdoors, you will need to devise some means of focusing your attention. In strange or familiar places, you could fill several sketchbooks standing on one spot, so you have to be selective. As with all subjects, you are dealing with space and form, light and color, but these elements are large and out of your control. Basic considerations are fitting the sketch to your sketchbook page, framing the image effectively, and adapting the visual information to the qualities of your medium (or vice versa). How you approach the work also depends upon whether you are trying to capture a broad view and the general atmosphere, or details such as changing skies and the qualities of light affecting the appearance of landscape or architecture. Fortunately, there will be occasions when you can easily do both, but often your first task is to survey the scene and figure out your priorities.

CHOOSING YOUR VIEWPOINT

Trust your instincts — when you see something immediately arresting, whether a full view or a special detail, sketch your first impression very rapidly. If you have time you can try different viewpoints or approaches, but don't lose the opportunity for a good sketch by being indecisive at the start.

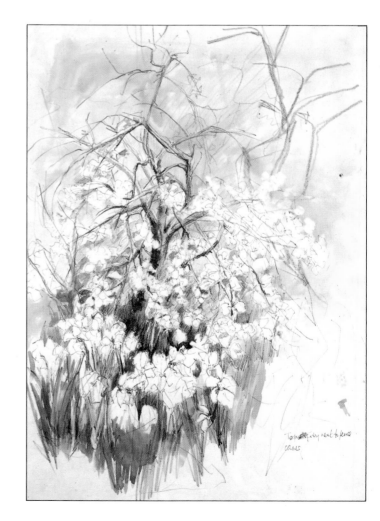

**Daphne Casdagli
Watercolor and Pen**
5¾" × 8¼"

A wide open landscape is an attractive subject — fields, hills, patches of woodland, hedgerows, and fences. Using broad strokes and subtle colors, with areas of bare paper giving spaciousness and light to the image, the artist creates an impression of openness and distance. This is emphasized by the relatively dark tone of the sky. The landscape's linear framework is loosely defined with ink lines that have sometimes diffused into the paint.

- Decide whether you are going to study a particular view or move fairly far afield looking for varied views and details. If you are keeping on the move, don't burden yourself with an unnecessary amount of equipment.

- If you are spending some time in one location, check out comfortable places to sit, and look for a flat stone or wall, for example, where you can set out your materials.

- When using paint, make sure you have an adequate water supply or there is somewhere near your work spot where you can rinse out and freshen water jars. Although you don't want to carry huge quantities of water, it is frustrating when colors become muddied and you can't clean brushes properly.

- Choose clothes that are comfortable and practical — take a hat if it is very hot, wear lots of layers and fingerless gloves if it is cold. The outdoor temperature affects you surprisingly quickly when you are immobile for periods of time.

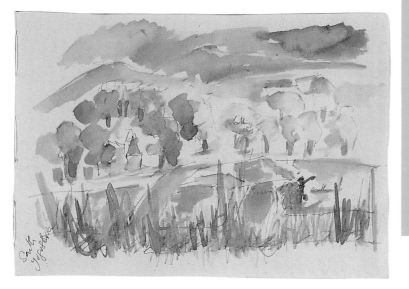

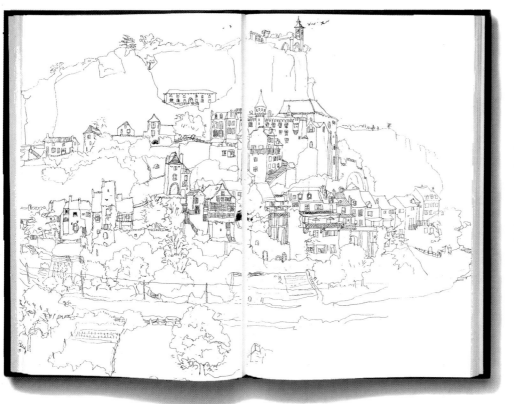

**Moira Clinch
Pencil**
14" × 17¾"

The line qualities in this drawing are nicely adapted to the elements of pattern and texture in the subject. The artist's high viewpoint gives a clear perspective to the panoramic sweep of the landscape. A detailed outdoor sketch of this kind may require several hours of concentration — you need to find a comfortable location.

Any long journey, or a business or vacation trip, provides the opportunity to sketch unfamiliar places and people. This is valuable for simple practice in sketching technique, and also forms an interesting personal record of where you have been and what you have seen.

Sketching while you are traveling gives you an occupation for time that might otherwise be wasted. During the hours spent in an automobile, bus, train, or plane, you can draw

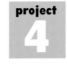
Stan Smith
Ballpoint
5¾″ × 8¼″

Journey time is often wasted, but sketching makes good use of it for sharpening your perception and technique (right). Public transportation such as trains or buses provides interesting perspectives and a wealth of human subjects.

Sketching on the move

GETTING STARTED

the people accompanying you, your fellow travelers, or the interior of the vehicle itself. There are also snatches of time on any trip when you might be waiting for someone in a lobby or restaurant, or marking time in an unfamiliar hotel room. Then you can use a small sketchpad and a simple tool, such as a ballpoint or felt-tip pen, to make quick visual notes.

Materials for sketching on the move should be basic and portable. Bound sketchbooks, available in various sizes, are easy to handle and can be quickly pulled out when you get an unexpected moment for drawing. Pencils and all types of reservoir pens – ballpoints, felt-tips, a fountain pen, or technical pen – are the most convenient drawing tools. You could carry colored pencils for color work, but it is more difficult to use materials that may be a little messy, such as soft pastels, or that need diluting, such as watercolors. However, if you take a watercolor set with you on the trip, although you may not be able to use it on the spot you can take color notes while you draw and then add color detail to the sketch later while the image is still fresh in your mind.

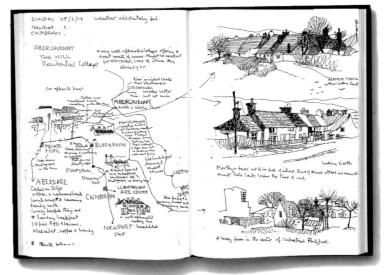

Ray Evans
Technical Pen
5¾″ × 8¼″

This sketchbook spread makes pleasantly literal reference to sketching on the move, since the artist has created a map of locations visited and has added notes that form a diary of how his time was spent. The map includes details of local views, supplemented by the drawings on the right-hand page. The pages form a valuable record of particular events.

BEING PREPARED

Make a careful selection of the materials you need, keeping to the minimum so that you don't have to carry extra bags. Carry the basics with you in your hand baggage – a small sketchbook, pencils, and pens – ready for use at any opportunity.

If you are on a long trip and want to be equipped with watercolors as well as drawing tools, choose a small, lightweight watercolor set rather than individual tube or cake paints, and select two or three brushes, including a fine one for detail work and a broader size for color washes.

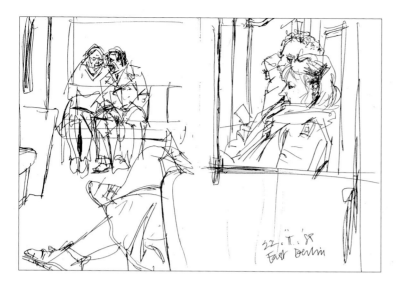

- *Quick impressions of place.*

- *Interesting perspectives – interiors of vehicles, waiting rooms, and hotels.*

- *Portraits of fellow travelers.*

- *Things seen on the journey – at any stopping point you can draw the houses, stores, and roadside features of the location.*

- *Cafés and restaurants – the décor, the customers, the table setting, the food.*

Moira Clinch
Pencil and Colored Pencil
14″ × 17¾″

Sketching while traveling in a moving vehicle may help to loosen up your technique (below). The movement of a bus or car makes it difficult to retain tight control of an image. As in this example, some of the motion translates into an active line quality that only adds to the character of the drawing.

Travel notes

Unfamiliar locations offer a wealth of material for sketching. When you are absorbing so much of great visual interest, you may find that this inspires a fresh vitality and confidence in your technique and interpretation. In all the sketches on these pages, the artists have given themselves time to consider the detail of their subjects and the ways of translating it to the page. For this you need leisure time, but the more concentrated approach can always be combined with keeping a record of quicker, visual "diary" notes.

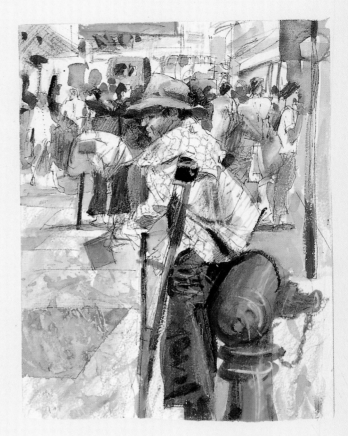

Moira Clinch
Pencil
14″ × 17¾″

For many of us, a small fishing boat with its full regalia is hardly a common sight, and the artist has immediately focused on its visual potential in terms of the varied structures, textures, and patterns contained within the single subject. These are interpreted through the pencil's capacities to create a rich linear and tonal range. The interesting perspective gained by looking down onto the deck from the harbor wall creates a pleasingly self-contained shape within which every feature is carefully mapped out.

Stan Smith
Mixed Media
13″ × 10″

This busy street scene is given depth and character by focusing on a single individual and making him the central axis of the image. With a free and confident approach to technique, the artist has combined ink, pencil, and pastel drawing with watercolor washes to capture the vibrant range of colors and textures in the scene. The visual links formed by the strong reds and yellows traveling through the image underscore the thoughtful organization of the composition. composition.

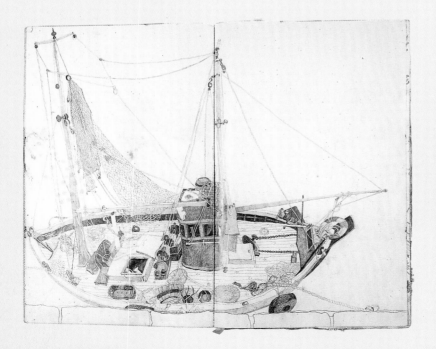

Stan Smith
Watercolor on Colored
Paper
11¼″ × 15¼″

It is not always among the tourist sights and the hustle and bustle of the streets that you will find your most intriguing subjects for sketching on your travels. This subdued workplace interior has provided the artist with a gentle geometry and subtle coloration that together create a strongly atmospheric image. The use of a mid-toned warm buff-colored paper as the basis for the watercolor sketch sets the mood and unifies the image.

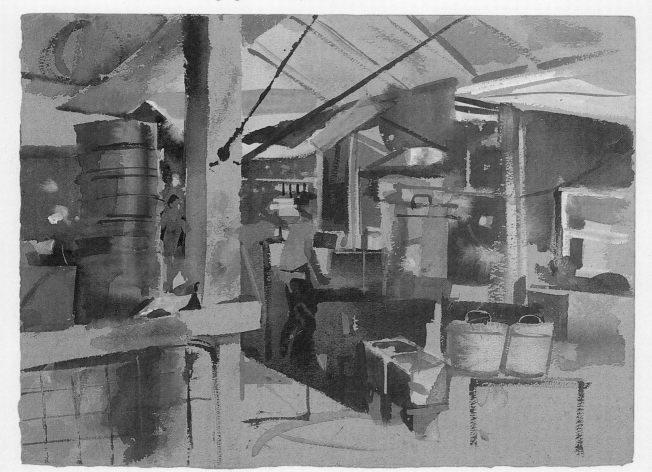

The ideal tool for sketching is clean, light-weight and easily portable, and can be quickly put to use in any situation. Pencils, ballpoint and fiber- or felt-tip pens all answer this description, but their practicality is not the only good reason for using them. All have a particular fluidity and variable quality of line that lends vitality to your sketches. Each has its individual texture, but the linear qualities are very soft and responsive to the movement

Elisabeth Harden
Felt-tip Pens
5¾" × 4¼"

Felt-tip pen colors are typically somewhat bright, so the challenge is to make the colors work together in an image that is both descriptive and expressive. In this sketch the red-brown makes a pleasing contrast with the close-toned green and blue, and the three-dimensionality of the subject is enhanced by the distribution of colors in line and tone.

Pencil, ballpoint, felt-tip pen

GETTING STARTED

and pressure of your hand.

For sketching, you need B-coded pencils — H pencils are too hard and the line too light to give you a good result. Remember that the softer the pencil "lead," the more easily the point is blunted, so keep something at hand to sharpen the pencil, and a plastic bag in which to keep pencil shavings if you are sketching outdoors or in a public place.

Colored pencils are equally portable, and valuable for quick color notes. Choose a few in what you think will be the most useful colors. Allow for color mixes too — yellow and blue shaded together into green, yellow and red hatched over each other to form orange.

The line quality of ballpoint pens varies greatly, as does the quality of the ink, so you may get blobs and smudges on your drawing. Since this is an inexpensive form of drawing tool, try out a few different kinds to see which feels most comfortable to use and gives a well-defined line. You can use any color, but black and blue are the most versatile for creating a range of tonal values.

Felt-tip pens provide a fine, fluid line quality that can be varied in emphasis, which helps you to vary your approach to image qualities such as volume and tone. Felt-tip pens are usually thicker and heavier, not always desirable, but you may sometimes appreciate their boldness.

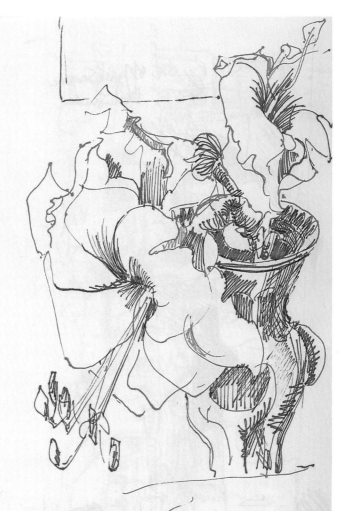

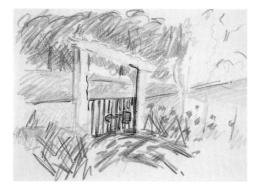

Daphne Casdagli
Colored Pencil
4½″ × 6¼″

Colored pencils provide a wide range of color potential (left), from subtle neutrals to vivid hues. This rendering of a decorative gateway flanked by flowers makes good use of the medium's specific properties.

All these items can be kept in your pocket or in a purse or bag, and this makes them very handy for rapid sketching at any moment. However, with pencils, if you are using very soft types they may spread dirt from the graphite content of the lead, so you might wish to keep them in a pencil case or box. With ballpoints and felt-tips, make sure the caps are secure so that ink cannot leak out into your pocket or purse lining.

John Lidzey
Pencil
9″ × 12″

A pencil is a versatile tool, producing a range of values from palest gray to densest black, and possesses soft, responsive linear qualities (right). A well-balanced composition here gains emphasis from the heavy pencil hatching.

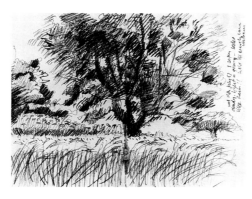

Stan Smith
Ballpoint
5¾″ × 8¼″

Using a ballpoint or felt-tip pen forces you to take a direct approach to your sketches (below), because the ink line is strong and not easily erased. If you make an error, you can go back over it to refine and correct the shapes, as in the image of the seated child on the right of this sketch, where the artist has made amendments. Although the emphasis is on line work and the interaction of shapes within the group, the density of the ink is exploited with shading that develops the tonal balance of the image.

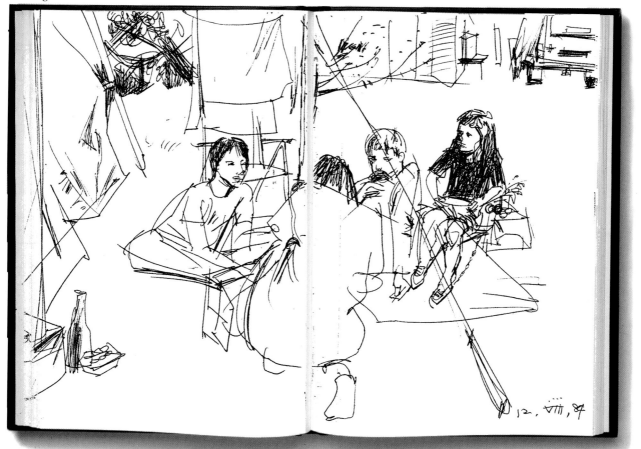

When you are using a linear medium, you may feel that there is some restriction on what you can put into your sketch. Elsewhere in the book, you will find plenty of examples of sketching techniques that give tone and "color" to monochrome work, but the drawings on these pages show the exciting potential of simple line drawing for describing the different emphases of three-dimensional form and space, and creating an atmosphere or mood.

GETTING
STARTED

The magic of line

Pencils and pens of all kinds — ballpoints, felt-tips, dip pens, and fountain pens — provide a responsive line quality that can be bold or nervous, even or variable, heavily etched or briefly traced across the page. Quick sketches of any accessible subject (see also pp.14-15) are the best way to discover the capabilities of your medium. You can learn a certain amount about the formal qualities of the line just by doodling with a pen or pencil, but to discover how to apply it to creating form or mood, you need to study the contour and detail of a particular subject and let your hand manipulate the drawing tool freely according to your visual response.

There are various tricks you can play to achieve a sense of space and volume in a line drawing — letting the line taper or break as it describes a receding form; giving the line itself an emphatic swell on a beautifully curved shape; feathering the line or working over and over it to allow a distinctive contour to emerge from a network of marks. Study the examples of figure work shown here to identify the range of linear treatments the artists have applied; then look through other sections of the book to see how such techniques have been appropriately used in describing other subjects.

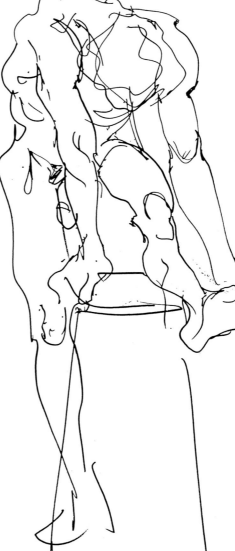

Moira Clinch
Pencil
11½″ × 16″

The interior space of the vehicle is expertly suggested with the simple sweep of the lines around the seat backs and window areas (right). A kind of tension in the line itself seems to express the driver's concentration and grip on the wheel.

John Elliot
Felt-tip Pen
10¾″ × 6¼″

This demonstration sketch for a life class (left) shows the varied line qualities that can be achieved with a felt-tip pen. As the pen tip swirls around the figure, tracing its strength and vitality, the lines swell and taper to describe the forms.

Stan Smith
Ballpoint and Technical Pen
11½″ × 8¼″

The linear structure of this sketch (right) endows the figures with weight and solidity, although many of the individual pen strokes are brief and fragile. The line treatment of the baby and the woman's body throws the heavy hatching on the face and head into sharp relief, these different technical approaches working effectively within the whole. Note the attention to detail, as in the rendering of the baby's curled fist.

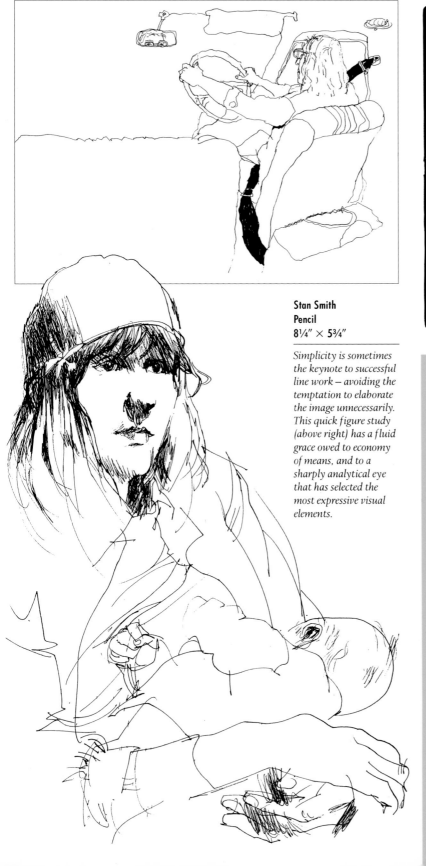

Stan Smith
Pencil
8¼" × 5¾"

*Simplicity is sometimes
the keynote to successful
line work – avoiding the
temptation to elaborate
the image unnecessarily.
This quick figure study
(above right) has a fluid
grace owed to economy
of means, and to a
sharply analytical eye
that has selected the
most expressive visual
elements.*

MEDIA FOR LINE WORK

● *Pencil – the line quality depends
upon the softness or hardness of the
pencil, the quality of its point, and the
pressure you apply. Sometimes you need
to maintain a sharp point so that the
line is clean and incisive; a blunted tip
gives a softer feel to the drawing. You can
angle, turn, and twist the pencil point to
vary line width and texture.*

● *Ballpoint – ballpoint pens have a
particular fluidity that encourages free
manipulation. You can let the tip trail
and turn to create a nervous, active line,
or press hard and scribble vigorously to
develop a bolder image.*

● *Felt-tip pens – these give a more
even line, since you cannot press too hard
without eventually spreading or
breaking the pen tip. However, there is a
wide range of thicknesses and ink
qualities to choose from. Experiment
with a few types to find the ones that
best suit your aims.*

● *Fountain pen – as easily portable as
a ballpoint or felt-tip (though make sure
the pen cannot leak while you are
carrying it), the fountain pen makes a
line of gentle, variable quality because of
the ink flow, and you can manipulate
the line weight by angling the nib and
subtly altering the pressure of your
fingers on the pen's movement.*

Sketches, whether on loose paper or in a sketchbook, can always be regarded as purely personal visual notes. In this respect, you are under no obligation to produce accurate or highly descriptive images, nor to explain to anyone else what a particular sketch signifies. In fact, many sketches are more or less incomprehensible to anyone but the artist; but because the artist has the visual memory that supplements the drawing, a few lines or

Visual shorthand

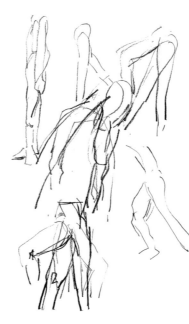

**Elisabeth Harden
Pencil and Watercolor
11½″ × 8″**

In this sketch (right), one of several working drawings for a lithographic print, the actual shapes of the objects in the still life are unimportant. This version is a rapid color trial investigating the range of hues and tones, the general distribution of light and shade across the image. Working drawings may appear very different visually from the intended final image.

simple blobs of color can recreate a very vivid impression of a whole scene in his or her mind.

Everyone develops forms of personal shorthand for use in sketches that have to be made on the move or under pressure. You need to pinpoint quickly but effectively the key elements of the scene — those that are likely to revive the observations stored in your mind when you return to the sketches later — and let this information be freely interpreted by your hand and medium. This type of sketch is an approximation of an image that serves as a prompt; in the same way, you might remind yourself of the content of a discussion by noting down key words.

Visual shorthand also includes the kind of sketch that is the record of an idea rather than of something seen, to be elaborated later. The freedom of a sketch can also introduce accidental surface effects that can be developed in further workings toward a final image. Sketches made as a way of planning out the form and content of a painting or print, for example, may at the same time suggest technical solutions for dealing with particular visual effects.

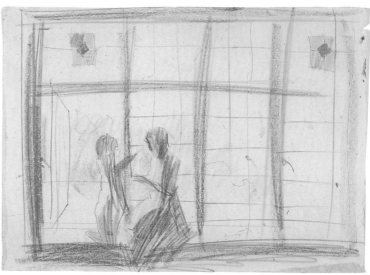

**project
7**

**Stan Smith
Pencil and Pastel
10½″ × 14½″**

It is clear what this image represents and it has a descriptive mood, but there is no attempt at precision (above). The easy approach to the geometry of the window, allowing the lines to bend and taper, is matched by the vigorous working of the silhouetted figures.

**Daphne Casdagli
Pencil
11″ × 7¼″**

Sketches of moving subjects produce a rather abstract effect (top), but it is important not to inhibit yourself by trying to create a whole, recognizable image. This kind of drawing exercise is a good way to develop instinctive hand-eye coordination.

Interpreting what you see ✎

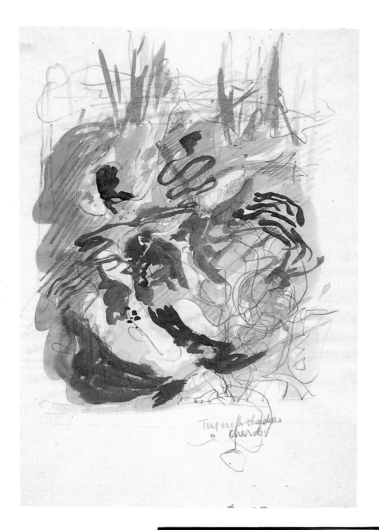

- The contrast of line and mass – in trees, for example, the weight of the foliage against the linear structure of the branches; in buildings, the flat planes of walls and roofs interrupted by structural detail or surface decoration. Use methods of rapid notation – freely worked lines, marks and scribbles appropriate to the nature of the subject.

- Direction and movement – the general rhythms and patterns of the image. In a street scene, for example, there are the horizontal and vertical emphases of the buildings and roads that contain the random bustle of people going about their business. Your sketch notes for such subjects may seem fairly abstract when divorced from the situation.

- Tonal values – a simple breakdown of the pattern of light and shade can create a sense of space and volume; the absence of detail may even enhance the sense of atmosphere. Look for silhouetted shapes, the deepest shadows and strongest highlights, the surface planes and textures that are described by distinct tonal variations.

- Colors – if you haven't time to concentrate on detail, make visual notes that represent overall color balances and the interaction of particular color combinations. Have separate notes on pattern and texture. Don't waste time worrying about accurate shapes – you can refine these later if necessary.

Paul Hogarth
Pencil
9½″ × 14½″

Many sketches combine a record of something seen with ideas about how that information might be interpreted. This outline sketch (right) includes written notes that contain points of interest on colors, shapes, light and shadow, and the general impression of the scene. As often happens in a sketchbook, there are elements out of scale with one another and images overlaid, but to the artist the sketch provides a coherent guideline to his idea.

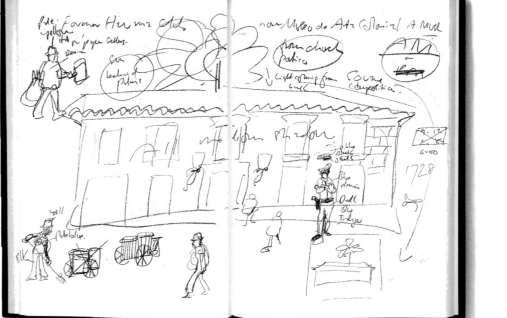

One of the most important practical aspects of sketching is to understand what you can achieve in the time available. If you are on vacation, or spending the day in the country or at the beach, you may have a chance for a leisurely approach to your subject and be able to try out different techniques and media for interpreting its range. But sketching is often most successful when it is a matter of seizing a chance opportunity, and there is no point in

John Elliot
Felt-tip Pen
8″ × 10″

The rapidity of this sketch (left) can be judged by the fact that it was done from a moving car, so the artist has had time only to dash in the briefest outlines. This snatched opportunity to draw is an interesting contrast to the character of the subject, which even so loosely described conveys a mood of leisure.

A sense of timing

GETTING STARTED

project
8

Assessing the right approach

embarking on a detailed drawing when you are likely to be interrupted or swept onward within a few minutes. Starting with realistic intentions for your sketch notes is also a crucial way of building your confidence — otherwise you may assume that your technique or observation were at fault when, in fact, you simply didn't have time to achieve what you started out to do.

Timing is also part of your method in working out how to focus on a subject and translate it to your page. Even when you have plenty of time to observe a particular subject, you do not need to begin by making a detailed or all-embracing sketch. Rapid thumbnail sketches are invaluable for getting to know a subject — of different viewpoints and features; of the various ways of arranging your composition; for trying out different processes of mark-making to see how to express the linear, tonal, and textural qualities of the subject; for making quick color notes that provide impression and atmosphere rather than shape and form.

Keep a mental note of your instinctive approach to sketching — whether you tend to try to capture a whole scene in one go, or prefer to doodle around it until a sense of the subject comes through more clearly. Then be prepared to challenge yourself by doing the opposite of your natural method.

John Lidzey
Pencil and Watercolor
9″ × 12″

A detailed color study of this kind obviously needs an unhurried approach. In addition to the time it takes to draw out the subject, lay in and adjust the color values, and build up the impression of detail, there may be the extra practical element of allowing time for some of the color washes to dry, so that the brighter hues and finer brush strokes remain distinct. Also, the more detail you include, the more selectively you need to plan and execute the sketch, which means the process cannot be rushed.

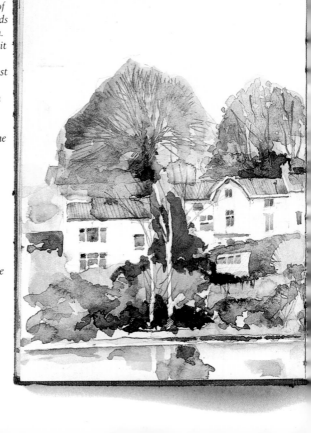

The Mere, Diss. Easter Monday 1990

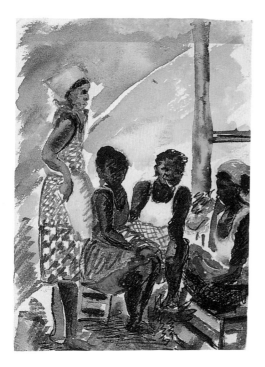

Daphne Casdagli
Watercolor and Pen
7¼" × 5½"

This color sketch incorporates a variety of detail of colors, tones, patterns, and textures in its description of the subject, but there are signs that it was executed with some rapidity. The artist has concentrated on the figure group, leaving the background as a mere impression, and has worked up the figures with loose, lively layers of color and ink drawing, getting the feel of the subject without concern for realism.

• *Choose a simple subject and give it full attention for no fewer than 15 minutes. Even if you choose to draw just the outline of an apple, say, concentrate on getting the contours absolutely right and consider whether the line is expressively drawn. In this amount of time, you could also make a highly effective color study (see pp.40–43).*

• *Go to a busy location where there is a lot going on and make a series of very rapid sketches, trying to capture some particular essence of the subject in each. Limit yourself to one, two, or three minutes per sketch and don't complicate the technique – just use pencil, ballpoint, or felt-tip pen and a small, easily portable sketchbook.*

• *Draw the same subject once a day for a week. Decide each time whether you are going to spend more or less time than on the sketch of the day before – and see whether you can gradually reduce the time you need as you become more and more familiar with your subject. (Still life and self-portraiture are ideal themes for this exercise.)*

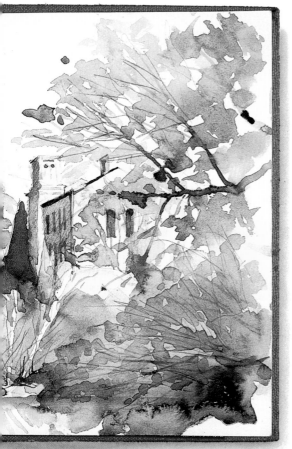

Stan Smith
Pencil
8¼" × 11½"

As with the sketch of the two men in a boat on the opposite page, this brief visual note (above) of a landscape view is caught with just a few essential lines, although here the artist has roughly scribbled in a little tonal detail. It is evident that the scene has left a fairly vivid mark on the artist's memory and he has chosen to include written notes on color, suggesting that there is an idea for a composition here that he may wish to return to.

Different kinds of pens and inks give you many exciting options for exploring sketching techniques and making images. The simplest media are ballpoints and felt-tip pens (see also pp.22–25), but dip pens and fountain pens, while potentially more messy to use, provide a range of more subtle qualities in both line and tone.

Dip pens are available with a vast array of interchangeable nibs, both drawing and calli-

Using dip pens and ✎ fountain pens

The line and ✎ wash technique

Sketching in ink

GETTING STARTED

graphic nibs, that give you all sorts of line weights and textures, including multiple lines (from split nib units). With these you can use waterproof or water-based inks, in black or various colors. Line and wash is a traditional and very effective sketching technique for which you need to be equipped with brushes and water jars as well as your pens — for the wash you can use diluted ink or watercolor. This gives you wider scope for work in tone and color, but it does mean that if you are working outdoors, you have to carry pens, brushes and ink bottles, perhaps a watercolor box, a basic palette, and your water supply.

Fountain pen ink, since it is water-soluble, gives you the instant option of line and wash. When you have made a mark with the pen, you can just wet the tip of your finger and spread the ink into a softer tone. Writing inks can create surprising color effects when mixed with water — some black fountain pen inks, for example, separate into soft tones of blue and brown.

Technical pens are useful to work with because they are clean and easily portable, the ink reservoir being contained within the pen. In comparison with dip or fountain pens, however, their drawback is the precision and consistency of the line made by the very fine nib. This is essential to the kind of detailed graphic work for which these pens are designed, but it can prove restricting to the artist seeking a freer result.

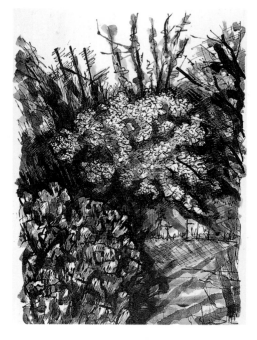

Judy Martin
India Ink
18½″ × 14″

In this drawing (right), the rich tones of full-strength and diluted india ink are worked with dip pen and brush. These may be messy implements to carry around with you, but they can be freely used for studio work, as here, in a garden view seen through a window. The sketch is concerned with tone and texture, focusing on the way the bright blossom of some flowering trees stands out against the shadowed foliage.

Kate Gwynn
Pen and Ink
11¾″ × 16½″

A simple outline drawing of a posed figure (below) can have a solid, almost monumental quality if the line work sensitively describes the volume and mass of the body. This sketch achieves precisely

that, and adds a unique visual quality in the way the paper surface has diffused the ink, giving weight and softness to the line itself.

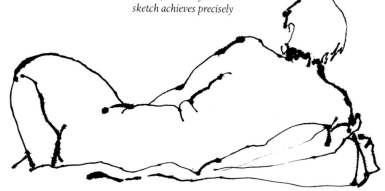

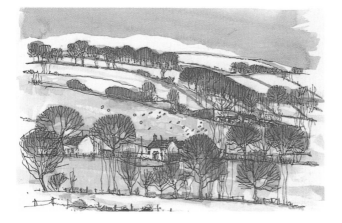

Ray Evans
Ink and Watercolor
6″ × 8″

The properties of line and wash technique have been excellently exploited here (above). A strong linear framework full of detail and texture has been firmly established to support the application of color.

John Elliot
Refillable Sketchpen
10″ × 8″

The fineness of the pen line has not inhibited the technique applied to this sketch (below). Through a busy network of vigorously hatched and scribbled lines, a remarkably precise image emerges. A pattern of hatched lines with horizontal and vertical emphases used to construct the wooden shack is contrasted with the more fluid, irregular textures of the trees. The drawing provides a detailed sense of place.

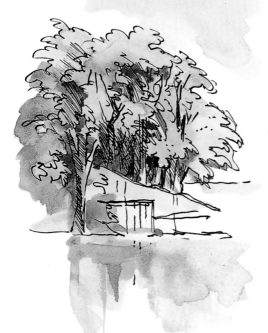

John Lidzey
Ink Line and Wash
9″ × 6″

The effective tonal qualities of line and wash drawing are here enhanced by a gentle color bias (left). The structural lines of the drawing are strongly black, but are overlaid with brown and blue tones creating a warm/cool contrast that gives depth to the shadows.

LINE AND WASH TECHNIQUES

• *Tonal studies* — to get the depth of tone and texture you need, you may have to go over and over certain parts of the image, allowing drying time in between. You can achieve tonal variation by using different dilutions of a single color, or by adding subtle colors — perhaps brown and blue with basic black — to increase the range of tones by the natural contrast of color density.

• *Color studies* — there is something particularly attractive about the crispness of an ink line drawing flooded with soft color washes. Usually, the structure of the image is defined in the line work, while the detail and surface texture are added in color. Let the ink drawing dry before you wet the paper surface. Waterproof ink maintains its linear clarity when overlaid with washes; a water-soluble ink will spread gently into the colors, diffusing the lines and creating new tonal values.

Some of the most magical sketches are loosely and freely drawn, with an image barely emerging from just a few lines or a network of scribbles. However, merely having the intention to sketch freely does not always make it easy to let your eye travel adventurously or allow your hand to mark the paper uninhibitedly. When you begin a drawing of any kind, especially if you are an inexperienced artist or lack confidence in your technique,

Adopting a confident ✏ approach

Daphne Casdagli
Crayon
7¾″ × 5″

The bright hues and blunt shapes of colored crayons encourage a very free and easy approach to drawing. The grainy texture of the medium can be exploited in line work and color shading. This drawing captures a vivid effect of light and warmth with these simple means, making use of the full strength of the yellow crayon counterpointed by blues and reds.

Freeing the eye and hand

GETTING STARTED

there is sometimes a determination to "get it right" that can limit the potential of the work from the start.

If you find that your ambitions and expectations exceed the quality of the results, it may be that you need to become more relaxed in technique or approach. So, for the time being, forget about recording detail or producing "finished" sketches — set yourself a few projects designed to challenge your preconceptions about drawing and sketching. Allow yourself to treat technical skill and the crafting of an image with less than the respect that they deserve — pick up a pencil or felt-tip pen and embark on an exercise that might even seem mad, bad, or dangerous, well outside your usual range. You may be surprised how enjoyable and impressive the result is.

MATERIALS

Use a simple medium that makes well-defined marks and travels freely on the paper surface: a soft pencil (3B–6B) or a graphite stick; felt-tip pen; charcoal, wax crayon, or Conté crayon.

Work on a piece of paper or sketchpad large enough to allow you to make free gestures with your hand and lower arm — don't confine yourself to cramped movements of the wrist and fingers.

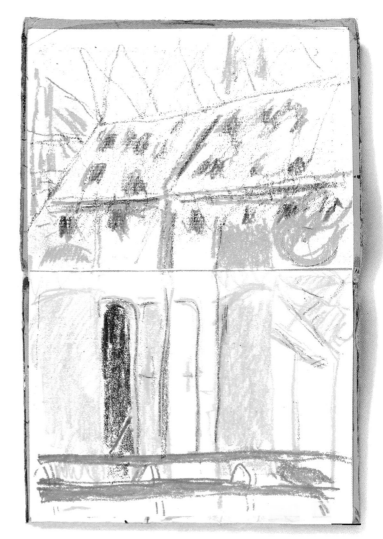

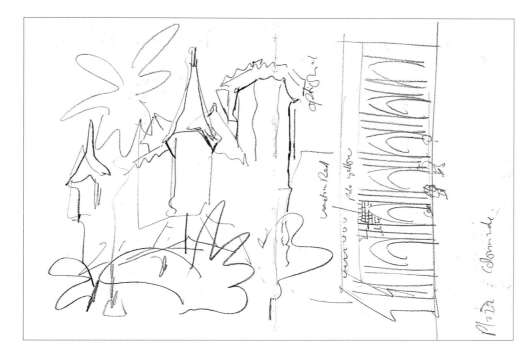

Paul Hogarth
Pencil
9½″ × 14½″

These rapidly sketched architectural studies create a highly expressive impression of their subjects even though so little detail is included. The nervous, fluid lines of the drawing on the left have different weights that construct the perspective of the building effectively. The trees surrounding it are sketched with mere starbursts of pencil scribble, but the scene is readily elaborated in the mind's eye.

Daphne Casdagli
Watercolor
4¼″ × 5½″

Watercolor painting is frequently associated with subtle, painstaking technique, but in this sketch full-strength color and uninhibited brushwork demonstrate how the medium can have a quite different mood.

Stan Smith
Ballpoint
8¼″ × 5¾″

An unusual effect of light points to a different way of dealing with volume and movement in this figure study. The outlines of the figures are loosely etched on the page, but the pattern from the shadows of a Venetian blind contributes to the expression of their contours and actions.

IDEAS FOR A FREE START

● *Select a readily available subject — furniture, a vase of flowers, a simple still life, a self-portrait — and draw it rapidly in line without lifting your pencil or pen from the paper. Make all the necessary marks and outlines relating to the subject, but let your drawing tool travel freely between them.*

● *Choose a single object and study it very closely for a few minutes. Close your eyes, and spend another few minutes sketching the object from memory, just letting your drawing hand follow the mental image — and don't give in to the temptation to look back at the object or down at the paper.*

● *Sketch what is happening on the television screen, making an absolutely faithful record only of what you are sure you have seen. You will find that the images change so quickly, you can only make more or less abstract notations of what passes before your eyes. Keep working on the same piece of paper for at least 15 minutes, building up a network of marks.*

● *Create a still life of objects with well-defined outlines — for example, a collection of china dishes, cups, and jugs, or a group of fruits and vegetables. Sketch them by defining on your paper the shapes between and around them, rather than the shapes of the objects themselves.*

Movement is an attractive and at the same time baffling element for the visual artist. No sooner does a particular movement attract your eye than it is gone, replaced by another set of shapes and visual relationships that has passed equally quickly into another. Sketching is the ideal technique for recording things in motion, because with practice you can get your brain and hand to respond very rapidly to what you see. Your sketches may not be quite

Developing hand-eye coordination

GETTING STARTED

Sketching movement

visually coherent as whole images, but the intention should be to capture the essence of the movement in a way that makes sense to you.

It is tempting to "freeze" a moving subject by taking photographs and using the photographs as the basis for a drawing. This makes it easy to analyze the split-second motion recorded on film, but it tells you nothing of what came before or after, or how the movement fell within a pattern of change. It also reduces the information you receive because the camera's eye is selective, so the photographic image may be missing the most telling angle or gesture that might describe the particular motion as you would have recognized it firsthand, without a camera lens.

This is a difficult area to deal with and there are several options for your approach. The key factor is to allow the very quick and receptive activity of your eye to be translated instinctively to your drawing hand. Practice instant sketches, making your drawn record in just a few seconds. Try to avoid any delay between seeing and doing, when your brain will intervene between eye and hand, since you may then introduce elements based on assumption or memory rather than respond to what you have actually seen in that immediate moment.

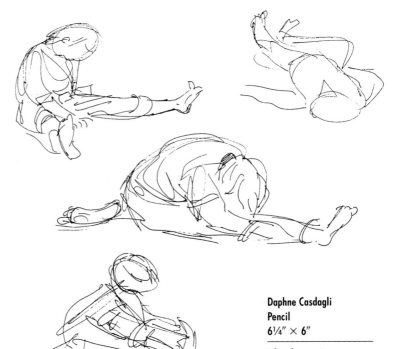

John Elliot
Refillable Sketchpen
13¾″ × 11¼″

One approach to movement studies is to work through a series of rapid thumbnail sketches, building up a sequence of movements through fairly simple individual images. There

is an extra component here in that these drawings were made in a children's karate class, so there is the added challenge of conveying the particular physique of a child, as well as the changing motions.

Daphne Casdagli
Pencil
6¼″ × 6″

The alternative approach to sketching the moving figure is to go over and over a single image (right), adding the different gestures and angles of the limbs to build up a composite effect. This may seem daunting when you first try it, but gradually the necessity to work quickly and freely has a liberating effect on your technique.

Judy Martin
Felt-tip Pen
11¾″ × 8¼″

Pets are a good subject for movement drawings (right), since they are easily accessible and often on the move. Repetitive patterns of movement occur when a cat is washing, so that you have more opportunity to understand the motion and translate it effectively to the page. The fineness and fluidity of a felt-tip pen are well suited to small, quick sketches.

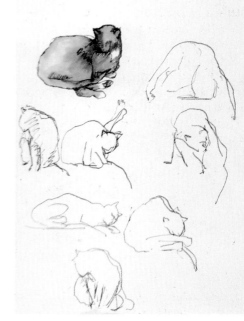

Judy Martin
Pencil
11¾″ × 16¼″

This life class study (left) was continuously worked over a period of about one hour. The model was given a brief movement sequence and asked to repeat it slowly throughout that period. The result is a complex network of lines building to a solid but active image.

Elisabeth Harden
Pencil
24″ × 16½″

These sketches (above) are from a life class where the model was asked to move around the room, and the artist has chosen to work on a large piece of paper with a heavy, soft pencil, to gain the freedom to follow the model's movements easily.

TYPES OF MOVEMENT

● *Simple motions and gestures – for example, a figure in a relatively still pose but moving head and limbs, or turning slightly, or getting ready to get up from a chair or walk away.*

● *Everything in motion – a good example of this is busy shoppers on the street; each person is making individual motions and gestures, but at the same time all the figures are traveling around and between each other.*

● *Patterns of movement – these will occur among people or animals performing particular actions; watch a dancer exercising, for example, or a cat washing itself. There are also patterns of mechanical movement in factory machinery, road diggers, cranes, etc.*

Zoo studies

A day at the zoo provides endless source material for the artist's sketchbook. You might choose to make studies of several different animals, or to concentrate on one species, attracted by the form, color, pattern, or movement of the particular animal. While you are working on location it is best to keep your range of materials fairly simple, so that they are easy to carry and handle, but you may also wish to develop your sketch notes later in the studio, introducing a wider technical range that enables you to interpret your images of animals more broadly and inventively.

Stan Smith
Oil Pastel and Paint
14¾" × 19¾"

This study (left) catches different aspects of the creatures' body shapes and postures, with the outlines boldly worked in oil pastel, and overall color briefly suggested.

Stan Smith
Pencil and Pastel
14¾" × 19¾"

Some zoo animals stay fairly still for long periods of time, so your sketches can include animal "portraits" as well as movement studies (above). Here the artist has portrayed the heavy heads of the lions with only a few well-placed lines and marks. The color treatment is almost incidental, but adds visual interest to the sketch as a whole.

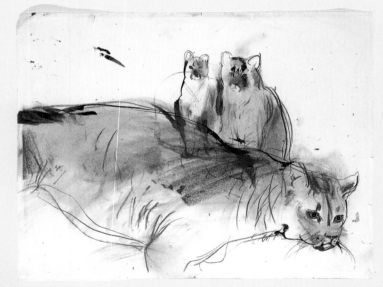

Stan Smith
Oil Pastel and Paint
14¾" × 19¾"

The fluid grace of a moving tiger is similarly traced across a large paper sheet (right).

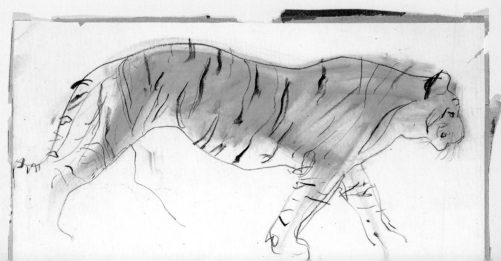

Judy Martin
Ink Line and Wash
17½″ × 14″

*This drawing (right)
follows a leopard
confined in an old-
fashioned barred cage, so
the creature could only
pace a few steps and
turn, creating a rapid
movement sequence. The
type of writing ink used
for the line and wash
naturally dilutes into a
range of blue-gray tones
when mixed with water.*

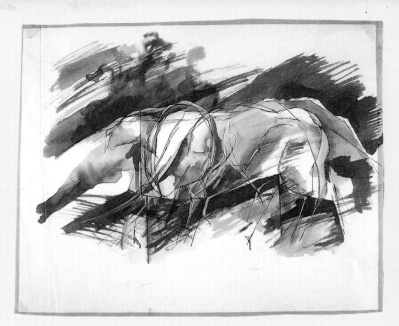

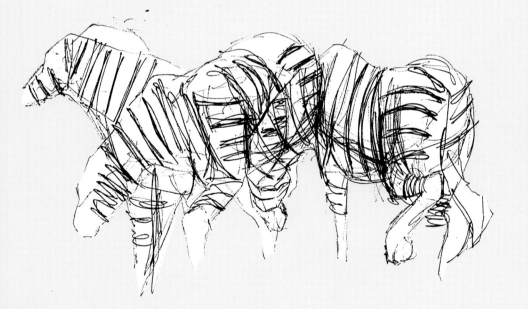

Judy Martin
Ballpoint
5″ × 9″

*There is a special visual
fascination to animals
that have a pronounced
pattern (left), and this
extends to a range of
creatures from zebras to
birds, snakes to big cats.
The strange black and
white camouflage of
zebras can be an endless
source of compositional
ideas. This sketch is
concerned with the
pattern of interlocking
stripes made by three
zebras lowering their
heads to take a drink.*

Judy Martin
Black Paper on White
14″ × 9″

*This collage (right) was a
development of one of
the zebra sketches done
at the zoo, completed in
the studio the following
day. Direct use of torn
paper shapes created a
very different, bolder
and cruder impression of
the stripe patterns and
animal forms.*

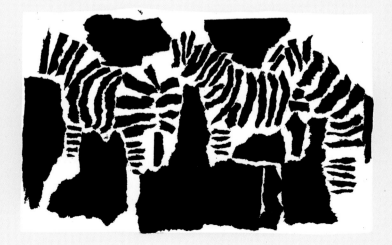

Of all the media that you could use for sketching, charcoal and crayon are perhaps the most loose and free, and will encourage you to adopt an easy manner and technique in your drawing. Charcoal can be a practical nuisance because it is so crumbly. It may break in transit if you are carrying it for use outdoors, and a finished work in charcoal requires an immediate application of spray fixative if it is to remain stable. But the textured tones and crunchy

Using a bold, direct medium

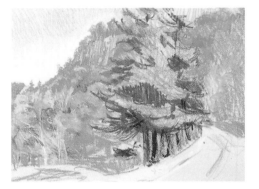

Charcoal and crayon

black lines of charcoal are inimitable. Go for bold strokes and dramatic interpretation.

The term "crayon" covers a multitude of possibilities. It may be taken to include wood-encased, soft-leaded colored pencils, but also ranges through the soft natural tones of brown, red, and black Conté crayon and the vivid, child's-play colors of wax crayons.

Conté crayon has some of the properties of charcoal in its easy handling and grainy texture, but being more oily in substance, it is a little more stable on the page. Conté crayon is a traditional medium of life drawing and landscape studies. The browns — umber and red-brown (sanguine) — give warmth to an image; the black is rich and pure; and you can also obtain white crayons for highlighting. You can achieve interesting results from working the limited tonal range of Conté crayon on colored paper grounds.

Wax crayons, whether the type made specially for artists' use or the bright-hued selections sold for children's drawing, provide one of the most direct and unpretentious of the color media for sketching. The bold colors and blunted points encourage you to scribble down your color impressions very simply and directly; often the result may be a little like a child's sketch, but planned and executed with the sophistication of the adult eye. There is a special character to line work in colored crayon, but you can also create soft blends and shades of subtly mixed hues.

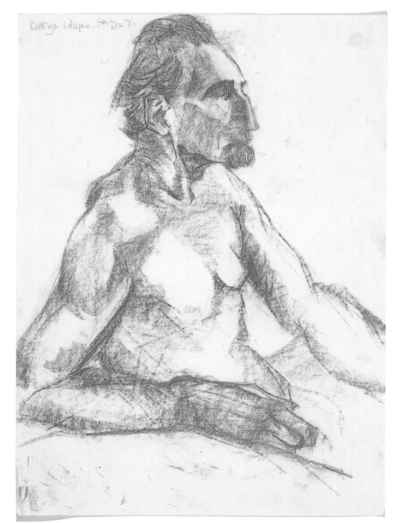

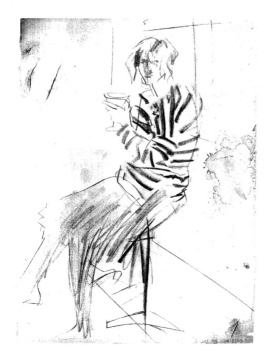

Stan Smith
Charcoal and Pencil
14¾″ × 11″

Charcoal is a loose, powerful medium best used boldly, as here (left) to give emphasis to the heavy stripes on the model's sweater. As the artist varies the pressure on the charcoal stick, the lines deepen and lighten with the swell of the curves.

Daphne Casdagli
Crayon
7¾″ × 5″

Often there is a necessary precision to drawings of architectural subjects, so this lively, colorful crayon sketch provides a pleasing reversal of expectations (right).

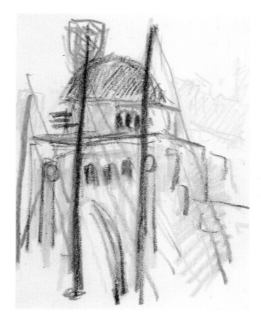

John Elliot
Crayon and Pastel
9″ × 12″

Landscape is an ideal subject for direct color drawing (above left). The grainy, bold textures of crayon and clear, vivid colors correspond well to the range of natural effects. There is an excellent contrast in this drawing between the rich fall colors in the background and the central focus of the darker evergreens.

Kate Gwynn
Chalk
20″ × 15″

This is a classical form of life drawing (left), a detailed representation in brown chalk using line and tone to structure the figure. The marks are varied appropriately between sharp line and gentle shading to create depth and contour.

PRACTICALITIES

- *Keep charcoal in a box or cylindrical container, with as little room as possible for the pieces to shuttle around inside if you are carrying it. The charcoal twigs snap and crumble easily, and while the charcoal dust can be useful for spreading textured, grainy tone (use your finger or a cotton ball to dab it on the paper), you don't want your entire stock to disintegrate before you have a chance to use it.*

- *Have a good supply of protective spray fixative, and if you cannot take it with you while sketching, fix your drawings as soon as possible after you return home.*

- *If using charcoal or crayon when sketching on the move or outdoors, carry a rag or cleansing pads on which you can wipe your fingers every so often. The dust and smudges from these media cannot be entirely avoided, but it is best to keep the risk of fingermarks on your page to a minimum – unless it is a deliberate element of your drawing! In color work this is especially important, since the colors will muddy if you spread and mark them with your hand.*

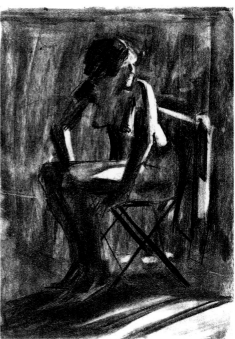

Stan Smith
Charcoal
16¼″ × 11½″

It can be difficult to handle charcoal when using it to create heavily massed tones in this way, but it has a unique depth and richness for tonal studies. One of the problems is keeping the white areas free of loose charcoal powder. Highlights can be lifted with an eraser before the drawing is fixed, so in effect you work from light to dark and then retrieve the lights.

Of the various features of a subject that might attract you to sketch it, color is often one of the most immediate and vivid. However, as sketching is by nature an opportunistic activity, you may not have just the right materials to hand when you see something that you would like to record in color. In these circumstances you should learn to develop your eye for color and your visual memory, so that you can take some sort of

Working from color memory

Experimenting with color media

GETTING STARTED

Color notes

record and supplement it later with color work. Often artists' sketchbooks are covered with roughly scribbled notations on individual colors, color combinations, and effects of light. These are extremely useful when you are working in a linear or monochrome medium, and may even enable you to record a more accurate impression than if you worked directly in color with the limited resources of a few colored pencils or a small watercolor box.

If you do have color materials with you when out sketching, you may not always have the time or opportunity to develop the image in detail. In this case, try to focus quickly on the essential elements of the color interest and record them as briefly but effectively as you can. In a predominantly green landscape, for example, look for the incidental color contrasts that enliven the overall impression; when sketching people, street scenes, or outdoor events, look for the key colors that seem to indicate the character or atmosphere of your subject; when working on a still life or nature study, identify the combinations of hues and tones that also relate to form and texture.

Judy Martin
Crayon (top, center and bottom)
Various dimensions

These quick crayon studies are from a series of sketches intended to investigate the color moods of landscape without too much attention to form and detail. The different elements of each view are treated as simple masses, lines, and irregular marks. The crayon is gently hatched and shaded in overlaid layers to create color mixes.

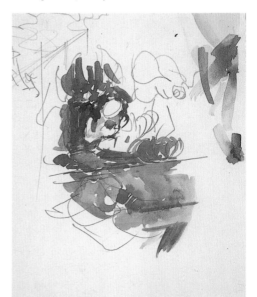

Judy Martin
Pencil
15½″ × 22½″ (inset)
Gouache 13½″ × 20¾″

*A quick pencil sketch
taken on open ground in
the location includes
written color notes that
enabled the artist to
later work up a gouache*

*sketch of the same
subject in the studio.
Both images acted as
working drawings
subsequently used as*

*reference for further
paintings, including a
larger version on canvas.*

Elisabeth Harden
Watercolor
9½″ × 8″

*This is one of several
color sketches of market
scenes (below), the loose
technique demonstrating
the artist's need to work
quickly due to the
interruptions of a busy*

*location. This image
focuses on the color
variations in the produce
of a meat counter – rich,
heavy, subdued hues.*

MATERIALS FOR COLOR WORK

- *Pencils and pens – when your medium is restricted to
monochrome, make written notes on color effects.*

- *Colored pencils – these are convenient for sketching since they
are easy to carry and don't make any mess, but you don't want to be
burdened with a vast selection.*

- *Crayons – waxy-textured colored crayons are used in much the
same way as colored pencils, but the marks they make are softer and
less precise because of the thickness of the crayon tip.*

- *Pastels – the drawback of soft pastels for outdoor sketching is
that they break easily and create color dust that can make the
drawing procedure a messy one. Also, the image is not stable until
you have applied spray fixative.*

- *Watercolors – these fresh, translucent colors are excellent for
recording quick color impressions.*

- *Felt-tip pens – these are typically very strong, simple colors, and
are not suited to subjects with subtle color nuances. But they are
good for capturing particularly colorful atmospheres and encourage
a loose, vigorous sketching style.*

In method and result, color studies fall midway between sketching and painting. When you have the time and concentration to develop a sketch image more fully, color is often the element that you will want to focus upon in greater detail. As the examples here show, there is much to gain from making color studies of indoor or outdoor subjects, simple or complex images.

For this kind of work, paint is the essential

Color studies

medium, rather than colored pencils, crayons, or pens. The potential for mixing and over-laying colors gives you the necessary degree of subtlety and range of interpretation. Soft pastels are another possibility, especially for figure studies, interiors, and still lifes. To get a really versatile color range with pastels you need a fairly large number of individual hues, and it can be difficult to carry and use them easily on outdoor sketching trips; but the final effect of a fully worked pastel sketch can be remarkably vivid and impressive (see page 59 and page 88).

Watercolor is the traditional and most suitable medium for outdoor color work. It is a better choice than gouache because the colors are translucent and do not readily devalue when they blend and mix, and they can be mixed and overlaid directly on the paper surface, building up strength and tone layer upon layer, whereas opaque gouache generally has to be mixed in a palette to achieve accurate color effects. However, you may sometimes need what is known as body color — a degree of opacity — to create particular nuances such as strong highlights or textural detail. Many watercolor boxes include a small tube of opaque white for highlighting, which should always be done at the final stage of a water-color study.

Using pastel and ✎ watercolor

Developing color ✎ awareness

**Stan Smith
Watercolor
7½″ × 8″**

Gum arabic mixed with translucent watercolor enhances the vibrance and depth of this simple still life study (right). Highlights are added in opaque white body color. There is careful attention to local color and precise qualities of tone and texture.

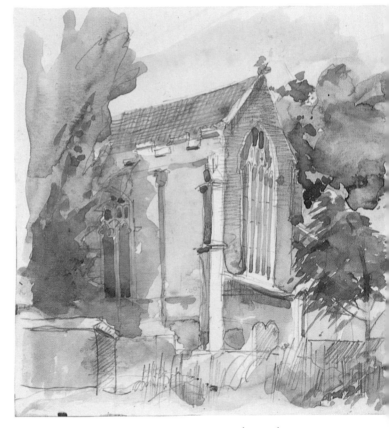

**John Lidzey
Pencil and Watercolor
9″ × 12″**

The particular color quality sought in this sketch is the combination of muted

hues and tones so expressive of the subject's mood. The cool grays, blues, and mauves applied to the architecture of the church are offset by touches of warm red,

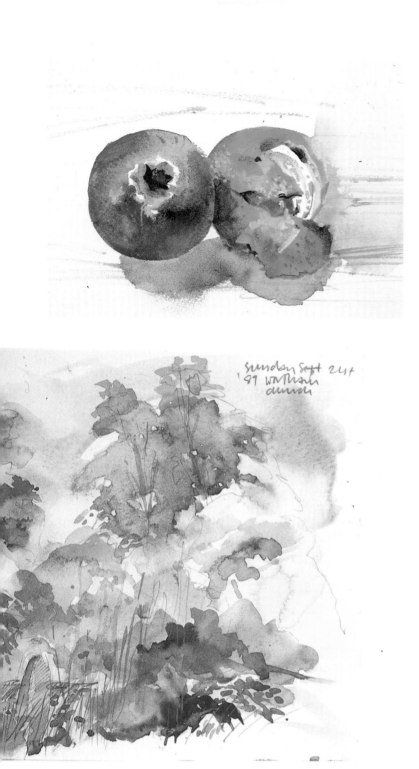

Remember that, because watercolors are translucent, you cannot retrieve a light tone from a dark once you have laid the color, or overpaint with a paler hue. Spend a little time studying the subject before you start work, to establish a general sequence of colors, but do not abandon the spontaneity of allowing yourself to dash in a particular color effect at the very moment that you see it.

If you are unsure where to start, devise an economical technique that also enables you to establish the relationships of colors. For example, identify one hue and work right across your sketchbook page, putting down that hue wherever it occurs in your subject. Work through the next most obvious color, and so on, until you have woven the general pattern of colors. Then start to develop the image by adjusting the balance of individual hues in relation to one another and overlaying smaller color areas to achieve more subtlety and depth.

- Learn to differentiate between local color – the actual color of a surface or object – and the variable color influences that may be the result of qualities of light and reflections from neighboring objects.

- Look for color in every area of the subject – even in a deep shadow that appears almost black, you may be able to detect a hint of, say, blue or purple that will give depth and tone to surrounding colors.

brown, and yellow in the trees and undergrowth surrounding the building.

Ray Evans
Watercolor
Dimensions unavailable

The layered colors in this watercolor study (right) stress the vertical format of the composition.

Blues predominate in the foreground but give way to siennas and ochres, then are echoed more palely in the sky.

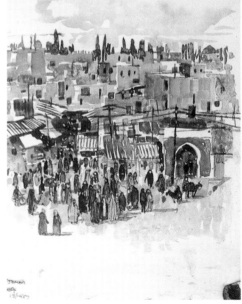

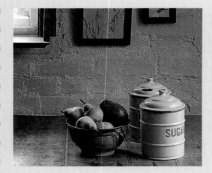

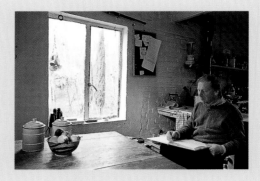

1 **2**

A simple still life in keeping with the character of the room is set up under a window (left). From the artist's viewpoint (right), the light falls obliquely across the objects.

Kitchen Interior

These studies by John Lidzey of an old-style kitchen are concerned with both the character and contents of the room, and the qualities of light in the interior. The windows are important points of focus, contrasting the strong light outside with the poor illumination inside that creates mood and a dramatic sense. The play of light is studied in terms of various still-life compositions within the room.

John Lidzey uses sketching as a form of exercise that enables him to loosen his technique and maintain a fresh approach. He appreciates the freedom of sketching, the fact that the work need not be very carefully drawn and painted but is an opportunity to work things out.

The completed sketch shows the artist's concern with giving weight to tonal values, to create depth and solidity. His method is to apply wet color very liberally, then to lift it with absorbent cotton, creating a varied tonal range and fluid textures that increase the visual interest. This illustrates the artist's interesting comment that the paint itself is more important than the subject, and he exploits his medium fully.

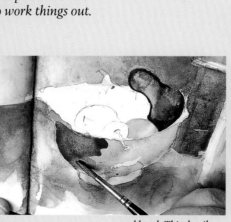

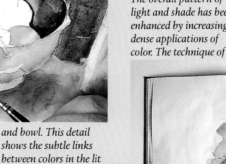

9

The overall pattern of light and shade has been enhanced by increasingly dense applications of color. The technique of alternately wetting and blotting the surface creates interesting textures that give a very active quality to the whole image.

10

With the general balance of tones laid in, it remains to develop the color range of the fruit and bowl. This detail shows the subtle links between colors in the lit and shadowed areas.

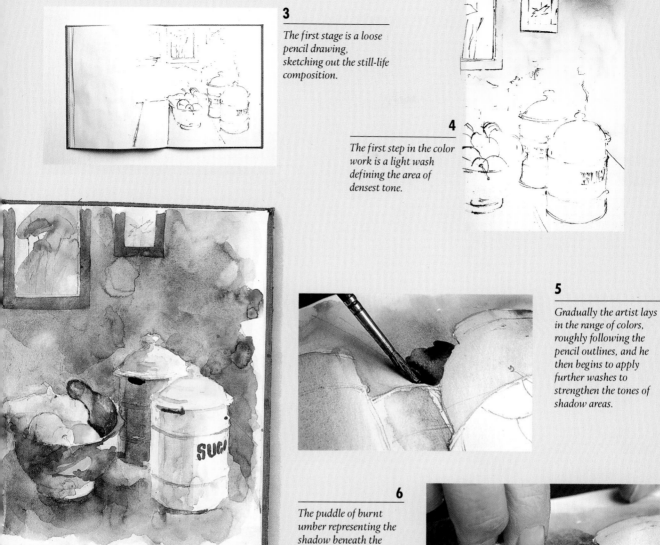

3

The first stage is a loose pencil drawing, sketching out the still-life composition.

4

The first step in the color work is a light wash defining the area of densest tone.

5

Gradually the artist lays in the range of colors, roughly following the pencil outlines, and he then begins to apply further washes to strengthen the tones of shadow areas.

6

The puddle of burnt umber representing the shadow beneath the bowl is blotted with absorbent cotton to create tonal gradation.

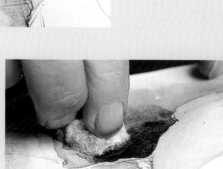

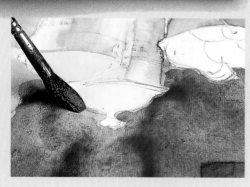

8

Washes of burnt umber and ultramarine are laid side by side using a large sable brush, and the wet colors are allowed to blend together fluidly.

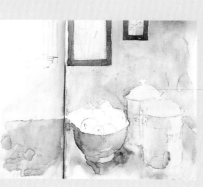

7

By this stage the overall color balance is laid out across the whole image and the quality of light that is an important part of the subject has begun to emerge.

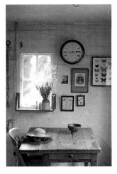

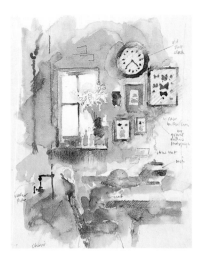

Quick sketches can be used to assess the possibilities for different compositions.

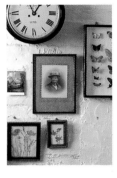

The pictures on the wall are of interest in conveying the style and character of the room.

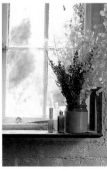

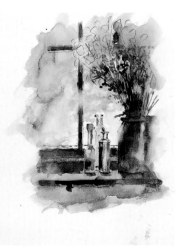

An economical color range is used to develop an expressive tonal study of the window area.

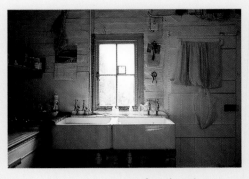

1

This sketch focuses on a directly frontal view of one wall of the kitchen, where the sink area is illuminated by a single window. This will be the central feature of the composition.

4

The wet color is blotted with absorbent cotton, creating subtle edge qualities within the broad outlines of the color areas. By this method the artist gently integrates the blues and browns and controls the tonal gradations.

2

The first color washes applied to the pencil sketch establish broadly the areas of mid-tone and the recess that is in darkest shadow.

3

The artist develops the tonal detail in the lower part of the drawing, where the shadow is most intense, gradually layering the colors.

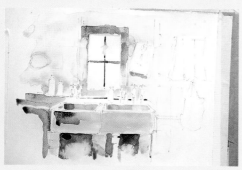

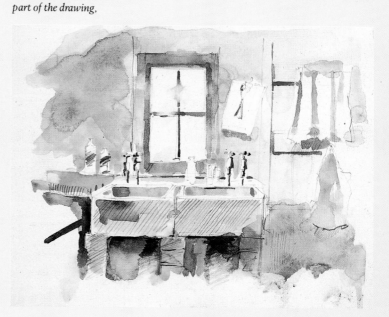

5

The three-dimensional layout of the window area is now established by the range of tones.

The next step is to develop the individual objects in more detail to balance the image.

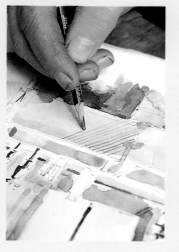

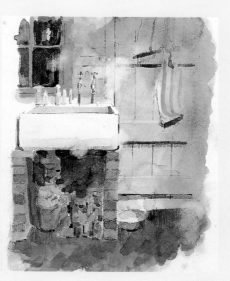

6

The artist chooses to use pencil shading to supplement the watercolor work. The shadowed vertical surfaces of the sink are overlaid with hatched lines.

The details in this sketch are succinctly chosen and the color range is deliberately limited, but the artist has successfully used these economical means to show the quality of light that specially interested him (above). The importance of light effects is demonstrated in the very different mood of the same subject at night (left).

2

Learning
from
sketching

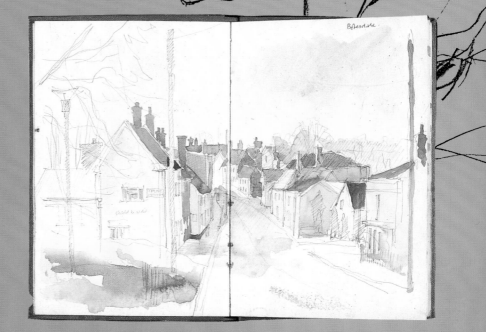

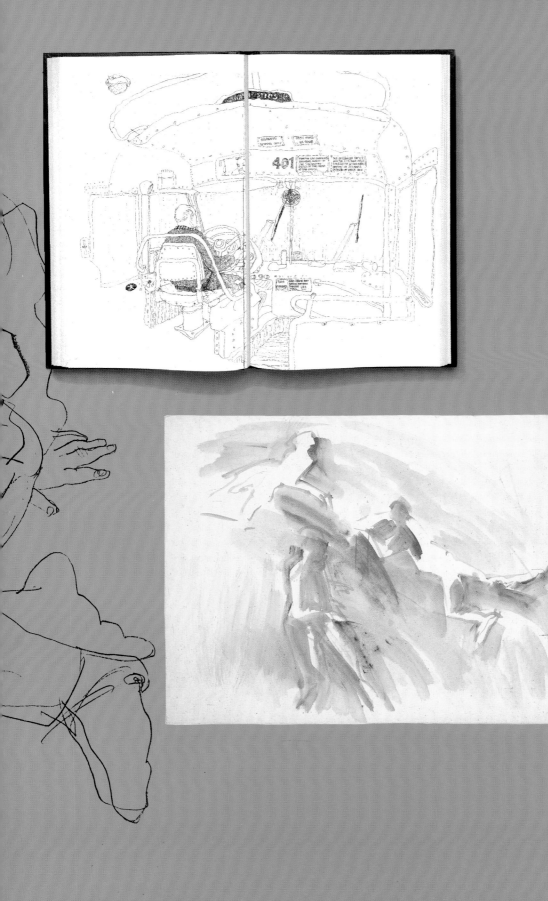

Learning from sketching

When you have tried out some different approaches to sketching, experimented with materials, viewpoints, and subjects, and begun to realize your capabilities, you may wish to develop certain areas of visual interest and technical skill more purposefully. While the contents of this chapter are still very much based on the freedom of sketching – working where you like and on what you like – the individual topics cover visual studies that relate fundamentally to all forms of two-dimensional interpretation. This, in turn, leads to the following chapter on the themes that you might take as your subjects for sketching, when all of the analytical and technical skills that you can acquire through sketching may be applied to producing more complex images, which will, it is hoped, retain the qualities of freshness and immediacy that are characteristic of quick, free, and instinctive sketch work.

Each selected area of study in this chapter covers a basic principle of visual representation that can be traced through a variety of subjects and interpreted in equally various ways. The text and examples used in demonstrating a particular topic may help to draw your attention to the formal possibilities of the image on the page, and particular elements that are

John Lidzey
Pencil and Watercolor
9″ × 12″

The space and scale of landscape may seem difficult to translate when you are confined to working in the pages of a sketchbook, but careful attention to setting the format, arranging the composition, and adapting your technique can produce an image of extraordinary impact. Contrasting elements such as this stand of spreading trees rising from an open background characterize one kind of solution to depicting a sense of distance in a landscape.

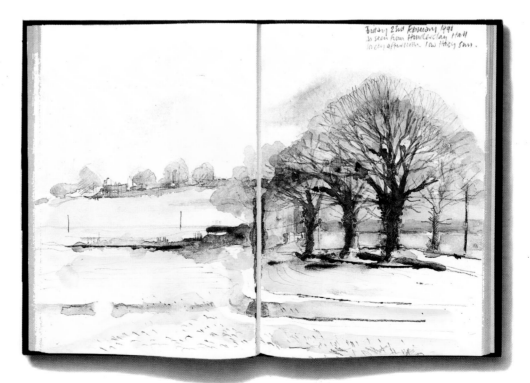

expressed by certain forms of representation. However, this information is intended to raise suggestions and illustrate particular solutions: it is aimed at expanding your "vocabulary" as a sketcher, not at offering ready-made projects and solutions.

TECHNICAL AND FORMAL SKILLS

One of the elements that may be apparent in glancing through the following pages is a sense of increasing ambition in style and technique. The media covered in more detail in this chapter include pastel, watercolor, gouache, and mixed media, which give you a greater range in sketch work that includes such detail as, for example, light effects, pattern, and texture. The potential of the sketchbook page itself and the value of using colored paper as a support in sketching are also investigated. In technical terms, some of the work deliberately addresses skills that come closer to the conventional definitions of drawing and painting than the more free and easy approach usually associated with sketching.

In this context, it is also appropriate to draw attention to another of the functions of sketching – in studio work that teaches the artist more about content and technique, and may involve developing images through various stages of interpretation, but which may not necessarily result in what could be termed "finished" works. As well as sketchbooks, any artist who consistently produces a range of work over a sustained period will have masses of paper sheets and scraps containing odd drawings, incidental studies, thumbnail sketches, and different versions of the same idea. Sometimes these will have been generated in the effort to work out a particular theme, or single image, to a logical and satisfactory conclusion; some will be random "jottings," others technical trials. Once again, the question of the definition of a sketch comes up: Here it can be simply answered in broad terms – that it is a manifestation of the artist's observations and thought processes and can take almost any form.

The formal elements discussed here – structures, space and distance, light and shade, composition – are the analytical tools by which the artist learns how to render three-dimensional objects and events by means of two-dimensional conventions using a variety of media. Part of the process of learning through

Elisabeth Harden
Pencil
11¾" × 15"

This is one of several sketches developing the image for a lithographic print. The free style was deliberate – the artist was by then familiar with the shapes of the still life and allowed herself to work instinctively on this drawing, looking for randomly produced marks that could be used to add to the visual qualities of the final image created.

sketching is to ask yourself what is the function of your sketch and what useful reference will it be when it is made. This is going beyond the simple pleasure and interest of sketching for its own sake to regard sketching in a wider context – that of the artist training his or her hand and eye to work together to achieve a desired result.

The composition of a sketch, for example, sometimes arrives by accident, and a chance image may be as powerful as one which is more considered and even contrived. But when you make sketches in which the very purpose is to study compositional possibilities, awareness of the organization of the subject and its translation to the page format become of equal importance with the journalistic or decorative functions of the image. This requires you to fix your aims more clearly and apply an analytical approach.

Stan Smith
Pencil
5¾" × 4"

Various interests may encourage you to sketch details of sculpture and architecture – visual elements such as their structure and texture, and also the background to the subject in terms of cultural style or historical context.

LEARNING PROCESSES

Only you can tell whether you are learning something through your methods of sketching and the subjects and materials that you choose to deal with. The fact that you might produce pages of sketches that appear very similar to the casual glance does not deny the possibility that the repetition and familiarity of the activity might have taught you some quite new aspect of style, technique, or observation. As a simple example, there is great satisfaction in suddenly getting right a particular shape that you have always got wrong, however mundane it may seem (the object of your interest might be nothing more elaborate than a coffee cup). This means that you have achieved three distinct results: You have seen what went wrong, have worked out how it should be, and have contrived a technical solution that conveys it accurately. This signifies progress.

Many artists have a favorite theme — the human figure, animals, landscape — and will work for years on similar sorts of subjects. Yet they will argue that the individual subject is always fresh, that they are constantly looking for new nuances and ways of conveying it, and that each new pose or location is a specific challenge. The validity of this approach may depend upon your willingness to be rigorous with yourself about observation and technique. If you find that you have acquired a facility for certain types of work and are resorting to the same kinds of solutions because you know that you can make them work, it may be time to move into a new field — by changing your subject or medium, for example — that forces you to abandon your assumptions and seek new forms of interpretation.

However, the activity of sketching should always be seen as a pleasure rather than a trial, and while it is possible to teach yourself a lot through your sketches, it should not become a dry process or seem like a chore. If your subject doesn't hold your interest, or you try out a technique that just doesn't seem to suit what you want to do, don't be afraid to abandon the task, at least for the time being. Sketching is an opportunity to make errors and messes, and that is an important aspect of learning as an artist, but you also need to allow yourself the successes and stimuli that make you want to go forward.

Daphne Casdagli
Felt-tip Pens
7″ × 9½″

A busy situation such as an orchestra rehearsal provides certain fixed reference points for your sketches while all the time there is a certain amount of change going on. This is a challenge to your perception and technique – what elements to choose, how to depict them, how far to go in a single image. A subject that at first glance seems to contain almost too much information will exercise your skills to the full.

Mark Baxter
Pen and Ink
5¾″ × 8¼″

Many sketchbook pages contain half-finished (or barely begun) images, sometimes without ever getting to a final result as complete as this sketch of a bounding dog. Reworking the same theme over a period of time encourages you to keep taking a fresh view of your subject, and your visual notations, however brief, gradually add up to a considerable record of knowledge.

The most organized and definitive structures are those that are man-made: exterior and interior architecture, machinery, vehicles, artificial boundaries. The frameworks of such subjects contribute the basic compositional elements in your individual sketches of them. They provide specific guidelines for spatial organization and the ordering of detail. There are, however, considerable variations in the ways you might interpret these structures as

Structures

two-dimensional images. You may choose to emphasize the geometric precision of, for example, the construction of a building, or you might use only the most general notion of its form as a base for studying surface detail and texture. You might wish to approach the perspective view of a cityscape quite accurately, or you may prefer to interpret its mood rather than the solid fact of its physical framework.

There is also a more elusive, almost abstract sense of structure that has to do with the relationships of forms in space. This is an underlying element of any subject that you might sketch — landscapes, still lifes, and figure compositions as well as architecture and interiors. The framework of a composition consists not necessarily of precisely defined areas and objects, but of related reference points, directional lines, and other such "markers" that contribute to a pictorial structure. In subjects that incorporate open spaces and irregular shapes and textures, you may have to search more carefully for the underlying frameworks than in views that have an obvious order and pattern, but a clear sense of the interrelationships of forms in space will help to give coherence to an image.

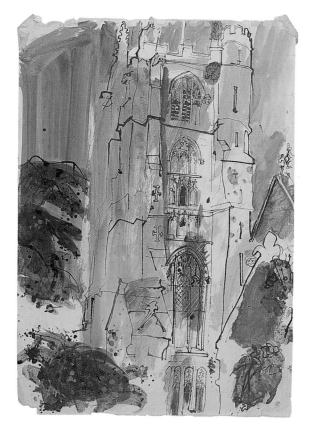

Stan Smith
Mixed Media
20″ × 14″

An interesting aspect of the technique used in this sketch is that the ink drawing overlaid on brushed and sponged color describes not only surface detail but also the basic framework of the church. The drawing imposes a sense of solidity on the building as if that quality were in its outer layer rather than its inherent mass. The sketch gives unexpected life and character to a conventional structure.

project
15

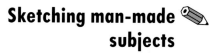

Sketching man-made subjects

The basics of linear perspective

**Neil Meacher
Felt-tip Pen
5½" × 4"**

A beautifully detailed subject sometimes deserves equally detailed treatment (below). Successfully tracing a complex structure of this kind need not involve a knowledge of perspective nor a mathematical approach to scale and measurement, but it does require keen observation and a patient eye and hand.

USING PERSPECTIVE

• *The theory of perspective is quite complex, and even if you work to its formulas, it is often necessary to provide optical "correction" to a drawing so that the image corresponds to normal perception rather than to a set of pictorial rules. However, it may be helpful to be aware that there is a perspective element in both large- and small-scale subjects.*

• *Horizon and eye level – a basic element of perspective drawing is the establishment of a horizon line that corresponds to your eye level. In general, horizontal lines above your eye level appear to slant down toward the* horizon line, while those below your eye level travel upward.

• *Vanishing points – the simplest perspective system is based on a single vanishing point which is set on the horizon line. Parallel horizontal lines going back into space appear to converge on that point but lines or planes that are vertical in your view remain vertical in a drawing. When you face a building corner-on, with the sides of the building receding from you on either side, there will be two sets of receding parallel lines converging on two vanishing points on the horizon line, one to the left and one to the right (two-point perspective).*

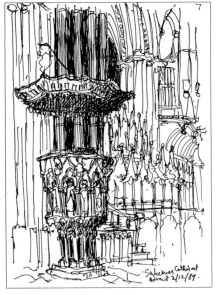

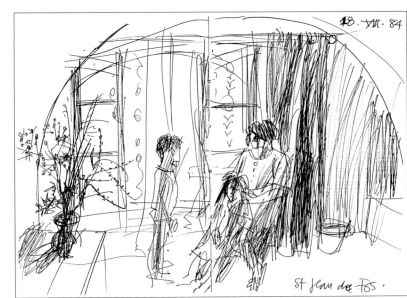

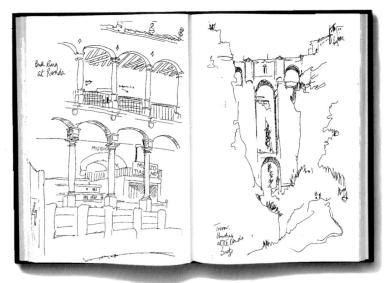

**Elisabeth Harden
Technical Pen
8¼" × 11¼"**

Arches have a natural visual fascination, being pleasing shapes in themselves and also suggesting the view through that may contain items of further interest. These two very different locations (left) create a satisfying balance across facing pages of the book.

**Stan Smith
Ballpoint
5¾" × 8"**

Architectural elements act as a frame for other subjects in both interior and exterior views (above). The unusual sweeping arc that delineates the window area of this room provides a theatrical backdrop for a simple figure group.

The open vistas of landscape translate surprisingly well to even a small sketchbook page, provided that you pick up the key elements describing space and distance. These visual clues can be very simple: If you make a single mark near the bottom of the page and a smaller, fainter mark toward the top, you will naturally begin to read these marks as having a spatial relationship — the lower one nearest to you, the other farther away. Our eyes are

Space and distance

accustomed to defining pictorial space in terms of foreground, middle ground, and distance.

Broadly speaking, there are a number of pictorial elements that create space: foreground details are larger and more distinct than those in the background; colors are clearer and stronger. The visual phenomenon known as atmospheric perspective is a function of color: distant color effects appear hazy and blue-tinted as compared to the greater strength and variety of hues and tones in closer view. Horizontal lines or emphases traveling away from the viewer converge toward the horizon line — a basic principle of perspective. In landscape this may be represented by linear elements such as streams, rivers, pathways, lines of trees, ploughed furrows, fences, and hedges. Relative scale is another way of implying distance: Focus on a flower stem close to where you are working, hold up your pencil to measure it roughly, and you will find that it appears taller than a tree that is two fields distant. These, however, are basic formulas for creating space in two dimensions. In sketching you should rely on the evidence of your eyes, looking for details that correspond to visual effects of such kinds, but allowing your own impression to be freshly recorded on the page.

Kate Gwynn
Pencil
15″ × 11″

In a classic reversal of scale, a fragile flower stalk easily embraces the height of a church tower. This is due to the artist's low eye-level. Sometimes the visual effects of scale and distance are difficult to grasp because you know the relationship is not real, but the interplay of elements can produce exciting compositions.

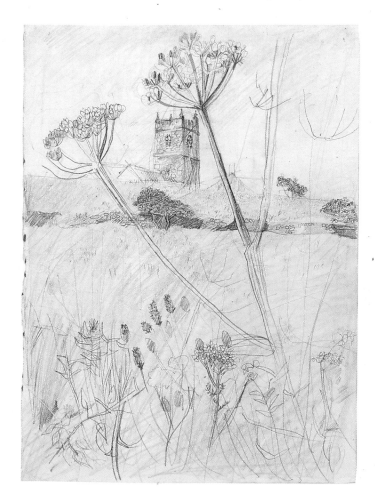

Elisabeth Harden
Gouache
10¾″ × 12″

This watercolor was an attempt to capture a particular quality of light at the end of the day, when the island became very stark. The hues and tones of the muted palette are carefully controlled to create an austere but atmospheric image. The blue-grays of the far horizon and their lightening tones naturally suggest receding space.

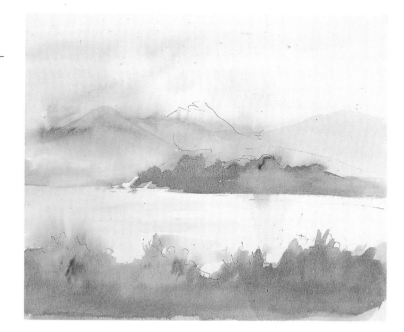

John Lidzey
Watercolor
9″ × 12″

This startling asymmetry (below) is a bold but successful approach to the vast spaces of landscape. The brief color splash representing the disappearing sun risks becoming detached from the image, but remains casually but effectively linked through the echo of yellow in the trees and the wispy trail of cloud crossing the junction of the sketchbook pages.

Space and distance

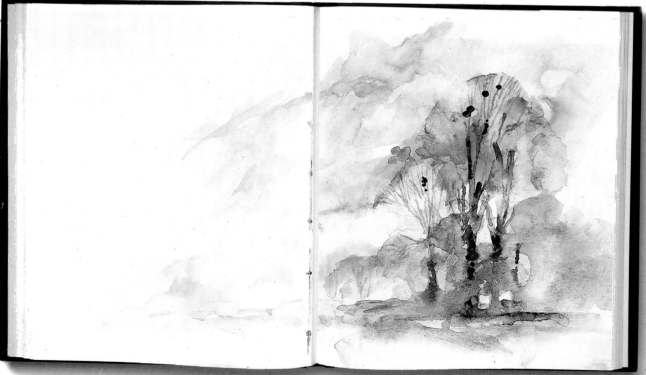

T hese sticks of color are in effect the most direct color media, because there is no intermediary between your hand and the paper surface as there is when you are painting. You also have access to a very wide range of pure hues, tints, and shades which you can use as generously or selectively as you wish.

The textures of pastels and crayons have an expressive range equal to their color values. Soft pastels, cylindrical or square-sectioned,

The properties of soft pastels, oil pastels, and wax crayons

Mixing colors on the paper

Judy Martin
Pastel, Pencil, and
Gouache
18½″ × 13½″

The dense textures of foliage and flowers are a natural subject for pastel drawing. The range of marks you can make with the pastel sticks gives you different options for matching what you see, and even the dark colors of pastels have rich intensity.

Pastel and crayon

can form sharply cut lines or gentle, powdery masses. You can blend hues and tones or, with frequent, light applications of spray fixative, weave the colors, layer upon layer, so that all the pastel strokes remain clean and brilliant, and interact vividly together. Some soft pastels are water-soluble, so you can spread them with a brush into gentle washes of color.

Oil pastels also produce a range from fine lines to broad, grainy shading; the greasy-textured colors can be spread with your finger or softened and blended with turpentine. Because oil pastels are moist, there is a limit to how much you can overlay heavy strokes before the colors turn to a muddy, dulled mixture. They are best used for bold, uninhib-ited statements of pure color.

Wax crayons come in brilliant colors and one of the most effective ways of using them is as a resist medium — the wax repels water-based paint and powdery pastels will not adhere to it, so you can mix your media while maintaining their individual qualities.

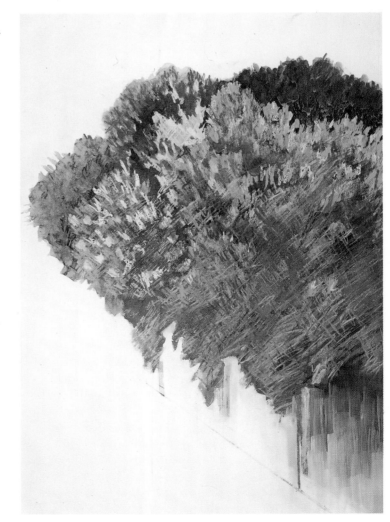

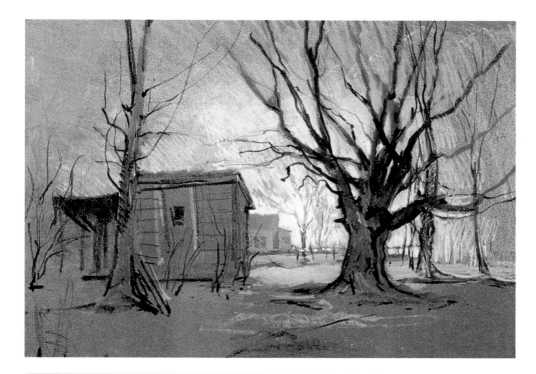

John Elliot
Pastel on Colored Paper
9″ × 12″

The brilliant pink, white, and yellow lights in this drawing are greatly enhanced by the warm buff-toned base. Using a colored ground (see also pp. 87–89) is a traditional technique that is freshly interpreted by each generation of artists. The overall tone gives an immediate interaction for the colors of the pastels that is more realistic than stark white. Allowing patches of bare paper to retain their color also saves you time.

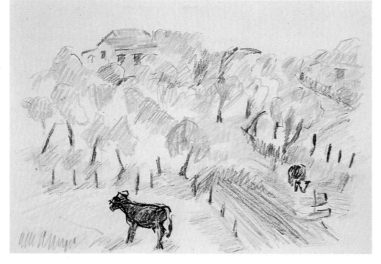

Daphne Casdagli
Crayon and Pen
4½″ × 6¼″

Soft-textured colored crayons have qualities quite distinct from those of pastel, but are also characterized by a textured, grainy line. This can be effectively combined with the sharper line of a medium such as ink or pencil, to give emphasis to details of the drawing. In this sketch, a controlled color range has been selected and most of the landscape is described with loosely worked hatching and shading. The inked detail on the animal in the foreground simply serves to crispen its shape.

● *Blended hues and tones – put down an area of grainy or scribbled color, lay another beside it, and rub gently with your fingers, a rag or a cotton ball to meld the colors together. Alternatively, use a brush or cotton ball soaked in a diluent to spread damp color – using clean water for water-soluble pastels, turpentine for oil pastels.*

● *Hatching – draw clear, roughly parallel, closely spaced lines. Fix pastel color before applying another layer, then work a second color into the first, the lines interwoven in the same direction or hatched across them at right angles.*

● *Dots, ticks, and dashes – use the tip of the pastel or crayon to apply freely worked, small marks, building an all-over texture on the area of your page relating to the particular color effect in your subject; add a second color, a third, and so on, until you have achieved the right optical mixture of colors.*

● *Powder color – with soft pastels, you can scrape the edge of the stick with a knife or scissor-blade to release the colored powder, then spread the powder on the paper using your fingers or a rag.*

Light is the medium that reveals form, structure, color, and surface texture. It acts upon everything that we see — our perceptions are filtered through light — and also creates effects of its own which contribute to mood or atmosphere. The subtlest and most complex effects of light are most appropriately dealt with in painting, where you have the time and the technical facilities necessary to manipulate tone and color. In sketching, where you are

Light and shade

LEARNING FROM SKETCHING

Stan Smith
Watercolor
5¼″ × 5″

Unusual light effects may be fleeting though dramatic, and you may need to work quickly to capture the impression (right). Here the artist has used a technique of rapid brush drawing in watercolor to describe the figure illuminated by

strong light falling through a Venetian blind. The colors, though muted, are mid-toned and there is little heavy shadow. The luminous bands across the figure are created by leaving areas of the white paper bare of paint.

concerned with immediate visual responses, and are possibly limited in the scope of your interpretation by your range of materials, it may be more rewarding to focus on dramatic or unusual light effects — such as strangely shaped cast shadows, strong uplighting or downlighting that appears to distort a form, a piercing shaft of sunlight, or a streetlight glowing through the dark.

In quick sketches, monochrome or color, put down the effects you see quite emphatically, even with exaggerated contrast. Cast shadows and those that describe a distinct change of plane, especially on a hard surface, often have very sharp edges; those that describe curved forms, soft materials, and low-relief textures usually have more subtle lights and shades. Because light is an insubstantial medium, you need to analyze carefully the effects it has on the objects and surfaces that you see, and investigate the technical possibilities for describing these effects with the solid materials of drawing and painting.

Neil Meacher
Pencil
5¾″ × 8¼″

The shadow areas in these drawings are made fairly emphatic, although the tone is gray, not black. Their solid shapes create definite contrast with the white areas to suggest a strong light source. In the sketch of houses (near right) the grainy pencil shading is overlaid on the line work rather than used to fill in shapes, since these are cast shadows falling on the buildings and the road, so there is an interesting interplay of structural detail and surface effect.

Graded values, as in ink wash or pencil shading, are the conventional method of describing form and volume, and their dramatic possibilities depend upon the tonal range you use — a direct contrast of black and white naturally makes more impact than shading from one to another through intermediary grays. You need not feel constrained if you happen to be using a linear medium: By varying the pressure on your drawing implement, and by varying the density of the marks, patterns of dots, ticks, lines, or scribbles can provide a complex tonal range.

Soft pencils and charcoal, when heavily applied, create rich, velvety blacks. To vary your technique, try working your sketch from dark to light — using an eraser to "retrieve" pale tones and highlights from areas of solid blacks and grays.

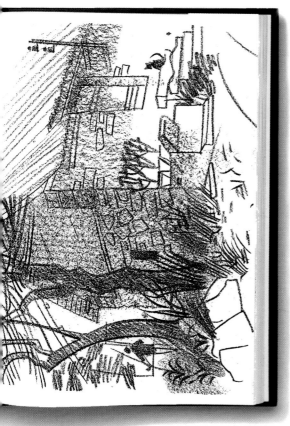

Stan Smith
Pencil
11½″ × 8¼″

Although pencil is an uncomplicated medium, it is one of the most versatile for studies of tonal values (right). It creates a wide range of soft grays and dense blacks, and the texture can be exploited through linear mark-making or smoothly gradated shading that has a grainy, dense quality. You can also use an eraser to retrieve the white highlights, a particularly useful method when, as here, the highlights are minimal but crucial to the effect.

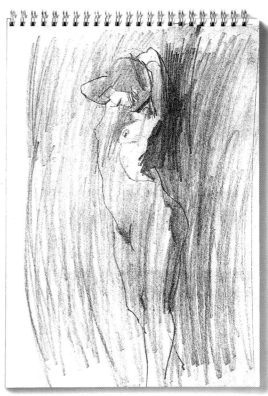

Interior light

Light is a basic medium of drawing and painting, but there are certain situations in which particular qualities of light are essential to capturing the mood of your subject. Interior lighting runs the range from the subtle diffusion of daylight through a room to strong shafts of sunlight or focused artificial sources. It is not always easy to see how to translate pure illumination via the material properties of your medium. Watercolor, being itself translucent, is an ideal medium for the study of color in light.

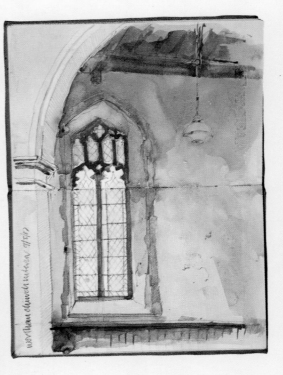

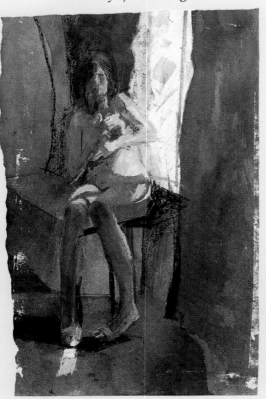

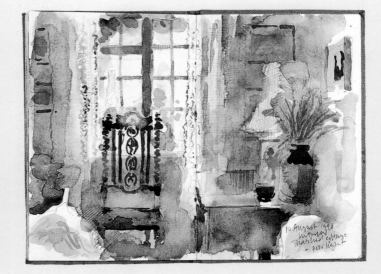

Stan Smith
Pastel and Watercolor
19″ × 12¼″

When you are drawing a life model or making a portrait, sidelighting your model with a single light source such as a window or powerful lamp gives you a dramatic study of form, color, and tonal values. Here the artist has laid in the overall composition in watercolor and has used pastel to refine the shapes and introduce strong color accents.

John Lidzey
Pencil and Watercolor
9″ × 6″

The light source itself can be the subject of the drawing (top). The church window is carefully delineated and the way it illuminates the alcove is delicately described.

John Lidzey
Pencil and Watercolor
9″ × 12″

Ordinary daylight entering a room is diffused and dispersed (above), giving the kind of gentle illumination that softens colors and shapes within the interior.

Stan Smith
Pencil and Watercolor
17″ × 15¾″

Brilliant sunshine falling into an interior has an intriguing dual effect, highlighting three-dimensional forms but subtly disrupting their true shapes and volumes. These three studies investigate this effect via the human form. The unusual contours of the shadow areas, worked in both pencil and watercolor are given an emphatic, hard-edged treatment.

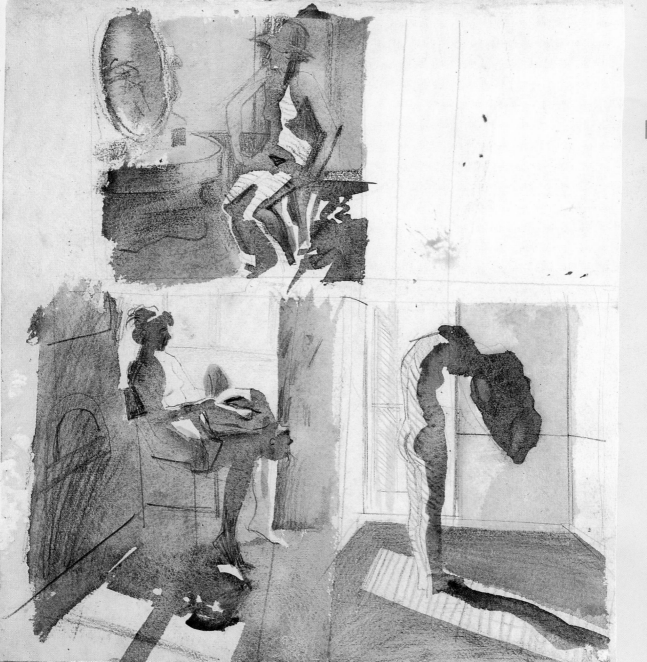

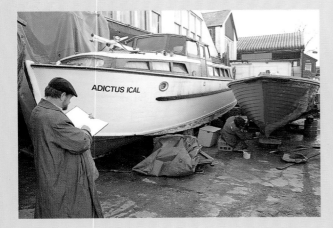

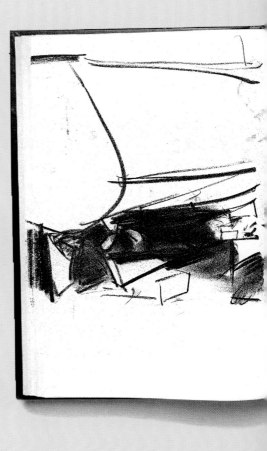

Boatyard

Stan Smith has a special interest in drawing and painting the figure and chose the boatyard as his subject because it presented exciting contrasts of scale and the chance to dramatize the figures through their poses. He feels that directness is of the essence in sketching, but that this should not imply a lack of discipline. He recommends varying the technical approach and scale of sketch drawings, so that your working method does not fall into a fixed pattern, but adds that it is important to develop the versatility to respond to unusual situations or limited facilities with whatever materials you have at hand.

A grainy pencil sketch describes the attitudes of men concentrating fully on their work (below right), the angle and tension of each figure directing the eye toward the center of the image. The artist works quickly and freely to capture individual poses; compare the more relaxed interaction between the figures when they cease work (below).

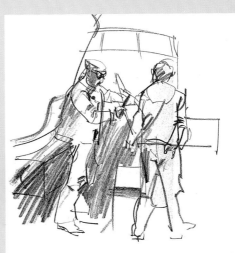

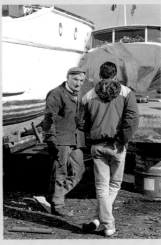

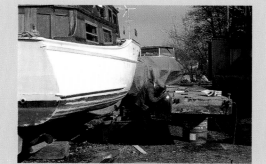

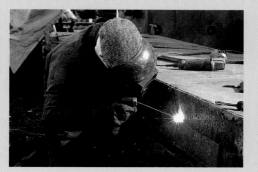

The photographs explain the specific detail of this view that have caught the artist's eye. A general viewpoint (top left) shows the context of the welder at work in the shadow of a boat that seems to dwarf the figure. The shapes and angles of the shadows as described in the sketch are also visible. The artist has incorporated in the drawing the burst of light from the welding tool (center left), an additional point of high contrast. The density of the shadows is sketched with a charcoal pencil, using heavily directional shading (bottom left).

This powerful study in charcoal and pencil sets up the linear framework of the view as a vehicle for the dramatic tonal contrasts. The areas of shadow are treated simply and directly as solid shapes.

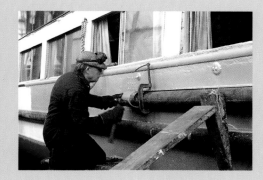

This brief sketch makes an interesting character study, almost a portrait, but it is not at all static. There is vigorous movement in the varied textures of the pencil lines, reflecting the fact that the figure is constantly in motion.

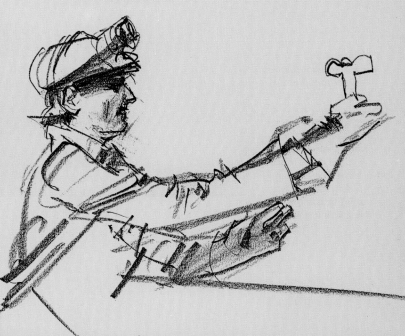

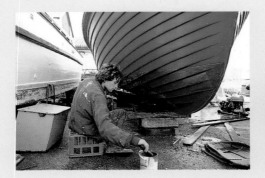

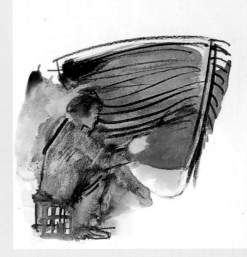

The strong colors of a boat being painted (above) suggest a color study of this subject. The artist works quickly in watercolor to block in the main color areas and an indication of texture. The inevitable consequence of working so rapidly with a damp medium is that the colors tend to run together, so it is only possible to establish a broad impression of color values. A pencil sketch with written color notes can be a useful supplement for recording detail.

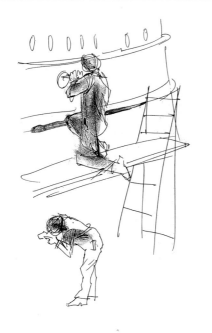

A brief linear sketch in pen and ink (left) is given light tonal detail simply by spreading the ink gently with a wet brush (below left). This subject demonstrates the variations of scale that are an important aspect of the artist's interest in the boatyard as a subject. The activities of the yard mean that there are figures working at different levels against the background of the boats, and the artist gains an interesting range of viewpoints.

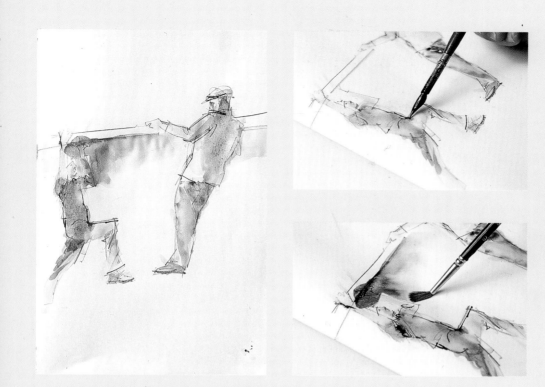

Gentle washes in blue and sepia give solidity and a suggestion of depth to an interesting two-figure composition (far left). Again, there are tensions between the figures that are caught precisely in the drawing and enhanced by the active character of the ink line. In laying the color washes, the artist brushes in the color very freely (top left). The shadow behind the left-hand figure overlaps his raised arm (below left), but the line work seen through the washed color maintains its form. form.

The habit of sketching makes you alert to unusual sights that might contribute to a dramatic composition. The pose of this figure, painting at the top of a tall ladder (below), is translated into a simple but very dynamic pencil line sketch (left).

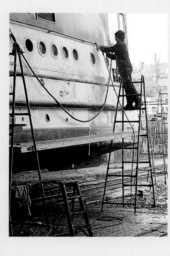

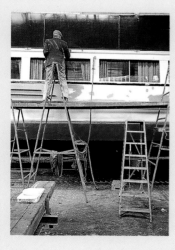

An interesting aspect of figure drawing is the way the balance and weight of the figure are disposed. These two brief sketches provide a comparison – the body leaning forward and away from the viewer. Both are economical but precise in using contour to convey the character of the pose.

Learning by copying the works of the master painters has been one of the great traditions of art training, from the studio apprentices of the Renaissance to the students of 19th-century art academies following their teachers' styles and studying works from the past. This principle has something for the modern student, although it is now unusual to see young artists copying a masterwork brushstroke by brushstroke. But there is a lot to be learned, of

Learning by copying

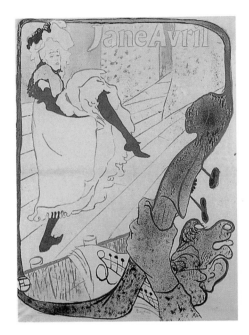

Sketching from the masters

LEARNING FROM SKETCHING

form and content, composition and technique, by examining the works of artists who have solved their own problems in their own ways. Sometimes, too, close study of the work of a famous painter reveals how certain aspects remain unresolved: This can be encouraging to anyone struggling with the initial challenges of visualization and technique — the apparent failures of an experienced artist have just as much, if not more, to teach you about how paintings get made as do the great successes.

There are two main methods of learning from artists past and present. One is by taking a sketchbook to galleries and special exhibitions when you go to view the works on display. Taking sketch notes on the paintings, or any kind of art object, can help to set the image in your mind. They act as a personal reference file on the works that particularly appealed to you, that brought home some interesting visual point, or made you see things differently.

You can also use reproduction prints — books, posters, and postcards — as a source of study. Although you may not get all the subtle details of color and brushwork from a small print, you can still investigate and analyze the composition as a whole and the way individual elements are worked into the overall image.

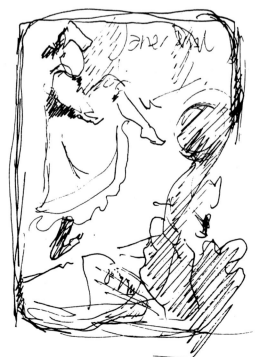

Henri de Toulouse-Lautrec (above)
Jane Avril Lithograph
Elisabeth Harden (left)
Technical Pen
8¼" × 5½"

The sketch of Toulouse-Lautrec's famous image of Jane Avril dancing, drawn while the lithograph was on public exhibition, made a record of the artist's immediate response to the original work and helped to set the rhythms and patterns of the composition in her mind.

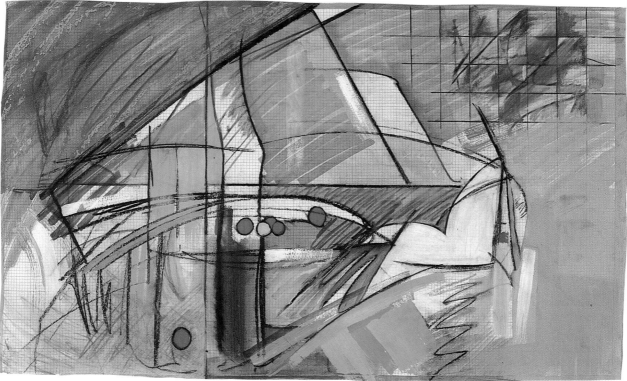

Marcus Stone (above)
In Love **Oil on Canvas**
Judy Martin (top)
Charcoal and Gouache
12¾″ × 21″

The Victorian original
that inspired this sketch
is fascinating for its crisp
qualities of light, color,
and composition. A

series of sketches was
made from a postcard
reproduction as an
investigation of how
certain visual elements
might be adapted to a
wholly different style of
image-making.

• If you have seen the original of the
work you want to study, try to find the
best possible reproduction that seems to
you to convey the color and detail
accurately.

• If you have no reference for judging
the quality of the reproduction, confine
your analysis to the elements least likely
to have changed dramatically – study
tonal qualities rather than color, or the
overall arrangement of the composition.

• Use any suitable medium that
represents the elements of the work that
most interest you. If analyzing linear
structure, use pencil or pen; if studying
color detail, use watercolors or gouache
to achieve the subtleties; if trying to get
an overall impression of the work, use a
quick, versatile medium.

• You will find it more valuable to
work through a number of rapid
sketches that represent different aspects
of the work than to overwork one sketch
trying to get everything in. Define the
points of interest clearly in your mind as
you make each sketch.

It is not unusual to start a drawing at one side of your sketchbook page, only to find that some of the detail you had hoped to include "falls off" at the other side. Although it is not always essential to create a formal composition within the sketchbook page, there are times when the balance of elements and the relationship of one shape to another within a particular area are a major aspect of the subject's visual interest. In this case, you need to take a

Creating a balanced design ✎

Basic principles of composition ✎

LEARNING FROM SKETCHING

Composing the sketch

little trouble over "composing" your sketch.

Firstly, there is the question of the page format. Few sketchbooks are square, which means you always have the choice of a portrait (taller than wide) or horizontal (wider than high) format. You also have the option to use the single- or double-page format (see also pp.86–87). The parameters of the drawing are therefore basically laid out by the paper size. Your task is then to establish where the key features of the subject fall within that format.

The basic divisions of your composition depend upon the situation. In a landscape, you will have to position the horizon line on the page. The relationship of land and sky forms the basic structure of the composition, determined by your viewpoint. There may also be distinctive features, such as trees, walls, fences, a river, that suggest a pictorial framework for the view. In a portrait or still life, you are focusing on a person or on specific objects, but to create a broader context for the composition you may wish to indicate, or hint at, background elements such as walls, floor, a table, or a chair. In an architectural study, there is a vertical as well as a horizontal axis; you may need to suggest a broad perspective view with a complex structure; or you may prefer a frontal view with a simplified, dynamic vertical emphasis.

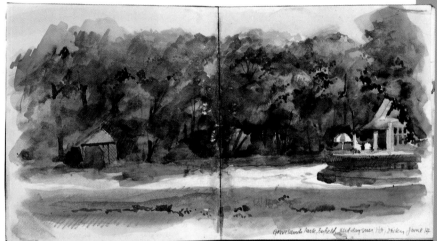

- *Central axis – it is one of the conventions of composition that you never allow a major feature to divide your picture area in half, as this can produce a dull, over-symmetrical result. However, there is a particular pleasure in breaking the conventional rules. A "mirror image" effect can be dramatic and surprising. Alternatively, if you wish to counterpoint the central balance, ensure that the elements on either side of your axis are distinctly different.*

- *Frontal views – a study of a building or a portrait, for example, can be disconcerting if the view is strictly frontal. There is a confrontational aspect that almost repels the viewer. Create plenty of rhythm and detail in the composition so that the eye is encouraged to investigate the surface.*

- *Off-center vertical – there is a naturally pleasing balance to a composition in which the vertical axis is off-center. An example of this is an interior view in which one corner of the room forms a strong vertical stress and the adjacent corner is unseen. In a still life, objects are usually grouped asymmetrically. In a figure study, part of the background is often indicated, leading the eye outward from the figure itself.*

- *Low horizon – inevitably this suggests a relatively high viewpoint. In a landscape, a low horizon compresses the area of the land. You need to consider how to "layer" the detail of the landscape within the more compact space, and put some interest into the sky.*

- *High horizon – this creates a broader foreground plane, and you need to take care that the detail in the foreground appears to recede on the horizontal plane, rather than rise vertically.*

- *Ways in and through – there are many ways to lead the eye into the space and depth of a picture. In landscape, a road or river running into the distance is a simple "route" through the image. Conventional perspective works this way in cityscapes, with the planes of buildings and streets converging on a vanishing point. In still life, ways into the composition are made by making the spaces around and between objects as interesting as the objects themselves. Doors and windows are obvious links between inner and outer spaces in an interior view.*

Stan Smith
Pencil
449 × 638mm

In this pencil sketch (left) the viewer's eye is cleverly led into the center of the picture by the diagonal line of the reclining figure, only subsequently is the figure in the background noticed. The background elements are hinted at rather than stated outright, and the artist's erasure marks create a textured feel to the composition.

John Elliot
Pen and Ink
210 × 170mm

An American landscape (top) in which the artist has superbly captured a sense of perspective through the positioning of the elements. The picture surface is divided into horizontal sections which diminish in size; the furrows are angled to increase the sense of a receding distance, and the buildings shown off-center lead the eye into the composition.

John Lidzey
Watercolor
229 × 304mm

A seemingly balanced composition (above), yet the dynamics of the piece are acheived by introducing the pool of sunlight which draws the eye to the terrace and introduces asymmetry to the sketch.

Every sketch, drawing, or painting is in some degree a selective view of the subject. The elements that you choose to feature and the techniques that you use to describe them demonstrate your own particular interests — every image is a unique, individual observation, one person's point of view. In sketching there are various ways in which you may select from and refine the visual possibilities — first and most obviously, by focusing on a specific

Selective composition

subject and taking a particular viewpoint. But you may also alter, adapt, or reorganize what you see when you put it down on paper. Sometimes this is a virtually subconscious process; at other times it is a deliberate working method.

Many sketches are intended to be an objective record of a scene or event. However, there may be some element that is visually disruptive, that distracts your eye from the main interest in the subject and adds nothing to your interpretation. There is no obligation to include everything just because it is there. If such a feature falls within the framework of your composition, you can simply leave it out. Make sure, however, that it is not obstructing your view of other things that you do need to include. Try first a few alternative viewpoints to see if you can actually eliminate the unwanted material from your line of vision. If not, simply ignore it and concentrate on what is of interest.

Another method of being selective in your sketch material is when you rework a subject from existing sketches and start to refine the composition from the visual information previously recorded. This is a process often used by artists in developing sketches toward work in another medium — studies for a painting, for example, or inspiration for design work of some kind. To be able to do this, you need to have enough initial information to be able to select from it without losing its essence.

Elisabeth Harden
Pencil and Gouache
17¾″ × 12½″

As an image develops in the artist's mind and on the page, there are various ways in which sketches may be made as developments toward a final interpretation. These drawings of cows at a fence are very loosely worked in pencil to build up a clear sense of the composition; an added feature here is a quick trial of suitable color combinations.

When you are making sketches that may serve as reference for later reworkings, try to record many different aspects of the subject, if necessary varying your techniques and methods of notation. If you intend using the sketches as reference for a painting, for example, sketch the impressions of tonal and color values as well as shape, volume, and spatial relationships. Establish a clear sense of the overall composition and make separate, individual notes on special details of form and texture.

Judy Martin
Pencil
13¾″ × 8¾″

This sheet of sketches comes from a long series of works based on drawings of zebras made at the zoo (see also p.37) which gave rise to a number of paintings in gouache and acrylic. The zebra stripes and body shapes became the basis of several totally abstract compositions. Sketching was a way of freeing the shapes from their original context and allowing an image to develop in its own right. In the paintings this process continued in terms of translating the images from the pencil sketches into a different medium.

Selective composition

Composition sketches

Sometimes a particular viewpoint forms a composition that incorporates all the essential aspects of the subject. At other times you can see so much potential in a subject or location that your series of sketches may be a way of looking at alternative possibilities. In either case, your sketches may be complete in themselves, or may form valuable reference for further work.

Elisabeth Harden
Watercolor
30″ × 21¼″

The workshop of a carpet restorer crammed with hanks of colored wools provides a ready-made composition for a color study (right). Although it makes a very complete picture, the technique is loose and the apparent sense of detail achieved by economical means — rough patches of color and sketchy, linear brushmarks. The sketch was worked very fast to capture the rich, dark atmosphere and although the colors are mainly low key, there is a vibrant mood to the painting.

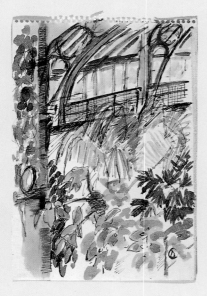

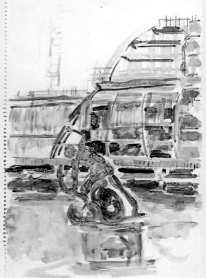

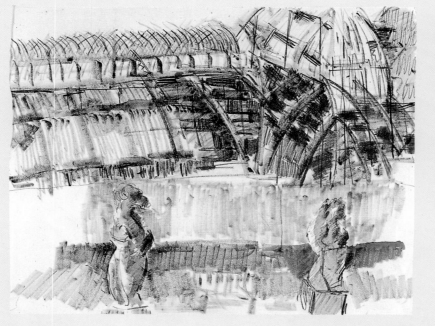

Daphne Casdagli
(left to right above)
Watercolor and Pen;
Watercolor and Crayon;
Watercolor; (left) Mixed Media
Various dimensions

A single location, England's famous botanical gardens at Kew, offers the artist many different and equally fascinating compositions.

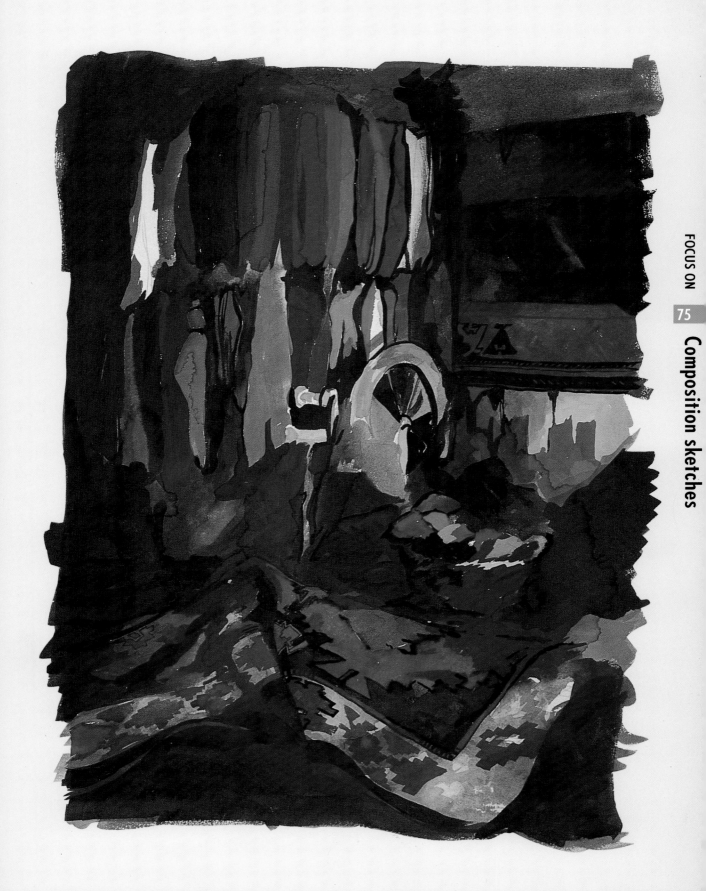

Sketching in paint may seem a much bolder step than simply working with a pencil or pen. Pure color is an element that people find difficult, even intimidating. Often you feel you can see so clearly the attractions of the subject, but the right combination of colors fails to materialize on the page — the image that was meant to be so alive and vibrant with color is dull and disappointing.

Remember that one of the principles of

Stan Smith
Watercolor
19¼" × 14¼"

This is classic watercolor technique: washes of color define the general shapes and are overlaid with finer brushwork building up the detail and texture.

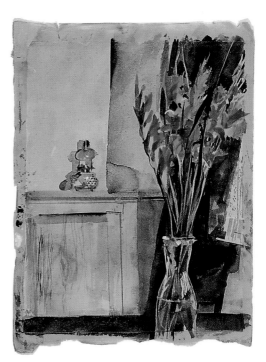

LEARNING FROM SKETCHING

Watercolor and gouache

sketching is to allow yourself time for trial and error. You can forget about notions of "correct" technique, but you need to be conscious of the properties of your medium and how it can best work toward the end result you seek. Paint is more difficult and more cumbersome to work with in hasty circumstances than are the drawing media, but as the examples on this page show, there is plenty of scope for different approaches to your subjects and for using the paint qualities to express not only objective color values but also the mood of the scene. If at first you don't succeed, just turn the page and try again.

The transparent hues of watercolor are jewel-bright; watercolor has a wonderful range for indoor and outdoor subjects, and is particularly suited to subtle light effects. Opaque gouache has, by comparison, a chalky quality, but it is a substantial and expressive medium which can be built up layer upon layer. In watercolor, every mark you make in a sketch will remain more or less visible on the page unless you introduce opaque color to cover previous marks — this risks muddying subsequent color applications and it is better to keep to a direct approach rather than try to disguise errors. You can use white for highlighting in the final stages or, as shown here, you can let the white of the paper create a sparkle amid the chromatic range of your colors.

project

22

Sketching in paint ✎

Drawing with a brush ✎

Painting equipment ✎

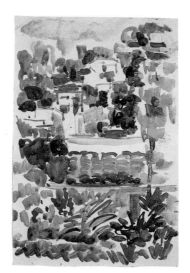

Daphne Casdagli
Watercolor
6¾" × 4½"

Often the white of the paper is left bare in a watercolor sketch just to stand for the main highlights in the image, but here the white background is treated as a positive element adding to the space and color of a lively landscape view.

Stan Smith
Watercolor
8¼" × 5¼"

Watercolor is typically used as a medium of mass, light, and shade, but as this brush drawing (below) demonstrates, it is adaptable to a much looser approach, lending color to fluid line work. The color transparency gives energy to overlaid strokes, while white body color is added to create solid, opaque highlights.

Neil Meacher
Ink and Watercolor
5¾" × 8"

Line and wash technique has a special charm when the color selection corresponds to the natural colors of the subject (right). This landscape, though fairly densely structured, has a fresh, open atmosphere owing much to the soft coloration.

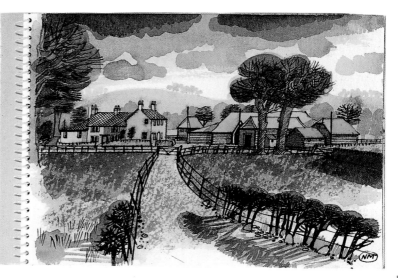

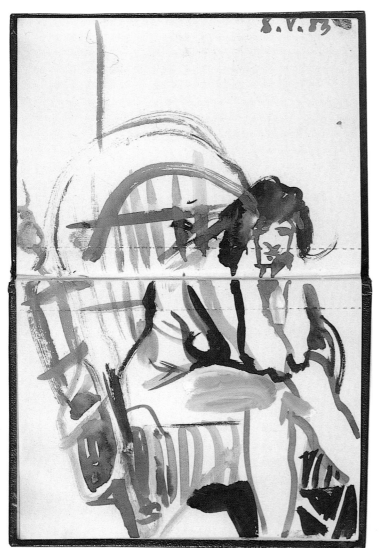

EQUIPMENT

- *Watercolor – a good-quality watercolor box is the best investment, being easier to handle but just as versatile chromatically as tube paints. Boxes vary in size and range of colors: consider how many individual hues you will need and how many more can be created by mixing the colors from a basic selection.*

- *Gouache – tube paints are messy, but usually you will get a better quality of opaque paint from tube colors than from cakes of gouache or "poster" paint in boxed form. Remember to carry a lightweight plastic palette or tray for laying out and mixing your colors.*

- *Sketchpads – when you use a wet medium, there is the problem that the paper buckles when wet and may not dry flat. Sometimes this is part of the charm of a quick color sketch, but if you wish to eliminate buckling, choose a pad of heavyweight watercolor paper, perhaps one in block form with all the pages temporarily bound together on each side, which has the same effect as stretching the paper to encourage it to flatten as it dries.*

- *Brushes – the traditional brush for watercolor sketching is the pointed sable; choose two or three varied sizes to give yourself scope for broad washes and details. Square-tipped brushes are also versatile if you use the edge of the brush for line work and the flat width for broader strokes.*

Arguably, every sketch serves the function of recording detail, however broadly it approaches the subject and however briefly or loosely this is described. Sketching is commonly a form of visual journalism, a record of appearances or events.

However, there are other ways in which you can more fully investigate the individual details of a subject. An overall image of a subject can be fairly broadly drawn and yet be

LEARNING FROM SKETCHING

Recording detail

enlivened by the inclusion of two or three points of detail that link to each other across the general layout of the sketch. This is a decision that you might make on purely visual terms, to put an element of the unexpected into your drawing. But it is not always appropriate to include the smaller or more elaborate details of, for example, a townscape or landscape within one image. The scale of the drawing or the range of your viewpoint may automatically eliminate some of the minutiae. You may want to take a different angle on particular aspects of the subject, describe fully the construction of a specific element, or make notes on the colour detail in a different medium from that of your original sketch.

Work on sketch details includes simple drawing practice – the effort to go into a topic again and again because you find it difficult to draw and are interested in analysing exactly how it works, and how to get it right on the page. Hands and feet, for example are a notoriously tricky element of drawing the figure. Often they are given much more sketchy treatment than they deserve, as a way out of the problem. If you fill a sketchbook with nothing but drawings of your own hands and feet, by the final page you should know all there is to know about their structure and articulation, and the kinds of marks you can make with your medium to convey the information that you have learned.

Suzie Balazs
Pencil
16″ × 5¾″

A valuable function of the sketchbook is to keep together visual notes relating to each of the subjects that interest you. In these sketches the artist has noted the poses and clothes of the *figure and has drawn the hands separately on the facing page. This gives her a larger scale for the study of hands, allowing them to be drawn with greater detail than she could have included within the confined space of the full-figure sketch.*

project
23

Highlighting points of interest ✎
Practicing difficult subjects ✎
Exploring a single theme ✎

Elisabeth Harden
Technical Pen
8¼″ × 11¼″

When a location contains a lot of complex visual material, you may get more out of a number of quick detail studies than from trying to encompass the whole impression. Notes on the ornate decoration of the Alhambra in Spain (far right) were intended as reference for a painting.

John Lidzey
Pencil and Watercolor
9″ × 12″

Focusing on the decorative shape and form of a church window (below), the artist builds up the detail of this area of the drawing and briefly indicates the solidity of the surrounding walls with faint lines and color wash.

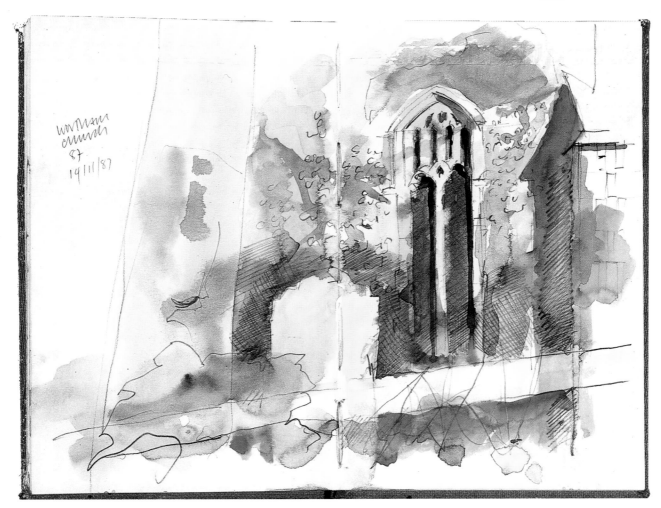

Pattern and texture are the elements of surface detail that can greatly enliven your sketches. Texture is a fascinating study in its own right – you could easily fill entire sketchbooks with different types of textures and various techniques of representing them. Whereas you can create interesting compositions using only the basic shapes and forms in a view, of landscape or cityscape, for example, when you start to deal with the individual

Texture

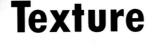

textures – brickwork, ironwork, roof tiling, grasses and foliage, stone and water – you can produce a drawing of startling richness by fairly simple and economical means.

The challenge of investigating texture lies in finding the mark-making facilities of your medium that adequately represent (not reproduce) the surface variations and complexities of detail that you see in your subject. A satisfactory solution to sketching a distinctive texture can work equally well in monochrome or color, so there is no need to feel restricted by your medium. Give free rein both to the qualities of the medium and the gestures of your drawing hand – let loose on techniques of shading, hatching, scribbling; drag, push, and roll the pencil, pen, or brush; make dots, dashes, ticks, blots, and trails of tone and/or color. In being boldly inventive or experimental, you may happen upon the perfect two-dimensional equivalent of the textural detail in your subject.

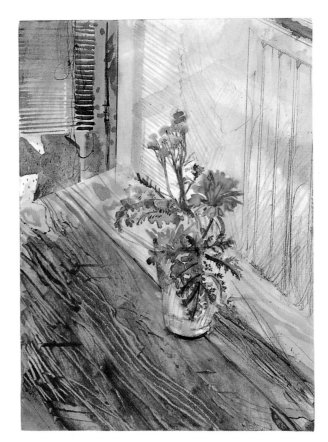

EXERCISES IN TIME

• *Find a distinctive surface texture that you can comfortably study at close quarters. Try out ways of representing it in different media, both monochrome and color, varying your mark-making techniques as much as possible.*

• *Study a mass of texture that is too complex for you to record directly in detail – such as intertwined branches and foliage.*

Developing your tactile senses

Intuitive interpretations ✎

John Lidzey
Pencil and Watercolor
9″ × 12″

The textures of tree branches and foliage (left) are so complex that every artist could devise a different solution for describing them. In this sketch it is the linear framework of the branches that creates the impression of textural detail.

Stan Smith
Pencil and Watercolor
15″ × 10¾″

Every element of this still-life composition (left) has an individual texture that has been given an equivalent in terms of drawn and painted marks. Careful analysis of shapes and colors provides the key to a suitable technique.

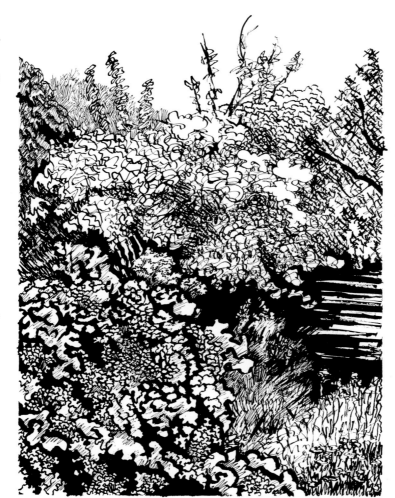

Judy Martin
India Ink
17¾″ × 12¾″

A strong monochrome image (left) makes a distinctive statement, converting natural textures to a kind of abstract pattern. Three different pen nibs of varying widths were used to give richness to the line work; the solid blacks were filled in with a brush.

Neil Meacher
Pencil
8″ × 19¾″

The full range of the pencil's versatility is used here (below) in finding marks equivalent to the many different textures of a landscape. The sketch is also a well-designed composition, stretching over the double spread to accommodate the breadth of the view.

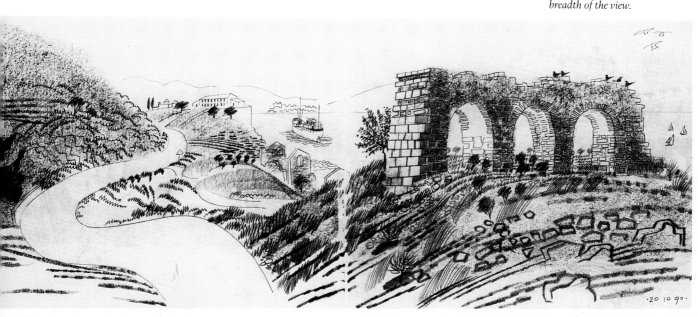

At its simplest, pattern is a purely decorative element of surface detail. The most obvious examples of patterning that can add visual interest to your sketches are man-made patterns — on fabrics used for interior furnishings and clothes, wallpaper patterns, designs for crockery and containers. The challenge of including pattern in your sketches lies in not just accepting it as a surface description in itself, but in judging how it conforms to

Using pattern to describe form ✎
Combining pattern and texture ✎
Creating rhythm ✎

project
25

Pattern

other elements of your drawing that involve translating three-dimensional objects into a two-dimensional representation. The underlying forms, the contours and volumes of your subject both affect the way the pattern appears on the surface and can sometimes be described by the intricacies of the pattern itself.

There is a natural crossover between the appearances of pattern and texture in drawing. Some textures are sufficiently regular and clearly defined to be also interpreted as pattern elements. Consider how you would define brickwork — as a pattern, or as a texture? Its structure is textural, with the solidity of the bricks intercut with the mortaring between them, but the overall impression of, say, a brick wall, is of a simple geometric pattern, unless you are viewing it at such close quarters that all the pits and roughnesses of the surface are readily apparent.

You will also find distinct patterns in the broader structures of landscape and cityscape. Agricultural land divided into fields with definite boundaries corresponds to a man-made pattern, but there are natural structures such as rock formations and the growth patterns of vegetation that can create intricacies of visual detail breaking up an apparently open expanse. Become alert to these rhythms as well as the more obvious pattern values of regular structures and you will find plenty of material for interpretation through your varied sketching media.

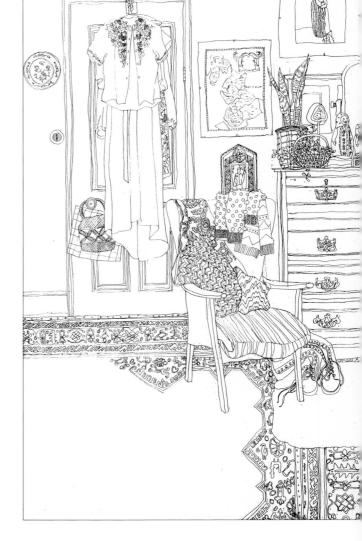

Moira Clinch
Pencil
14" × 18"

Although drawn in line only, this sketch is colorful in the broader sense of the term, being full of fascinating detail that gives a lively sense of the room's character.

The three-dimensional structures are simply outlined, but every single pattern element has been worked through meticulously, giving great richness and rhythm to the composition. The line quality is also precisely handled, with just the right amount of variation to give vitality but with enough delicacy to maintain the consistency of the image.

PATTERN ELEMENTS

• Flat patterns – interiors can be richly described in terms of their surface patterns; there are typically solid blocks of pattern arranged around a room, such as the carpet, chair covers, wallcoverings, and posters or paintings on the walls. These can be successfully represented in monochrome or color.

• Three-dimensional form – notice when you look at a scarf or patterned blouse thrown randomly over the back of a chair how the pattern is broken up across the folds of the fabric. If you precisely sketch the sections of the pattern, you will automatically arrive at an impression of form.

• Structural patterns – a network of interlocking shapes in landscape or townscape can be interpreted as a flat pattern or as form, texture, and pattern combined. Look for repeated elements that connect different areas of the view, and the rhythmic, internal patterns of general scenes in the street, yard, or park, or in open landscape.

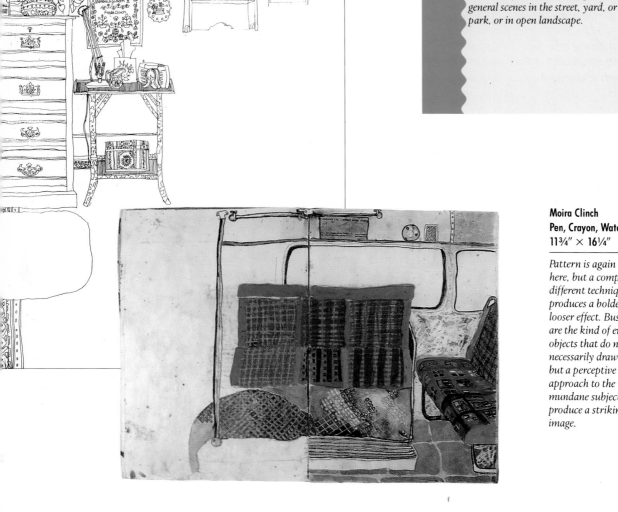

Moira Clinch
Pen, Crayon, Watercolor
11¾" × 16¼"

Pattern is again the focus here, but a completely different technique produces a bolder and looser effect. Bus seats are the kind of everyday objects that do not necessarily draw the eye, but a perceptive approach to the most mundane subject can produce a striking image.

Many of the sketches in this book qualify as mixed media works — from simple line and wash drawings to more complex combinations of three or four media mixing monochrome and color. When you are working quickly, varying the medium to represent a different element of the subject is a suitable way of covering its range. This method creates interesting textures on the page and gives you scope to develop a memorable image.

Mixed media

In practical terms, it is obviously easier to mix your media inventively in studio work than when you are working outdoors. If your materials have to be portable and economical, you may be restricted to simple combinations. Typically, many sketches are made with a black "keyline" effect, the basic structures sketched in using pencil or a reservoir pen, and are then elaborated with a color medium such as colored pencil, pastel, or watercolor.

However, when you are initiating or reworking sketch references at home or in the studio, you can bring into play the full range of your stock of materials, adding the richness of different kinds of paints, inks, and even paper collage to your repertoire. Most combinations of media have the potential for success. If you are using pastels and paints, the main rule to remember is that a wax- or oil-based medium cannot be overlaid or covered evenly with a water-based one, but you can take advantage of this property by using resist techniques. If your materials are heavily textured — as with oil pastels or graphite sticks — there is a limit to how accurately you can work one material into another, since the surface may become muddy or resistant. But keep in mind once again the principle that an important aspect of sketching is trial and error, developing your own technique and investigating your materials. There is no right or wrong approach to mixing your media — feel free to play.

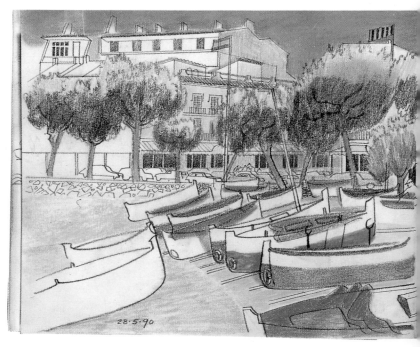

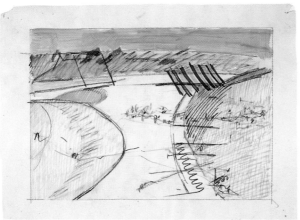

Stan Smith
Pastel, Crayon, Watercolor
14¼″ × 14¾″

The subject of this color drawing (left) is a springboard for technical experiment, resulting in a lively interpretation. Color, texture, and rhythm are developed through free use of the media, including resist techniques and loosely spattered paint.

Neil Meacher
Pencil, Crayon, Pastel
8″ × 19¾″

The combination of materials used here (below) gives additional depth and texture to the view, with very subtle surface variations. Line and color are confidently integrated.

Judy Martin
(left) Collage and Felt-tip Pen; (right) Pencil, Watercolor, Pastel, Felt-tip Pen
Various dimensions

These two sketches of the sweep of a seaside bay pick up the color accents in the view, with a range of marks corresponding to basic shapes and textures. Thin paper was used in the left-hand image to lay in a colored foreground.

MIXING YOUR MATERIALS

- *Pencil, colored pencil, and crayon –* use the black of the pencil freely to create structural line and tone, and interweave it with your colors.

- *Pastel and crayon –* combine dry with waxy or oily textures.

- *Pencil or pen with watercolor –* use fine black keylines and details to create a structure for loose color washes and effects of light and shade.

- *Wax crayon or oil pastel with watercolor –* make use of the resist properties of these media. The watercolor will wash away from waxy or oily lines and textures, settling only on the bare paper areas, but you can overlay further crayon work and build up the layers of paint color.

- *Pastel, gouache, and colored pencil –* all opaque textures, providing the interchange of broad and fine lines, thick color, and intricate texture to build up a rich surface.

- *Collage with pencil, crayon, pastel, or paint –* a base of colored paper pieces is sometimes a good start for an unusual image. This is typically a studio sketching technique, since it is usually impractical to carry pieces of loose paper and adhesive when sketching outdoors.

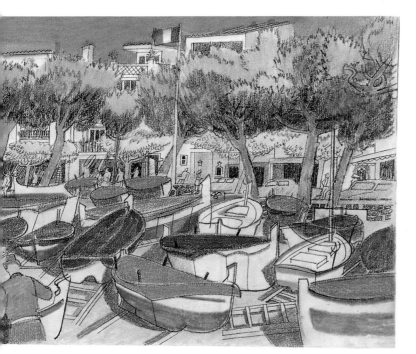

Positioning your drawing on the sketchbook page is as often as not a matter of instinct. When you see something that you want to sketch quickly, the simple contact of the drawing tool on the paper is the immediate, important thing. An image that simply materializes on the page in its natural shape and form can create interesting tensions in the relationships of the drawn marks to the white spaces surrounding them.

Finding the best format ✎

Using your ✎
paper to maximum effect

John Lidzey
Pencil and Watercolor
6″ × 18″

Landscape is the obvious candidate for use of the double spread. Often it is the breadth of open landscape that creates the drama of the view, although many other interesting elements may occur within that space.

**LEARNING
FROM SKETCHING**

Using the sketchbook page

Sometimes, however, the nature of the subject requires a little more inventiveness in the use of the page. Two stunning examples of color sketches shown here both make use of the double-page format to extend the artist's scope — one horizontally, to emphasize the broad spread of landscape; the other vertically, to create an intense, dynamic impression within the elongated format. When you go over the center binding of the sketchbook, you have the choice to ignore it completely or make it almost a feature of the sketch. In the second example of a wide landscape view over two pages, the artist has managed to accommodate the ring-binding of the sketchbook, which somehow adds to the charm of the final effect.

Throughout this book you will find many examples of drawings and paintings that burst out of the page or make their way gently across from one side to another. This is a solution to varying the format that does not always spring directly to mind — we tend to think of a left-hand page as being the "back" of the working page before. Several examples also show one of the most fascinating elements of the sketchbook — completely different subjects, sketched at different times, that happen to end up on facing pages. There is no particular hierarchy in the contents of most sketchbooks — in terms of image-making, a single hand can be the equal of a full-scale orchestra.

When working outdoors, interleave your sketchbook pages with sheets of tissue or tracing paper. Use the paper as a hand-rest when you are working on a page opposite one that has already been drawn on, to protect the surface and prevent smudging. If you want to move on after completing a sketch and need to close your sketchbook to make it easier to carry, slip tissue between pages where there is color that may not be completely dry (or those on which you have used loose pastel color), so that you do not get an offprint from one page to another or two pages stuck together.

Daphne Casdagli
Ink and Watercolor
15¾″ × 5¾″

Facing pages are also used here (right) to accommodate a landscape view, but it is unusual that the format of the sketch is vertical, especially as the height is so much greater than the width. However, this aptly describes the gradient of the land, and the lateral confinement of the image contributes a kind of isolated grandeur to the subject.

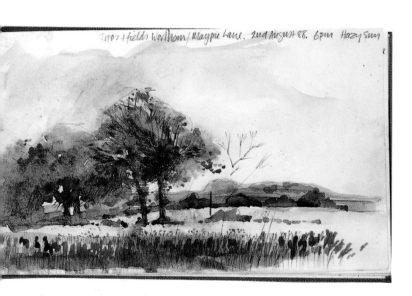

Neil Meacher
Pencil
4″ × 11½″

In a sketchbook with a stitched or glued spine, your medium may gradually disguise the join between the pages, but in a spiral-bound sketchbook the binding becomes a visual feature (left). In this example, it forms an unavoidable break in the image, but the two halves are successfully united by the strength of the composition and the drawing technique.

Working on white paper gives considerable versatility, since you can use opaque or transparent color, invent your own tonal range, and see the interaction of marks and colors against an apparently neutral background. However, the unblemished brilliance of white paper is arguably an unnatural visual experience – there are few things that you will be able to view against a perfectly clean white ground – and there are many good reasons for

Establishing values on a toned surface ✎
Choosing the ground color ✎

LEARNING FROM SKETCHING

Sketching on colored paper

including work on colored papers.

The logical reason for working on a toned or colored ground, which was the major tradition in both painting and drawing before the advent of impressionism's pure color sensations, was to begin with a middle or neutral tone against which the lights and darks in a picture could be played at either end of the tonal scale. This method of establishing a measure for the tonal range holds good for sketching in all media, and colored paper can be less intimidating than a pure white page. However, you must remember that if you use a colored ground, you cannot get clear color impressions from a transparent medium such as watercolor: the underlying tone will modify both darks and lights. The ideal media for this kind of work are opaque pastels and gouache, the marks from which can fully or partially conceal the ground color. It is also very useful for monochrome or limited-color drawings, when you can use, say, pencil or black crayon in contrast with a white or pale-tinted chalk or pastel, to create the extremes of tone against the central tonal or color value of your paper.

Traditionally, colored grounds have low-key or neutral color values – grays, buffs, browns, and beiges; subdued blues and greens. These are intended to offset the tones and colors of the media that you apply. But you could choose to use a paper color that has a strong chromatic presence – a vivid red or orange, say – if it relates well to the subject.

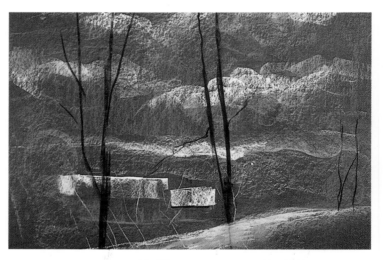

John Elliot
Pastel on Colored Paper
11″ × 13½″

Pastel is traditionally associated with the use of colored grounds, allowing the line, texture, and color of the medium to achieve full vibrance (above). Here the dark-colored paper gives a dense, threatening mood to a wintry landscape.

Stan Smith
Oil Pastel on Colored Paper
15″ × 11″

A large area of the mid-toned paper is left bare in this drawing (opposite), with strong effect on the balance of the composition. Its lack of color bias gives warmth and clarity to the bright pastel hues.

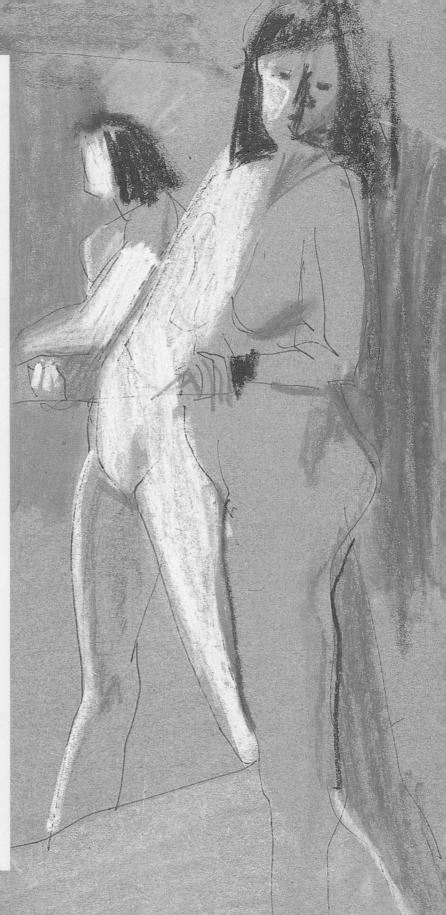

For sketching you can use individual sheets of colored paper, or you can buy a variety of sketchbooks and pads that contain a range of paper colors. Typically these will be one of two types — relatively smooth-surfaced drawing or poster papers in strong colors; or papers in subtle, muted hues, with a more noticeable grain and texture, such as charcoal paper.

• *Gray* — the perfect neutral, but there are many different tones from light to dark. You will need to judge the value that may best establish a basis for the scale of tonal variation in your subject.

• *Beiges and buffs* — although described as neutral, these usually have a color bias. If you compare different paper sheets, you may be able to perceive warm/cool color variations. This color range can provide an excellent basis for landscape and interior subjects.

• *Blues* — there is an enormous range here, from strong cobalt and rich ultramarine to muted blue-grays that barely register the color content. Blue is the complementary color of orange, so oranges, reds, and yellows will stand out well. Landscapes and still lifes gain a coolly atmospheric presence from an overall blue tone.

• *Greens* — seemingly the perfect choice for landscapes, but the variations of green in nature may be hard to match if you have a dominant base of one particular green.

• *Reds* — almost any red creates a stronger visual sensation than other colors; these are naturally dominant hues. You may have trouble achieving a color or tonal balance on a red ground, but if you can pull it off the effect can be spectacular. Red grounds have been effectively used in oil painting to give a strongly warm underlying tone, and this is worth trying with a densely opaque medium such as soft pastel, especially if you use loose strokes to create textured and broken color, letting the red ground glow through the upper layers.

• *Yellows* — here you can find some of the clearest, purest colors next to white, and built-in light effects, but yellows can be difficult to handle in combinations of hues and are better used sparingly as color accents in a composition.

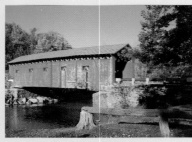

Covered bridge

In a body of sketches that formed the prelude to a highly successful series of paintings, John Elliot explores the range of shape, pattern, and texture in the structure of an old covered bridge, an unusual and unique feature of the local landscape. As a historic landmark and recreational focus for the community, the bridge also conveys a distinctive character and changing moods according to the time of day and the activities going on around it. These were aspects of the subject that the artist wished to integrate with the purely visual qualities, and he chose to use several different media to correspond to these varied considerations. This, in turn, was reflected in his varied approach to technique in the paintings that followed from the sketches.

John Elliot recommends the constant practice of sketching as a means of developing visual perception and improving hand-eye coordination. He never leaves home without a sketchbook and pen. Although he has an impressive technical range, he feels pen and ink is a valuable medium because it forces the artist to make a clear visual statement, encouraging confident analysis of the subject and of how it is to be translated onto the paper through the pen's unambiguous marks.

In a series of quick sketches on one page of a large spiral-bound sketchbook (below), the artist experiments with different viewpoints to try out the ways in which the bridge can be seen as a whole composition. The line work is loose and active, describing the overall structure of the image and providing a sense of tonal values and textures. The pen is allowed to twist and turn to make appropriate marks — broad lines and dense tone are made with the pen held conventionally and moving fluidly (top and center right); finer lines are drawn with the penpoint turned upside down (bottom right).

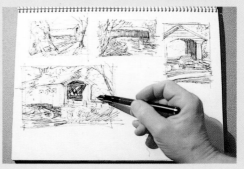

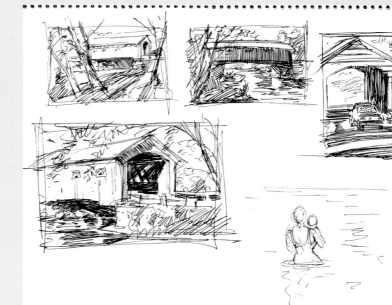

A heavy-pointed marker creates a bold impression of tonal values (right). The thick black strokes gradually produce a pattern of light and shade. The viewpoint is farther away, so that the bridge itself is less of a focal point.

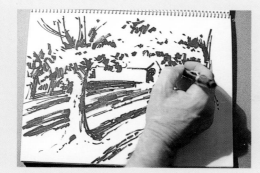

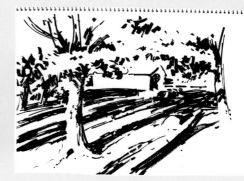

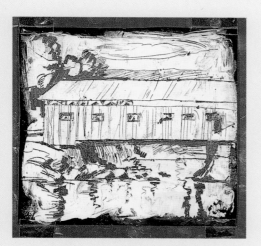

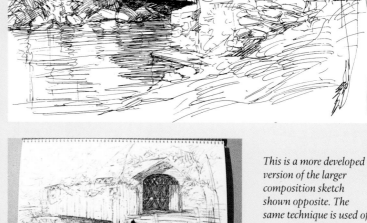

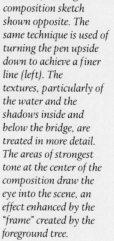

On sketching trips, the artist frequently takes a kind of scratchboard made by laying oil pastel over India ink. This gives a textured monochrome image very different in character from the pen sketches (above center).

The drawing is scratched into the surface layer, using a knife edge or pointed instrument (above). Corrections are easily made by retouching with the oil pastel.

This is a more developed version of the larger composition sketch shown opposite. The same technique is used of turning the pen upside down to achieve a finer line (left). The textures, particularly of the water and the shadows inside and below the bridge, are treated in more detail. The areas of strongest tone at the center of the composition draw the eye into the scene, an effect enhanced by the "frame" created by the foreground tree.

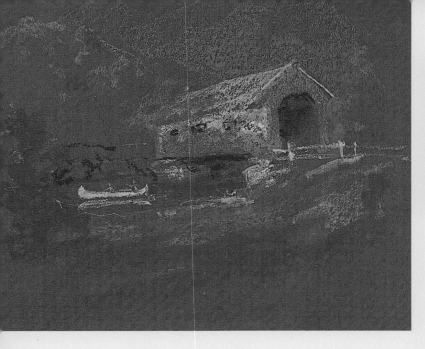

In a quick pastel sketch, the artist interprets the image loosely in terms of pure color, representing evening light. He uses strong, vibrant hues to create an interesting arrangement of values rather than a naturalistic rendering of the subject. The dark brown paper gives the pastel strokes full brilliance but also provides a uniform tone, linking different areas of the image. Against this background the sketchy treatment of form and volume coalesces into a vivid impression of the scene as a whole.

The fascinating structure of the covered bridge is effectively conveyed by this detail sketch in pencil, taking a face-on view of the wooden wall. The close view focuses the abstract properties of the subject.

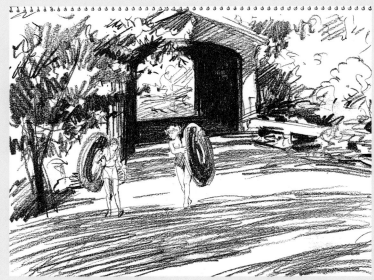

Looking through the tunnel created by the framework of the bridge, the artist deals with the foreshortening of its receding volume and takes advantage of the tonal depth in the composition, using a soft pencil to develop the range of grays and blacks. In this sketch he has chosen to incorporate figures of swimmers, who represent the recreational function of the bridge.

The very tip of the pencil point is used to delineate contours with crisp precision (left). For the heavy shading of values, the pencil is held sideways at a shallow angle (right).

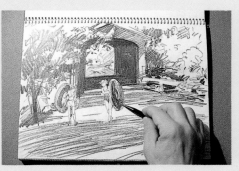

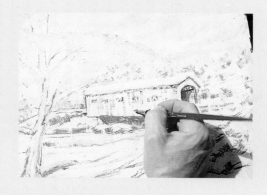

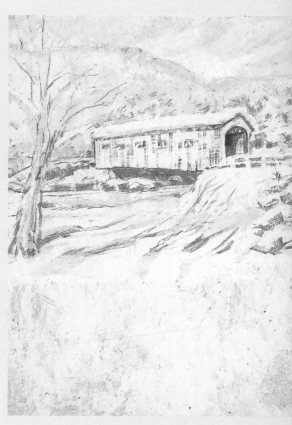

Bereft of the foliage cover that partly masks its shape in summer, the covered bridge under winter snow has a stark, formal presence. This sketch is worked black out of white, using the scratchboard technique also demonstrated on page 91. The surface of an artboard has been primed with India ink, followed by a layer of white oil pastel. The artist draws into the pastel with a knife or scratchboard etching tool.

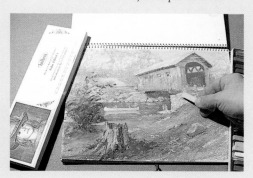

A detailed color sketch of this kind needs to be worked as a whole, continuously re-examining color relationships. Small finishing touches, such as bringing up the highlights, complete the picture.

A sunny mood is captured in a color scheme that plays warm against cool colors, rather than light against dark. The deepest shadow tone is represented by a cold mid-toned blue, which in the bridge itself is directly juxtaposed with warm pinks, oranges, and yellows. The technique is carefully judged so that the colors do not become overworked and muddy.

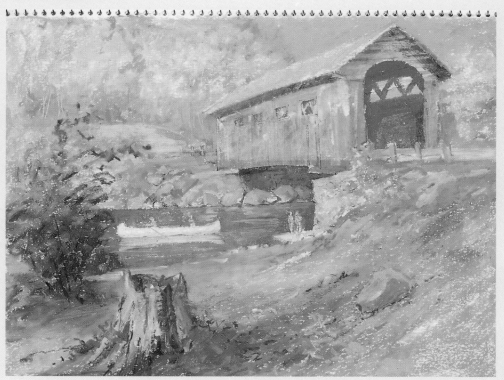

3

Themes

Themes

The potential themes of sketching cover a vast area including just about everything within your home and beyond your front door. The matter of selecting a theme is therefore of some importance in focusing your skills of observation and interpretation. One of the pleasures and values of sketching is to let yourself pick up incidental images, themes, and events that may never go beyond a hurried note in your sketchbook, but alternatively may spark a specific interest or train of thought that leads to a period of continuous work on a single theme or related subjects. However, if you aimlessly create random jottings and no special interest or technical progress emerges, you will shortly come to the limits of what you can learn from sketching and possibly even of its value to you as a recreational activity.

This section is a study of various classic themes for painting and drawing — all of which are also represented in the images displayed throughout the previous chapters. Many artists feel themselves drawn to a particular theme and it becomes the central platform of their technical experiment and visual development. Landscape and the human figure are

Stan Smith
Pencil and Pastel
19¾″ × 30¼″

The figure is one of the classic themes of art, and the traditions of life drawing still hold strong. This sketch depicts a relaxed and informal life room pose, suggesting that the artist has found as much interest in drawing the models while they are taking a break as when they are formally at work.

themes that often become highly focused and personalized in the work of individual artists, because both of them call upon instinctive and emotional responses that form a sort of subtext for the more disciplined aspects of artistic analysis. This is not to imply that there is necessarily something psychologically complex about engaging with landscape. Feeling drawn to a particular subject is on one level simply a powerful motivation that keeps a person at work. The character of that underlying response may be irrelevant to the visual range and expression of the work produced.

POINTS OF INTEREST

Sketching — or any type of drawing or painting — can be viewed as a formal exercise in matching your skills of observation and technique. To this extent, it doesn't matter what you choose to draw, as all subjects present visual qualities that can be effectively interpreted through one or another of your available media. This is an approach that might be encountered in art school training, where projects are set both as a means of acquiring discipline in applying particular skills and are geared to investigating specific areas of visual and technical potential. But if you set out to learn something from your sketching you have to impose a certain discipline on yourself, and this is easier and more enjoyable if you are really interested in your subject.

Selecting a theme is also a matter of opportunism. At times when you are making quick sketch notes of something that has caught your eye, the subject simply presents itself, and the time you may spend on it need not be long enough to demand much concentration or engagement. However, if, for example, you go out into the landscape for a whole day's work, it is better to have a clear sense of what aspects of it may be of interest to you and what equipment you will need to be able to make the most of them in your sketches. The variety of landscape offers different kinds of appeal. Are you interested in space and distance, form and color, structure and texture? What is the character of the place you would like to sketch, is it accessible to you, is there a realistic alternative that forces you to make choices between, for example, countryside and seascape?

**Moira Clinch
(top) Pencil;
(above) Ballpoint and
Colored Pencil,
both 6″ × 5″**

Portraiture is mainly about forming a likeness of a person, but there are many other aspects of character and interpretation to be taken into account.

These two drawings focus on the regalia and activities of these courtroom functionaries, as well as the people inside the uniform. In both cases, the medium is precisely put to work to emphasize the points of interest.

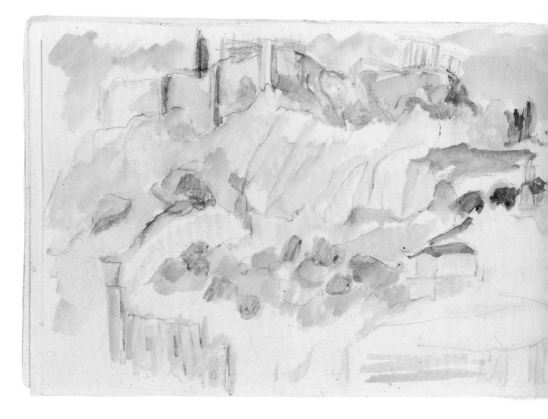

Daphne Casdagli
Watercolor and Pencil
6″ × 16¼″

The category of landscape covers a broad range of subjects, not only the natural shapes and colors but also the light, space, weather conditions, and evidence of the inhabitants of the landscape. This color study surveys the visual "layering" presented by a hilly landscape where rocks, houses, and trees variously contribute their colors and textures. The colors pass through a subtle scheme from left to right that describes increasing space and distance.

An advantage of selecting a clear theme for extended study is the continuity it provides to your work and the record of progress that this will create. Whereas you may also want to make progress in different areas, there is no point in comparing unlike things. A figure study compared to a cityscape gives basic technical points of comparison — such as how you have handled the structures, colors, values, and surface effects. There may be some valuable crossover — for example, a technical solution to evaluating graded tones worked out on one subject may translate as well or better to another. But when you look at two or more townscapes, or figure drawings, that you have done over a period of time, you can see whether you have learned more about form and composition, and about technical interpretation. A body of sketches is a record not only of what you have seen but of how you may have responded differently to similar stimuli over that period.

IMAGE-MAKING

The arrangement of themes in this section takes a methodical approach to the major and most popular subject areas — landscape, townscape, life studies, people, portraits, animals, nature, interiors, and still lifes. The examples representing these categories provide a wide range of inspiration on subject, technique, and the purposes of making different kinds of sketches. Spreads on the topics of vacations and special events look at the more leisurely or unusual situations in which you may wish to create sketch records. The final section, *The developing image*, approaches the different purpose of sketching for exploring the artist's own mind and vision, where the image that emerges on the page need not relate so directly to external or objective values. All of these subjects and ways of seeing them, from the most objective to the most abstract, present personal solutions from which you may gain encouragement in creating your own.

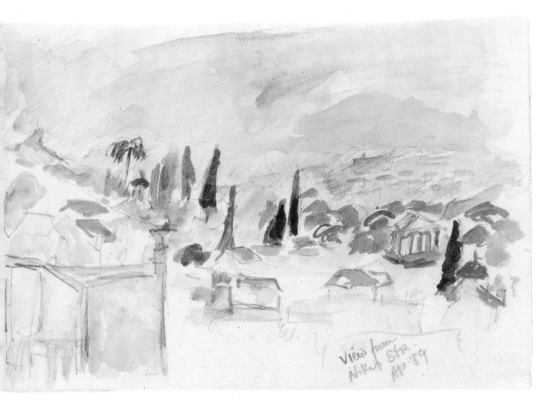

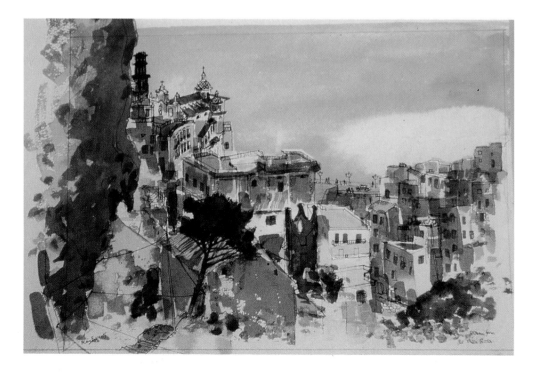

**Ray Evans
Ink Line and Watercolor
Dimensions unavailable**

The jeweled translucency of watercolor is used to fine effect in this unusual townscape. Washes of pure color are well integrated with an emphatic value structure that juxtaposes strong lights and darks. The overall composition has been carefully planned and executed with a tracery of fine pen drawing through which the solid masses of tonal value and color are woven.

Sketching in the landscape has a traditional association with preparation for studio painting; artists working outdoors may take down landscape details and color notes for conversion in the studio to a more fully realized image developed from the sketch references. At one time this typically meant that the landscape would form a background for figures or a narrative scene, but the importance of landscape as a theme in its own right, a relative

Landscape

Daphne Casdagli
Pencil
4¼″ × 5¾″

The interlocking shapes of fields and hills give visual interest to the broad spread of landscape (right). These are detailed in this pencil drawing using blocks of line and tone. The distant horizon and sky are given a heavy tonal treatment that reverses the usual balance of a landscape image.

newcomer in art historical terms, has steadily increased throughout the 20th century. As we have become more mobile, seen new locales, and gained a greater variety of portable equipment for painting and drawing outdoors, it has become a more practical proposition for artists to respond directly to the landscape. This has resulted in a wide range of work that conveys both the fascination of investigating our natural surroundings and the technical challenge of representing the countless facets of landscape.

Many of the elements of landscape are variable. The ground itself can appear to change texture and color under different lights and weather conditions; the vegetation that creates the detail of landscape moves in the wind and changes with the seasons. From hour to hour, the same spot will demonstrate innumerable variations. Sometimes you will start to sketch a view that has obvious and apparently straightforward attractions, but once you focus on the scene objectively you will discover any number of nuances and details that could be included in a sketch. The vast potential of any given landscape view for different interpretations, figurative and technical, means that your sketches must have clear intentions and be selective in their own range. The artists' impressions of landscape on these pages show how their particular interest in the chosen theme has been emphasized by their choice of medium, viewpoint, format, and overall composition, and the details they have

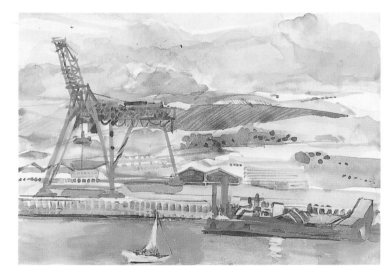

Stan Smith
Watercolor
9″ × 12¼″

This is landscape as background, since the featured area of the drawing is the crane rising above the waterside, but every element of the image contributes to the essence of the whole. The man-made shapes of the crane and boat are set off by the natural patchwork of receding fields. The colors are

beautifully integrated overall, passing through a subtle range of shades from blue to green, yellow to brown. There is a distinct horizontal stress in the layering of the image and the links of color and tone between the areas of water and sky unify the composition.

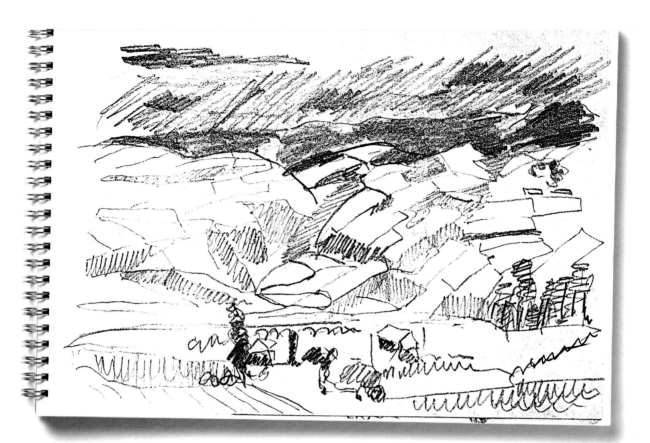

COLOR IN LANDSCAPE

In many kinds of landscape, you will find a predominance of greens accompanied by a range of browns and yellows. When you are working with watercolors, pastels, colored pencils or crayons, don't allow your eye to be deadened by apparently similar color themes within your view. Be prepared to exaggerate the color variations so that when they cohere into a whole, there is a clearer impression of the different elements of the landscape. Experiment with mixing blues, yellows, reds, and even purples into your greens to give them different flavors. Make use of color accents, such as brilliantly colored flowers among trees and grasses, and atmospheric light effects — even when they are only fleetingly seen — to enhance the range of tone and color variation.

John Elliot
Pastel
9″ × 12″

The rich colors and textures of pastel encourage a bold approach. This sketch is unusual in giving equal weight to the tones and colors of ground and sky, laid in thick pastel strokes over dark-colored paper.

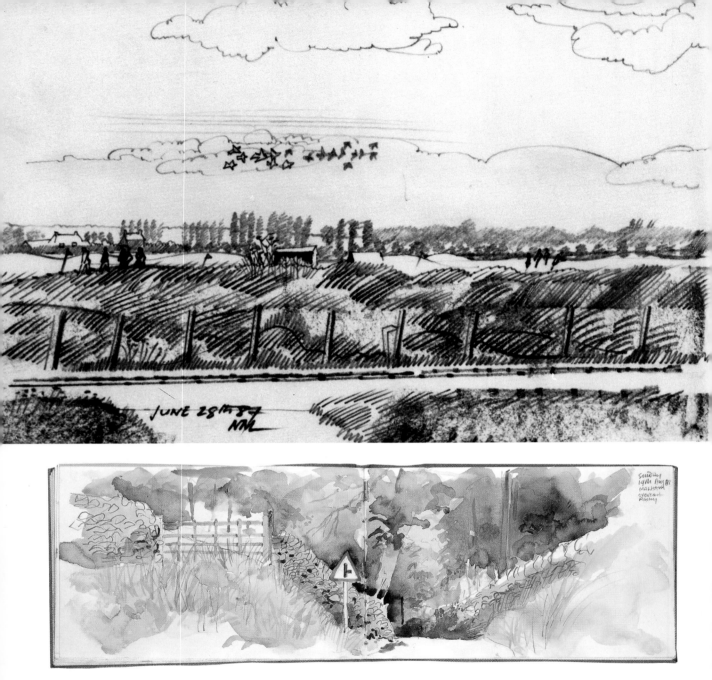

John Lidzey
Pencil and Watercolor
6″ × 18″

This color sketch (above) contains two main elements – the perspective depth of the wall-flanked road receding into the center of the picture, and the atmosphere of overcast skies that subdues the colors overall. The

inclusion of the traffic sign, with its strongly graphic quality, provides a contrasting focal point. The scene is vividly described and conveys a distinct sense of detail, although the marks made in watercolor and pencil are rapid and loosely worked, suggesting that the whole sketch was completed fairly quickly.

chosen to include that enhance the sense of place conveyed by the sketch.

Relate the structure of the composition to your immediate interest in the subject and the time you can spend on the sketches. If you have all day in one location, you might wish to produce a large, detailed view. If you are on the move, you can achieve a useful body of reference work just by doing a series of rapid thumbnail sketches noting different details of the scene in each, either from the same spot or from different viewpoints.

Judy Martin
Gouache and Colored Pencil
10″ × 16″

Scribbled marks (right) equate to a network of tree branches through which sky, land, and water are glimpsed intermittently. Opaque color is overlaid in layers to build the effect.

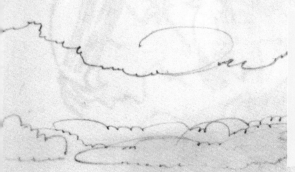

Neil Meacher
Pencil
4½" × 14"

The horizontal emphasis of the landscape is strongly stressed in this drawing: the double-page format gives an image much wider than it is high; the depth between the foreground and horizon is contained; and the roadside fence creates repetitive "markers" traveling widthwise through the image.

Elisabeth Harden
Watercolor
15¾" × 16½"

An interesting variation on the landscape sketch, this is not an outdoor watercolor but a copy of another artist's work, done to investigate his solution to depicting the flow and rhythm of a valley gorge. The original was by David Gentleman.

LANDSCAPE FRAMEWORKS

- *Vertical emphases – trees; hills; cliffs; rocky outcrops; buildings and man-made structures such as pylons or telephone poles; fences; walls.*

- *Horizontal emphases – fields; roads; rivers; low-growing vegetation, including grass, shrubs, and hedges; low-level man-made structures; stratified rocks; spreading cloud formations.*

- *Spatial relationships – position of the horizon line creating land/sky contrast; overall depth and relationships of foreground, middle distance, and far ground; enclosed elements such as caves, valleys, and river courses compared to open, flat, or rising ground surrounding them.*

- *Textures and patterns – grasses; foliage; flowers; water; stones and rocks; pathways and roads; plowed and planted fields; trees and woodlands; brick and stone walls; farm machinery and buildings.*

In some ways the essential character of a townscape is easier to grasp than that of a comparable landscape view. A cityscape contains clearly defined frameworks, straight lines, and solid structures, whereas landscape can be amorphous and changeable. For many people, too, cityscape is now their natural environment and the most accessible location for outdoor sketching. And it is often the case for people who travel that towns and cities form the

Sharpening your ✎
observational skills

Highlighting one ✎
element

THEMES

Cityscape architecture

markers of their journey, the intrinsic details of these stops along the route representing the flavor of the experience.

For the sketcher, one of the outstanding problems of architectural subjects is that of perspective. Do you or don't you need to know the rules of representing three-dimensional structures via two-dimensional systems? If you decide to ignore the theories and trust your eye, why does the drawing sometimes look so wrong on the page?

An understanding of basic principles of perspective may be useful when you are sketching cityscapes, but it is not a prerequisite. One of the main purposes of sketching is, after all, to sharpen your observational skills: therefore you may need to be more vigilant with a subject that is so highly structured. But don't be alarmed by the absence of straight lines and accurate measures in your drawing. As you can see from the examples in these pages, an active line quality combined with the inevitable distortions that you will get in such sketches can add greatly to the vivacity of the image. And you are not trying to record a precise architectural survey of your subject, but to capture its immediate impression on you. What you should be more aware of are the ways in which your viewpoint adds to or detracts from your mental image of the subject. Some artists will avoid frontal views of buildings because these can seem flat and uninteresting, preferring an angled view

John Lidzey
Pencil and Watercolor
9″ × 6″

Night light is a difficult subject to tackle, especially using color, since the subtlety of hue in the prevailing dark tones is not easily distinguishable. Watercolor is an excellent medium to use, as you can slowly build the tonal variations, and its translucent, fluid quality conveys the range of light effects.

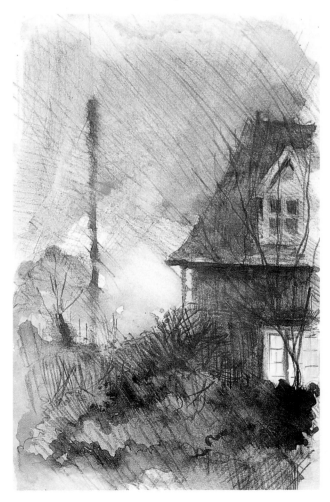

Ray Evans
Watercolor
Dimensions unavailable

In this atmospheric sketch of a bustling city, the impressive architecture is shown in enough detail to convey a clear sense of its style and structure. The overlaid watercolor washes have a range of relatively somber tones, but the use of subtle complementary contrasts gives vibrance to the composition. The trees and figures in the foreground add organic life to the inanimate architectural view.

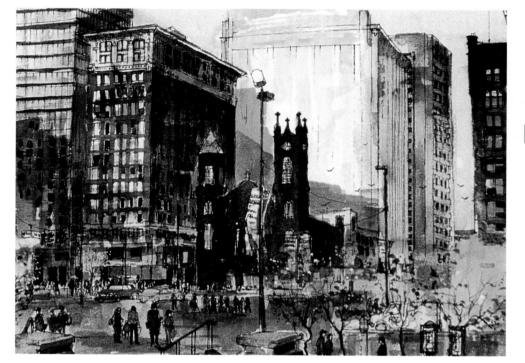

● *The overall view — look for surface interest and unusual angles. Bird's eye and worm's eye views of buildings give a very different impression from a frontal, ground level view. Brickwork, ironwork, and interesting structural details of doors, windows, balconies, moldings, etc. are all elements that can be selectively introduced to enliven the basic forms.*

● *Architectural details — whether or not you have drawn a full view, sometimes it is a particular detail that catches your eye rather than the full building. Quick reference sketches of unusually shaped or colorful features will provide good source material for later, more elaborate works. These are often obvious when you are in a strange place, where everything seems new and fascinating, but if you search more keenly in familiar locations you will see many interesting things that you have previously missed.*

● *Contrasts — most towns and cities are a mixture of old and new architecture, and have planted areas of trees or flowers contrasting with the inorganic nature of the buildings. You also have the choice in a street scene to include the movement of people or traffic against the solid structures of the buildings.*

that throws planes and corners into sharp relief; but for an artist fascinated by details — patterns, textures, the smaller features within the overall structures — a straightforward façade offers a wealth of incidental material.

Because of the variety of tone, color, pattern, and texture in a cityscape view, it is an ideal opportunity to investigate the potential of your materials for representing such different elements. The approach that you take to drawing brickwork with a pencil will be radically different from that which you may use in a watercolor sketch. You therefore have the opportunity to examine and re-examine familiar structures, discovering how to reinterpret them in a variety of contexts.

Elisabeth Harden
Technical Pen
8¼″ × 11¼″

The type of pen used here gives an even, consistent line that is not always expressive, but the artist has freely worked the linear qualities and tonal detail so that these formal elements of her sketches bring an extra liveliness to the record of the scene. These are quick sketches made from the same position, looking in opposite directions.

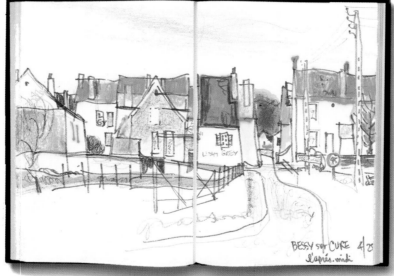

Sherman Hoëflich
Pencil, Crayon, Felt-tip Pen
Dimensions unavailable

In style and technique, the artist has used a semi-naive approach that brings to mind the vivid simplicity of children's drawings. Bold line work and strong color create a vivid impression of the hodgepodge of small houses in this French village, where a more conventionally structured image might fail to convey its real charm.

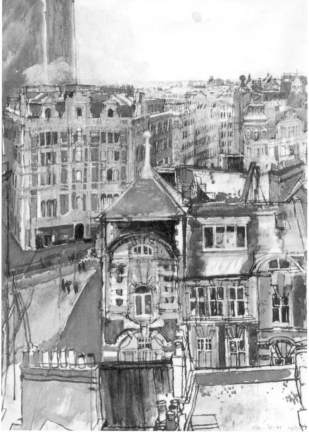

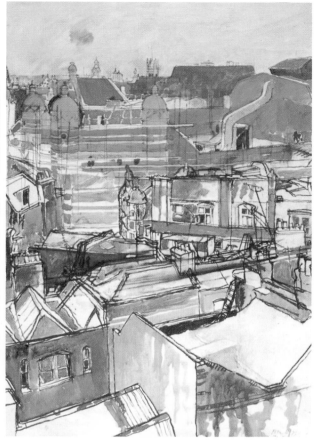

Moira Clinch
Pencil
2¾" × 15"

This elaborate pencil sketch (below) takes in all the detail and texture of the row of houses — verandas, fences, and awnings create patterns within the overall framework. The horizontal emphasis of the composition eliminates a broader context and focuses attention entirely on the fascinating character of the houses.

Ian Simpson
Ink, Pencil, Watercolor
Dimensions unavailable

A different perspective reveals aspects of the character of a place, enabling you to appreciate detail not seen from the normal view. Roofscapes create complex, layered patterns that are invariably full of textural interest, here combined with the patterned façades of the buildings as seen from above.

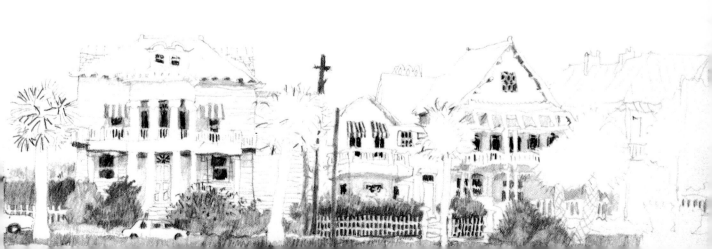

Life drawing has been the bedrock of artistic training for centuries and the life study is still a classic theme for both students and mature artists. One reason for this is that the human figure — nude or clothed — has always been a major focus of interest in painting and sculpture. Another is that the human body is a compact and accessible source of all the formal elements of interest to the artist — structure, form, volume, contour, tonal values, color

Using line, tone, and
color to model form

Analyzing the proportions
of the body

THEMES

Life studies

detail. The implied movement within even a static pose puts all these elements in tension within a single form.

The easiest way to pursue objective study of the human figure is to join a life drawing class where you can work with trained models able to hold a pose for as long as you wish. Several of the drawings shown in this section come from the art school life class. It is less easy to work on life studies at home: to find someone willing and able to maintain the pose, which is a more demanding task than it at first appears, and to take a detached and objective view of the body of a partner or friend. The best solution is to practice quick sketches so that you are not disrupted if your model needs to move, and so that the whole drawing session does not take so long that it becomes an unattractive chore for both artist and model.

As with sketching on other themes, when you are working quickly it helps you to achieve a good result if you are clear in your mind what aspect of your subject is the main interest in any particular sketch. Quick sketches of the figure provide little chance for detailed anatomical study: The underlying skeletal and muscular frameworks are of less interest than the general impression of the body, the broader forms, the balance of the figure, and its weight and movement. However, as you progress with life studies, if you practice careful observation, you will find that you are absorbing a good deal of information about the structure of

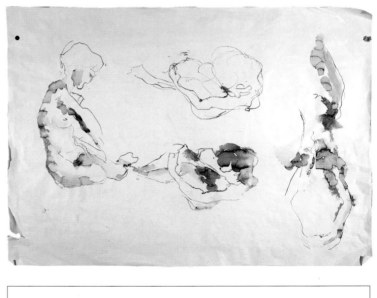

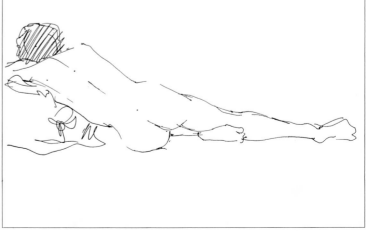

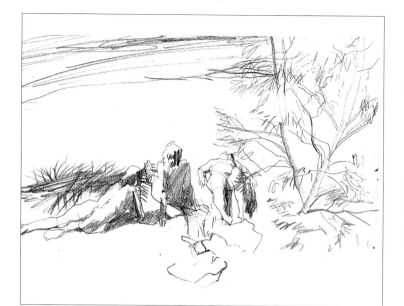

the figure even if you begin with no knowledge of anatomy.

In simple outline drawings of the figure, the contour can be highly expressive of what goes on within the form. You may prefer to attempt tonal studies that give more scope for describing weight and volume; in this case it is helpful to have a fairly dramatic lighting effect that throws parts of the figure into relief, otherwise it can be difficult to perceive the often subtle changes of shape and form. The moving figure is a considerable challenge (see also pp.34 and 35), but movement studies can encourage you to produce exciting technical and visual solutions.

Elisabeth Harden
Writing Ink
23″ × 32″

These drawings (left) suggest not so much the solid form and outline of the model, rather the fluidity and movement inherent in the human figure. The linear pen marks move freely around the shapes and the ink wash retains a liquid quality that enhances the interpretation.

John Elliot
Pen and Ink
11″ × 14″

In this demonstration work for a life class (left), the artist has used only the sketchiest impression of the figure's shape, yet the angle and solidity of the pose are evident, as is the way the body's full weight rests on the bed.

Stan Smith
Pencil
11½″ × 16½″

This unusual outdoor figure study (above) demonstrates foreshortening in the way the figure seems distorted from certain viewpoints. Note how the forms are compacted within the overall shape of the right-hand reclining figure that recedes directly from the viewer.

Stan Smith
Crayon
9″ × 6″

This fluid contour sketch exploits the character of the medium to describe the whole volume and attitude of the figure through its outline only.

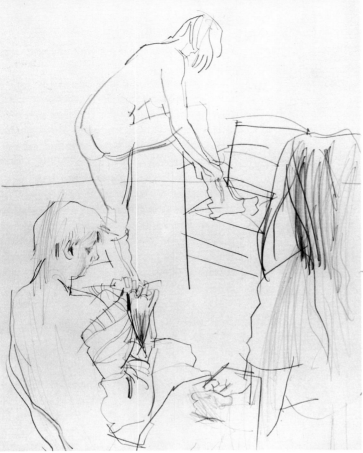

Stan Smith
Pencil
19¾″ × 14¾″

The easy informality of this composition (left) shows how readily the sketcher can take advantage of any incidental event to produce a memorable work. This is not a formal life-class pose but a transitional phase, perhaps between poses or at the end of the day, which the artist has instantly recognized as having its own fascinating dynamics.

Daphne Casdagli
Pencil
9½″ × 14½″

The figure in movement is a challenging proposition (below), but the best way to become easy with the subject is to sketch as quickly as possible and try to pinpoint the sensation of movement rather than anatomical accuracy. A dance studio or fitness center is an ideal location for sketching the moving figure.

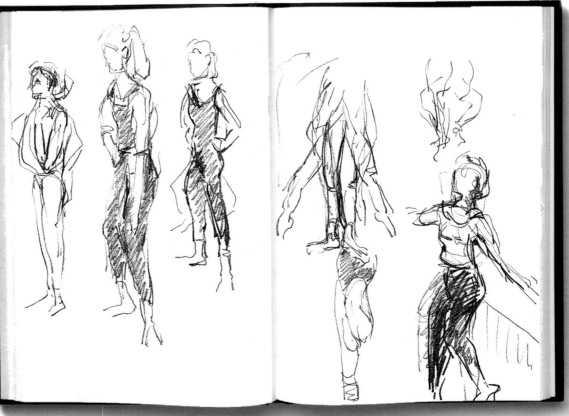

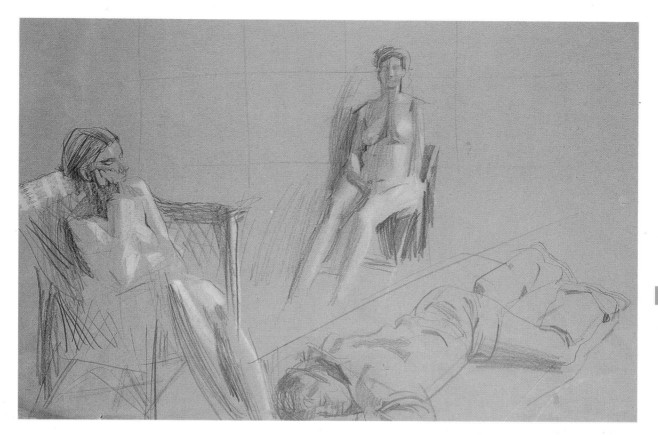

Stan Smith
Pencil and Pastel
20¼″ × 30½″

A bold and dramatic treatment for a figure group study, with the forms sketched in pencil on an overall gray background tone, then highlighted strongly with yellow pastel. By including the detail of the chairs and bed, the artist gives each figure a location within the horizontal space of the picture plane. A faint pencil grid defines the vertical plane.

TECHNIQUES FOR LIFE STUDIES

● *Line work — when using simple drawing media such as pencil, ballpoint and felt-tip pen, let your hand trace the shapes of the figure fluidly and allow the line to swell and taper to describe the figure's volumes. As you draw, be prepared to leave your errors on the page and use them as the means for achieving a more correct solution. If you make continual erasures, or start again each time you make a mistake, you are liable to repeat the errors and make slower progress in your understanding and appreciation of the form.*

● *Tonal studies — for these you can use pencil, ink and wash, pastel, or paint. Position the figure under the light source so that there is a clear variation of light and shade across the forms, and don't be afraid to exaggerate the tonal range in your sketch. You can obtain particularly dramatic effects by limiting your work to, say, three tones representing light, medium, and dark values, so that you are forced to make definite decisions about what you see. With practice, you will find that the drawing coheres easily as a unified form.*

● *Color studies — there is a wide range of opportunity here, from delicate color nuances described with colored pencil, pastel, or watercolor to strong, heavily overpainted studies in opaque gouache or acrylic paints. Flesh tones can be hard to identify — look for subtle warm and cool color shifts across the skin tones and try to find color in the shadows and highlights. Present these emphatically, as with tonal changes — too little surface variation will tend to flatten the form in your sketch.*

Taking people as a theme, there is naturally a broad crossover into the areas of figure studies and portraiture, but the preoccupations of these individual aspects of human study are at once the same and different. To capture the character of a person, the particular presentation of a person's appearance and activity, is not necessarily to draw his or her portrait. Nor are people studies specially concerned with anatomical detail or formal poses. For artists,

Daphne Casdagli
Ink and Watercolor
5½" × 4¼"

It is naturally interesting to encounter people who live in a very different lifestyle and culture from one's own, and they provide excellent material for your sketchbook. This painted sketch of South American women carrying their children on their backs has given the artist an unusual and colorful page.

People

THEMES

project

32

Observing details that express character

people are the most available and consistent subject in the world and have been at the center of composition and narrative throughout all periods of art history. In individuals you have the opportunity to study physical form and proportion, facial characteristics, varying modes of dress, gestures, activities; and in groups of people there is a special dynamic from the unpredictability of their interactions, bringing the potential for an infinite range of visual interest.

The opportunities to sketch people are abundant — from your family and friends at home to people you see in cafés or on buses and trains, or complete strangers that you meet on vacations in unfamiliar places. People with a distinctly different lifestyle and code of dress, or living in locations that seem more exotic to you than your own, are obviously attractive subjects for sketching. But you can find equal fascination in your own neighborhood if you become alert to the people who have the kind of character and visual interest that will contribute something unusual, expressive, or entertaining to a sketch.

The ways in which you sketch people may depend upon the purpose of your sketching at the time. The people around you are possibly your most accessible and interesting subjects when you are waiting in a hotel lobby or airport lounge, for example. But how do you approach your drawings — are you just doodling to pass the time, practicing your drawing

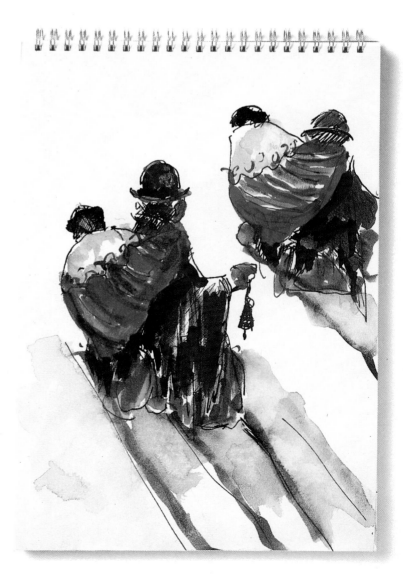

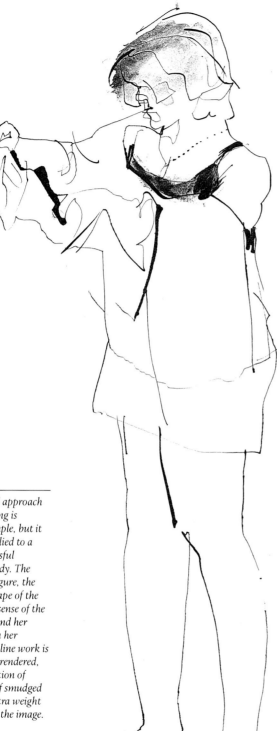

Neil Meacher
Pencil and Crayon
7″ × 4½″

The stylization of this image creates an element of caricature, yet it is also descriptive of the actual mood and character of the subject. The proportions and angle of the body emphasize its languidly relaxed pose.

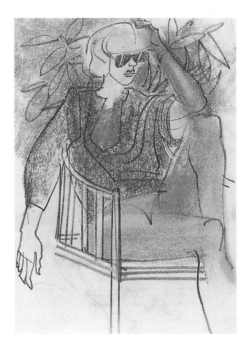

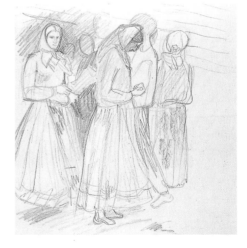

Stan Smith
Pen and Ink
20″ × 12½″

The technical approach to this drawing is relatively simple, but it has been applied to a highly successful character study. The pose of the figure, the angle and shape of the body, give a sense of the model's age and her absorption in her activity. The line work is descriptively rendered, and the addition of small areas of smudged tone gives extra weight and depth to the image.

Suzie Balazs
Pencil and Colored Pencil
9¾″ × 8¼″

These women, uniformly dressed in flowing skirts, are given a rather delicate treatment – fine pencil lines and soft color – that echoes and enhances the rhythms of the figure group.

Stan Smith
Acrylic Paint
18¾″ × 15″

In this freely worked sketch for a canvas painting the whole subject is treated with such vigor and colorfulness that the figures almost become incidental to the view, rather than its focus. Yet they gain a vivid presence from the uninhibited brushwork with which they are described, their clear colors highlighting the forms against the surrounding mass of greens and yellows.

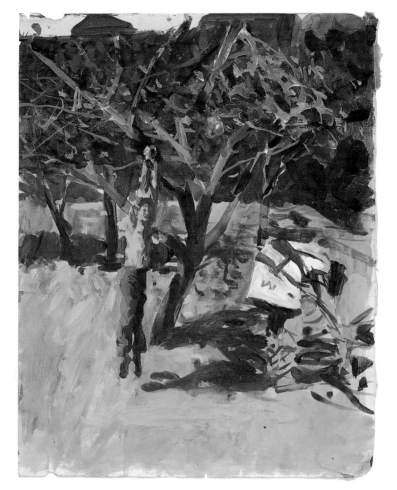

Stan Smith
Ballpoint
8¼″ × 12″

A figure group contains similar areas of interest to those of an individual study, but there is a greater sense of movement and visual dynamic in the ways the figures interact across the page (right). The fluid line technique of this drawing derives partly from the character of the medium itself – ballpoint is typically bold and expressive, and easy to use when you have unforeseen opportunities for quick sketching.

Stan Smith
(right) Pencil
24¾″ × 19¾″
(far right) Technical Pen
9″ × 12″

When sketching children, note that they are characteristically different from adults in shape and proportion. The head is larger in relation to the body, the facial features occupy a smaller area and children's gestures and poses are typically more supple, loose, and free.

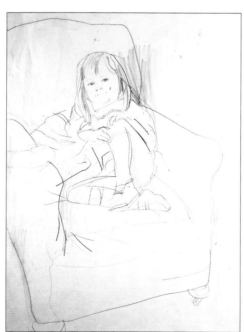

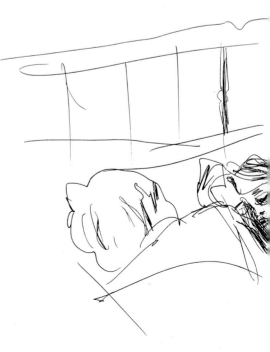

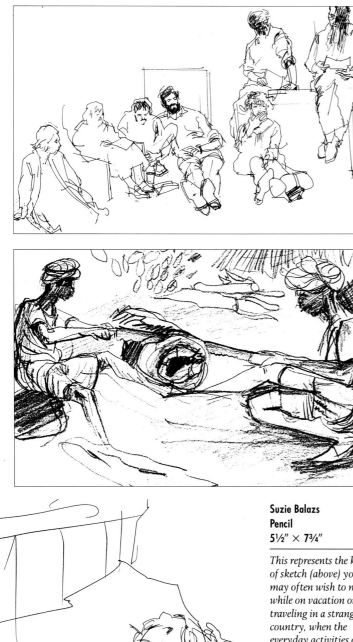

techniques, or gathering reference for possible future works? What you observe about your subjects and the ways you record them may be modified by your aims and intentions.

Much of the interest comes not only from faces and physical characteristics, but from details of dress and accessories that describe something else about the person. These also provide visual detail for a sketch – the patterns of clothing fabrics, the ways coats are buttoned, scarves draped, shoes fastened, bags carried. These increase the potential for pattern and texture that helps to develop an image in its own right, rather than to record it as a simple visual record.

On a practical note, sketching strangers is one of the more sensitive arenas that an artist can enter. Often people are gratified to be considered sufficiently interesting, but this won't guarantee that they like the results, so exercise some tact and restraint.

Suzie Balazs
Pencil
5½″ × 7¾″

This represents the kind of sketch (above) you may often wish to make while on vacation or traveling in a strange country, when the everyday activities of the local population provide new material for you as an artist because you are viewing them with an entirely fresh eye.

● *Facial characteristics – one of the fascinations of an unknown person is the facial expression that may indicate an immediate response to a specific event or an attitude to life in general. As your opportunities to sketch a stranger may be fleeting, try to identify the key elements of the facial expression as quickly as possible.*

● *Posture and gestures – in clothed figures you cannot always see the particular shape of the body and limbs, but there are many telling details of posture and mannerisms that contribute to a character sketch: the disposition of legs and feet in a seated pose, gestures of the arm and hand, the particular body language by which a person engages with the environment and people he or she encounters.*

● *Clothes and accessories – these may be of interest in their own right, but it is also fascinating how they relate to the body, whether for concealment or emphasis of body shape. The textures and patterns of clothing fabrics and the way the clothes are worn may help you to emphasize the character of your subject.*

● *Figure details – you may not get every detail into a sketch, or you may get something wrong while the rest of the sketch seems right. Take the opportunity to make detail studies when possible.*

Alikeness is the essence of a portrait, and the thing that most distinctly characterizes it from a more general study of the human figure or of a type of person. It is more difficult than it first seems to get a true likeness: You might achieve a satisfactory configuration of facial features, of tonal values and colors, if color is involved, and yet somehow still miss the essential character of that particular individual and the elements of facial expression and

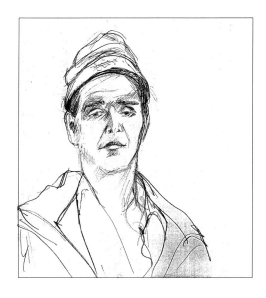

Portraits

THEMES

physical manner that would make the image instantly recognizable to anyone who knew your model.

While you can achieve a portrait of an unknown person while sketching "on the run," it is obviously helpful, if you want to study the features closely, to have a model who is prepared to pose specifically for your sketch work. This gives you the chance for leisurely study, perhaps to make a series of sketches studying different aspects of the individual which can then be used as reference for a composite portrait. Certain aspects of the facial features may be harder to pin down than others: it is usually difficult, for example, to draw the eyes in a way that is both accurate and expressive, so you may want to make several detail studies to define exactly how these are shaped, and how their expression contributes to the character study of your model. But it is not always necessary to draw a portrait in great detail to achieve a telling likeness – sometimes a few lines are adequate, if they are precisely chosen and well defined.

The conventions of portraiture include details of the figure as well as the face. Broadly, the various kinds of portrait can be categorized as head only, head and shoulders, half-length portrait, and full-length portrait. Once you include parts of the body, you may also be dealing with clothes and accessories, and these can be useful in describing character.

project

33

Achieving a likeness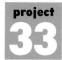

Creating mood 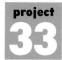 and atmosphere

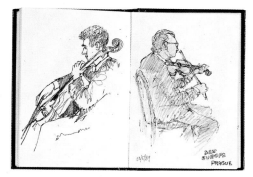

Suzie Balazs
Pencil
9¾" × 8¼"

This is a classical sketch portrait (above), simply drawn with a pencil in line and value, and by its simplicity demonstrating the essence of successful portraiture – a striking, in this case commanding, pose and a clear sense of both three-dimensional form and the individual character of the model.

Ray Evans
Ink and Crayon
5½" × 7¾"

The interest of a portrait may focus on what a person characteristically does, as well as who he or she is (left). These two studies of musicians both achieve a description of the individual while also expressing more broadly the skilled concentration and dexterity essential to the profession that they both follow.

Stan Smith
Pencil
5¾″ × 8″

Tonal studies (left) create mood as well as a likeness, and the use of tonal values in these two sketches works in somewhat different ways. In the portrait of the child, the roughly scribbled value enhances the feeling of movement, a suggestion that the head is turning. Although the marks are one-directional, they work three-dimensionally. In the adult portrait, the values are hatched and gradated to build the form more conventionally.

DRAMATIC PORTRAITURE

● Take a slightly unusual view of your subject, slanted upward from below the face or down from above, or a full profile silhouetting the lines of forehead, nose, and chin.

● Use light as a means of bringing out mood or character. Position the model with strong sidelighting to throw the planes of the head and face into relief.

● Set up a situation that creates atmosphere and visual interest: seat the model in a huge chair, or in front of a window; use scarves or jewelry to highlight the face; put a dramatically contrasting element behind or beside the model, such as a heavily patterned drape or the deeply cut leaves of a potted palm.

Stan Smith
Mixed Media
24¼″ × 16¼″

A full-length portrait contains variations of form, texture, and color that are aptly matched by a mixed-media approach to technique. In this color sketch the artist has used his materials freely to describe different aspects of the image. The line drawing in ink is overlaid with ink and watercolor washes, chalk, and crayon.

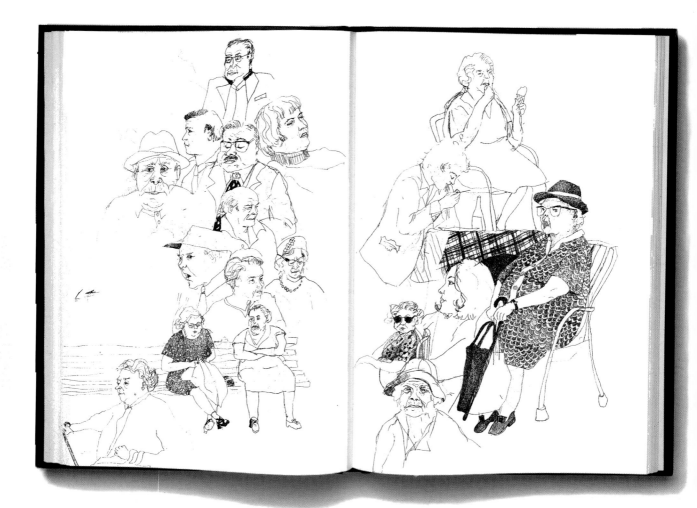

Stan Smith
Pen and Ink
22½″ × 17¾″

The contrast between the delicate line sketching out this portrait and the dense hatching on one area of the face suggests that it is unfinished (left). To build heavy shadow in this way with a fine pen needs patient, concentrated work. However, the result as it stands creates a dramatic image because of the extreme tonal values.

Moira Clinch
Pencil
14″ × 17¾″

This delightful spread has a somewhat random element (above), but the artist has gradually built the sequence of portraits into a fascinating composite picture full of character and detail. Each individual is precisely observed and their interplay gives rich texture to the pages.

Stan Smith
Pencil
20″ × 14¾″

Especially when you are
using a linear medium,
tonal values do not have
to be expressed as a solid
mass or dense gradation.
In this drawing the
shading is applied very
freely. It retains a linear
quality while also
conveying an impression
of the continuous planes
and volumes that shape
the head and body.

T his is one of the most attractive and also challenging themes for sketching. The enormous variety of animal and bird life offers an infinite range of shape, structure, color, and texture. The challenge is to cope with a "model" that refuses to hold a pose — but the inherent movement of living creatures is an essential aspect of their visual interest. If you do not come to grips with the sense of movement, you will end up with sketches that

Observing shape and gesture ✎

Sketching a moving subject ✎

Rendering texture ✎

THEMES

Animals and birds

seem to represent stuffed toys.

The simplest and most accessible animal subject is the family pet. Cats and dogs provide a wide range of movements and poses, but you can equally gain a lot from studying smaller creatures such as a gerbil, hamster, or caged bird. Your familiarity with the animal makes it all the more essential to take an objective view. The advantage of studying a pet (or pets) is the continuity you can achieve over an extended period of time, when you can be continually learning about your subject and the possible ways of representing it. Even when you are not drawing, you can be observing the particular shapes and movements that give the animal its character. And working at home, you can gradually try out your full range of techniques and materials.

Working in the zoo appeals to many artists, for the range of subjects and the fact that, although the animals have a degree of freedom, their movements are necessarily confined and often demonstrate repeating patterns that enable you to pick up on details that you missed first time around. Also, the more exotic the animals, the greater the range of form, color, and texture that needs to be matched by your selected materials and techniques. You may like to make varied studies of different types of creatures, or to concentrate on one particular species or animal group. It is worthwhile making a day of it, but also allow yourself follow-up time at home.

Mark Baxter
Pencil and Ink, each
spread 8¼″ × 11½″

These sketchbook pages demonstrate a continuing area of study with their variety of quick sketches of dogs and horses, from studies of the whole animal to individual details of movement and structure (far left, center). The line work is rapid and sensitive, sketching out form and texture. A family pet is a readily available subject for extended study and, as with the dog drawings here, a sense of familiarity can add to the charm and character of the rendering.

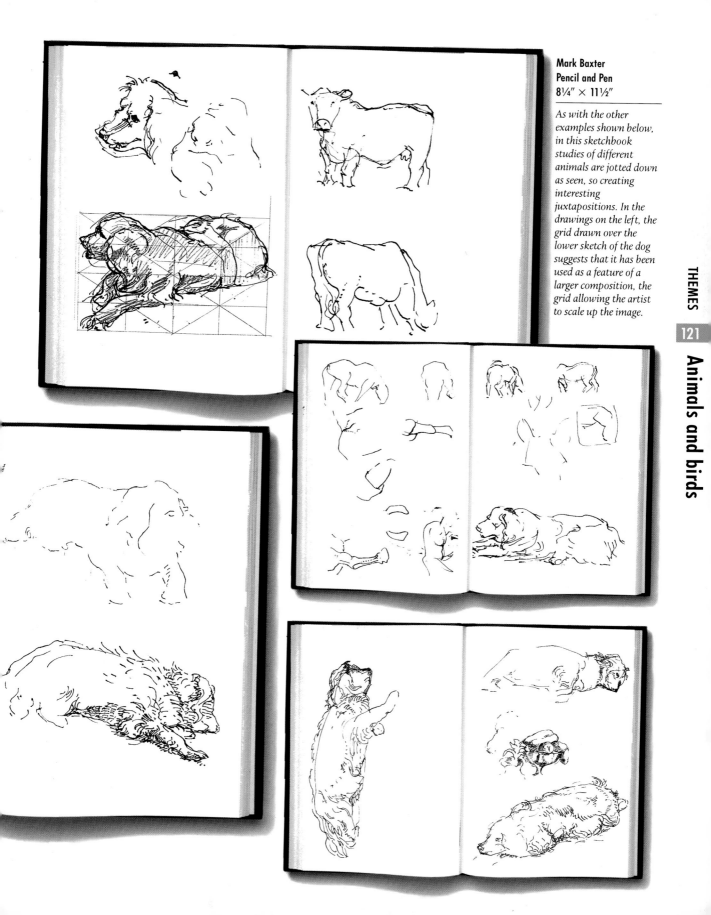

Mark Baxter
Pencil and Pen
8¼″ × 11½″

As with the other examples shown below, in this sketchbook studies of different animals are jotted down as seen, so creating interesting juxtapositions. In the drawings on the left, the grid drawn over the lower sketch of the dog suggests that it has been used as a feature of a larger composition, the grid allowing the artist to scale up the image.

Judy Martin
(far left) Watercolor;
(left) Felt-tip Pen
11¾″ × 8¼″

These pages are from a whole sketchbook of cats, trying out different approaches and techniques. The felt-tip pen drawings are quick movement studies, superimposed on the page almost diagrammatically. The watercolors investigate hints of color in the black fur of the cats.

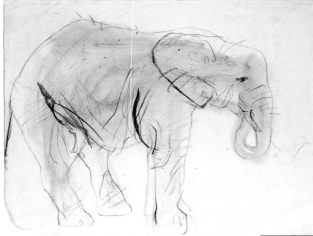

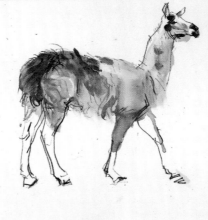

Stan Smith
Mixed Media (clockwise from left)
Various dimensions

In these sketches the artist has matched the animals to his materials inventively. The oil technique applied to the ocelot's spotted coat creates vigorous texture.

The "grayness" of the elephant is subtly represented by a range of dull yellows and gray-greens. The llama is fluidly brush-drawn in watercolor, and the monkey's face is etched in brown ink over pencil and pastel drawing.

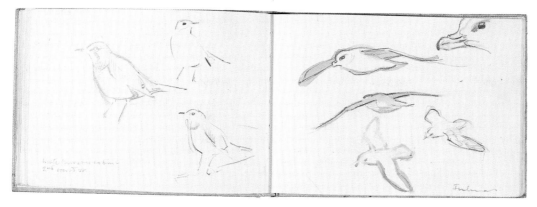

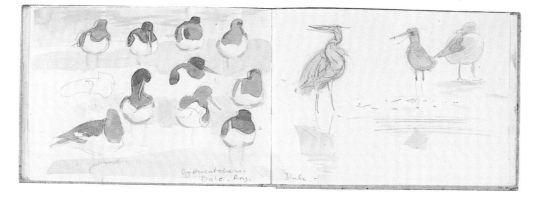

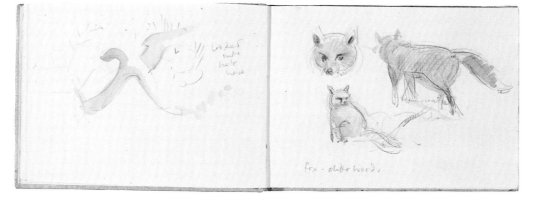

Peter Partington
Pencil and Watercolor
each spread 5¾″ × 16″

The immense natural variety of bird life is fully evident in these few sketchbook pages, explaining why some artists specialize in this area for their whole working lives. Simple media are used, but the technical approach is adapted to the particular features of each subject. In repose or in flight, the birds are rapidly identified and characterized by the artist's keenly trained eye. There can be an element of frustration in wildlife sketching, when a subject disappears before you have time to develop your sketch, so you need to practice watching as well as drawing to sharpen your receptivity and observational skills.

BIRD STUDIES

Most wild animals are reticent, and it is hardly worth trying to draw them in their natural habitats — even if you can sight them in the first place, they won't stay around for long enough to provide a model. However, birds are frequently sketched in the wild. Where you have a group of one species, their similarities enable you to turn freely from one individual to another while noting the general characteristics common to all. When birds are bathing or feeding, they may stay in one spot for quite a while, giving you time to draw — and there is a special fascination to studying birds in flight, when their physical structure is revealed in a different configuration from when they alight on land.

M any themes could come under the category of nature. Landscapes and animal studies focus on natural forms; still lifes are often composed of natural objects. The sketches selected for this section, however, have more the character of the nature studies that were once the province of the schoolroom: the investigation of a natural form to learn something specific about it — its structure, outline, color, or detail. The parallel investiga-

THEMES

Nature

tion lies in expressing what is seen and learned about the object through the character of the materials chosen by the artist. One aspect of technical interest that comes through strongly in a few of these examples is the versatility of the humble pencil as a drawing instrument.

Some types of nature study will naturally take place outdoors: the configuration of a stand of trees, the layering of rock strata, the intricacies of a bramble hedge — these are all subjects that relate to their own locations. However, you can work at home or in the studio using specimens gathered outdoors (check out local regulations on gathering plants or flowers from their natural habitats before you remove anything from the wild), or perhaps using potted plants, or leaf and stem material found in your own yard. And there are many other natural items, such as shells,

project
35

Detailed observation of form, structure, and pattern

Stan Smith
Acrylic Paint
9¾″ × 19¼″

The opacity of acrylic paint allows you to build color layer upon layer. Although usually applied to works that are broader in scale, this property of the medium has been well used in this detailed study. The head of the teasel consists of a mass of small overlaid brushmarks in a range of browns and yellows highlighted with white. The shadow, loosely described with textured strokes, anchors the image on the page.

Stan Smith
Ink and Watercolor
16″ × 12″

The fluidity and translucence of watercolor is exploited in this classical flower painting (left). The image appears very detailed, but it is cleverly elaborated by fairly simple means, using the liquid texture of the paint to give form to the leaves and dragged brush textures to highlight the flower petals.

Elisabeth Harden
Watercolor
11½″ × 8″

The free brushwork applied to this color sketch (left) of a butterfly produces an open, semi-abstract image from which the form of the creature gradually emerges. However, it is the overall effect of color and pattern that has interested the artist, and concern with the elements of shape and contour is secondary to that investigation.

Elisabeth Harden
Pencil and Crayon
16½″ × 20″

An unusual technique was involved in creating the downy plant spores in the left-hand image (below). The pattern of fine filaments was etched into the paper surface using the edge of a key, then graphite from a 6B pencil was lightly rubbed over the area, leaving the impressed lines showing white through the surrounding light gray tone.

fossils, stones, even insects, that provide subject matter for sketching.

Because these are typically small-scale and immobile subjects, you can study them at some leisure, and your sketching techniques need not be as hurried as they might be, say, if you were drawing an outdoor event or a human subject. This is an opportunity to investigate the values of individual materials and the ways of using them to make specific matches: the rough textures of stone or bold patterns of broad-leaved foliage might be equally well represented in pencil, pastel, or gouache, but for jeweled effects such as a bird or butterfly's wing, glistening fish scales, or a delicate flower, the subtle translucence of watercolors comes naturally to mind.

Neil Meacher
Pencil (left)
8″ × 5¾″
(below) 5¾″ × 8¼″

The brief pencil notes of plant stalks and foliage (left) represent the artist's eye almost randomly picking on interesting details that may simply fascinate in themselves or may be adapted to another image at a later date. The more finished sketches (below) appear to be two distinct images but are interestingly interlinked across the pages.

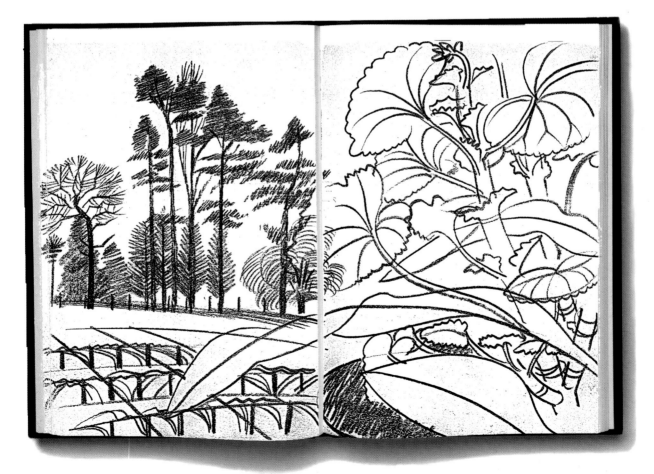

Judy Martin
(above) Pencil and
Gouache 19¾″ × 12½″;
(below left) Pencil 20″ ×
15½″

*These are two examples
from a series of sketches
made of foliage and
flowering plants
standing in a window.
Not all of the detail seen
in the subject has been
included in the sketches
– rather they are an
attempt to identify the*

*general shapes and
rhythms of the natural
still life and recreate
these as self-contained
images.*

Judy Martin
Pencil
19¾″ × 15½″

*Because the leaf shapes
of this large indoor plant
are in themselves very
bold and elegant (above
left), the purpose of the
pencil sketch was to
reproduce the pattern of
the leaves and stems as
cleanly and clearly as
possible, but areas of
faint tone have been
made by erasures of the
soft pencil lines.*

DESIGN IN NATURE

*Try investigating the structures and
patterns in natural subjects that are
indicative of their growth and function.
These basic frameworks provide
information on systems of design in
nature that can provide inspiration for
development of other images and even
the design of objects.*

Domestic subjects give you ready-made material for your sketches and the opportunity to work out the visual problems and possibilities at greater leisure. If you choose subjects around your own home, you can work longer term on the same theme than you can with an outdoor subject, whether this involves making a series of sketches relating to the same object or view, or more in-depth color studies, for example.

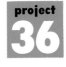
THEMES

Interiors and still lifes

There is a very wide range of subject matter to be found in any furnished room. The general structure of the interior architecture is one: its overall planes introduce the basics of perspective drawing; windows and doors may create areas of texture, unusual light effects, and glimpses of views through and beyond the room into adjacent spaces that give depth and visual interest to a sketch composition.

The way furniture is grouped in the room provides various incidental still lifes; the hard textures and surface values of wood, plastic, and metal from which furniture is made contrast with the fluid forms and gentle contours of soft furnishings – drapes, cushions, rugs. These often provide pleasing elements of pattern (see also pp.82–83) that can enliven your sketches with their varied shapes and colors.

Plants, flower arrangements, ornaments, and fruit bowls may be immediately recognizable as appealing subjects for still lifes, but don't neglect the more familiar and mundane possessions in your home that can create exciting individual or group subjects. A random jumble of everyday utensils lying on a kitchen counter; groceries spilling from a supermarket bag; garden tools standing by the door; the brushes, paints, and colored pencils lying about in your studio; discarded clothes on a bed or chair. Because these are functional rather than decorative elements, it is easy to overlook their visual potential. And any subject

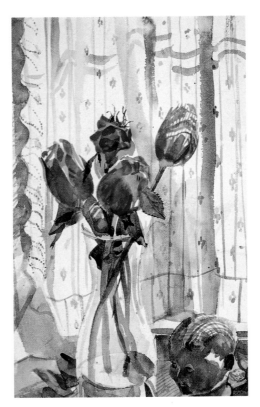

Stan Smith
Watercolor
17¾" × 11¼"

A simple flower arrangement is always a pleasing and accessible subject for a still life study. In this sketch it becomes a more complex recreation of pattern and texture with the backdrop of the curtain and the additional feature of the patterned shell. It is drawn directly in watercolor and the brushwork is cleverly handled to build up the detail.

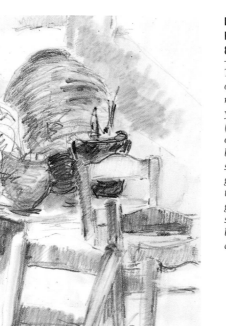

Daphne Casdagli
Pencil and Watercolor
8¼" × 5¾"

This is just the kind of ordinary sight that might meet your eyes as you enter any room (left). The arrangement of table and chairs has been treated as a tonal study, contrasting cool grays with warm brown tones. This interpretation gives the drawing a somber mood of its own beyond the everyday character of the subject.

Stan Smith
Ink and Watercolor
11¾" × 16"

Glass is a fascinating element for still-life study (above), the patterns made by its transmitted light creating unusual detail within a simple structure. There is a pleasing symmetry to the composition created by this straight row of bottles, within which the artist gives free rein to the colors and textures.

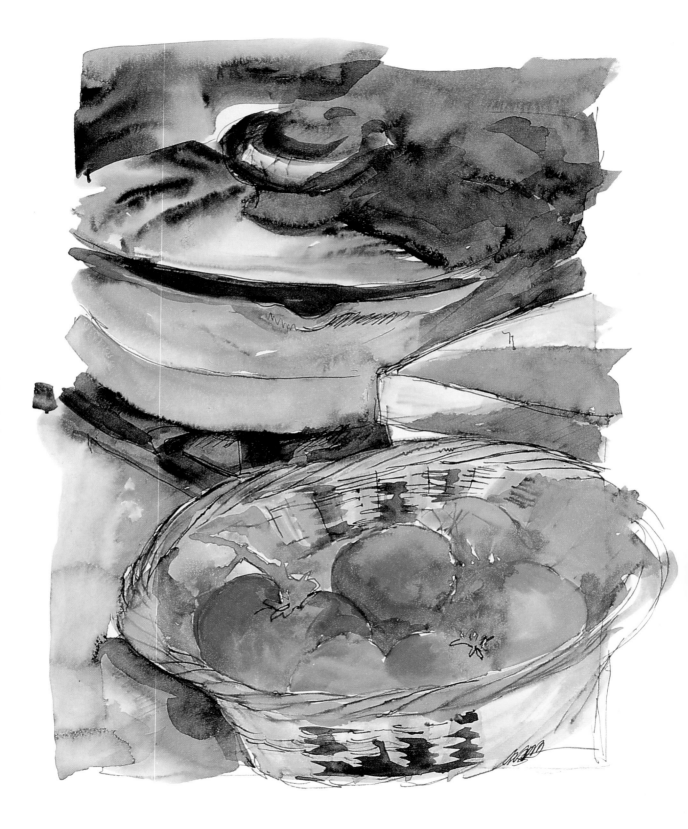

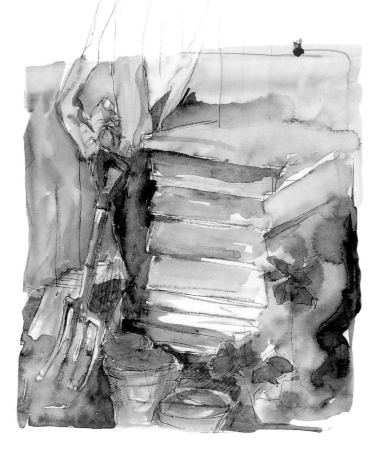

is useful practice for sketching techniques: Try out materials and methods that you do not normally use or that you cannot investigate fully in other situations – pastels, paints, even collaged elements.

Interiors and still lifes have formed an important strand of visual development for artists over many centuries, and the accessibility of these themes is one reason for their continuing popularity. There is also the matter of human scale and implied presence; these topics have to do with where we live and the way we live, and in a sense form a social record. In this respect, there is a special interest in including the human figure, or a figure group, within an interior, though not necessarily as the main object of study.

**Elisabeth Harden
(left and above)
Pencil, Ink, Gouache
each 11½″ × 9″**

These drawings represent the kind of still-life subject that you can readily find around your home, but they are used as an opportunity for technical experiment. The sketchbook pages were made very damp before the color was applied, to give the artist a fluid, free working method in which there would be accidental qualities deriving from the wet colors flowing together. On a practical note, wet paper that is unstretched will buckle and distort, and you may need to take this into account when painting in a sketchbook.

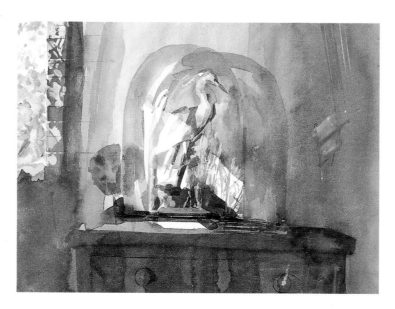

**Stan Smith
Watercolor
11¾″ × 15¾″**

This is a somewhat uncommon subject, and the artist has seen its potential to make a striking composition. Placing the bird under the glass dome at the center of the image makes a symmetrical arrangement of elements that could appear too bland, but the inclusion of the window area at left with its bright colors and busy textures creates a counterbalance to the detail of the bird. The relatively restricted color range emphasizes the effect of dazzling light flooding into the somber interior.

The prospect of time off, whether a day or two of leisure or a lengthy trip to an exotic vacation spot, has a dual purpose for the dedicated sketcher. Here are new subjects and interests, a sense of color and energy, unfamiliar places, and the different ways people behave when they are relaxing and enjoying life without the need to keep up appearances or watch the clock. And here is the time and opportunity that the artist needs to be able to

Vacations

THEMES

sketch freely and with a fresh eye, as both a participant in and an observer of the scene.

There are different kinds of vacation sketches, some being the kind of reportage that you might practice anywhere, the difference being that your clear intention is to record a subject because it is unusual or unfamiliar to you. Ancient and impressive cities, hilltop villages, street markets, docks, waterside cafés — all these interesting locations exist in countries all around the world. You may pay greater attention to them when you are on vacation, either because they are distinctly different and more picturesque than the sights in your own home town, or simply because you have more time to view such things objectively. The formal and pictorial interests — structures, composition, color, detail — are fundamentally similar whatever the subject or location. Alternatively, it may be less the objective image of the scene or view that interests you, more the mood or atmosphere that sums up the flavor of life and leisure in an unfamiliar place. And there are individual themes that may take your attention — the beach, for example, might be regarded as a colorful and informal life class for study of the human figure.

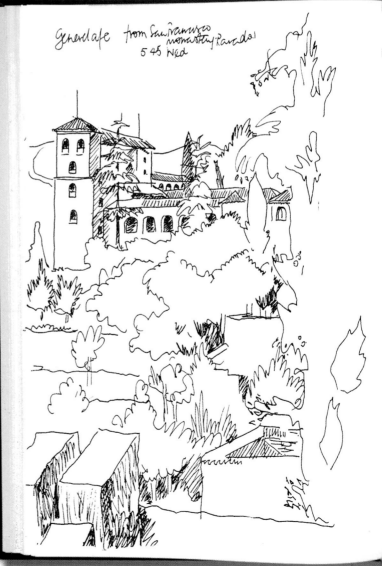

Elisabeth Harden
Technical Pen
8¼" × 11½"

These line sketches of landscape and townscape (below) express the warmth and leisure of a vacation mood, when new and interesting sights meet the eye all around. This is classic use of a sketchbook as a recording medium, a visual diary, with a busy combination of images evoking time and place.

Judy Martin
Felt-tip and Marker
each 5" × 8¼"

This series of images (right) is designed to describe the idea rather than the reality of a vacation, taking in different aspects of the events and locations that might be encountered on a vacation trip. Each image is based on something seen, but the references come from a variety of sources and the individual sketches

have almost a collaged effect. They are worked very quickly and loosely with bold, simple materials. The bright colors are intended to bring to mind the visual qualities of vacation postcards.

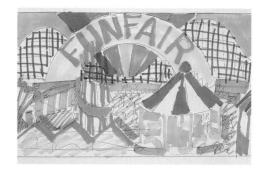

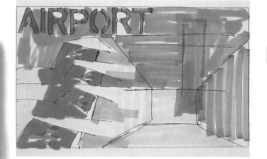

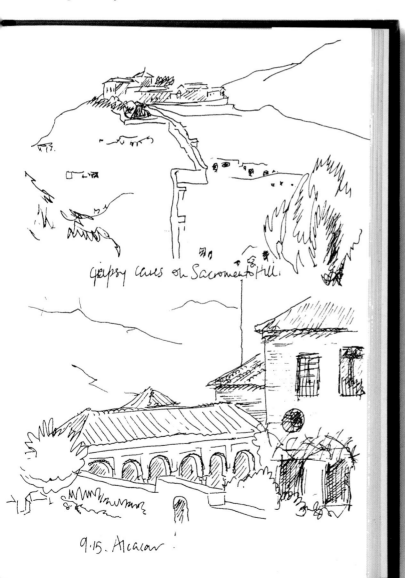

9.15. Alcacar

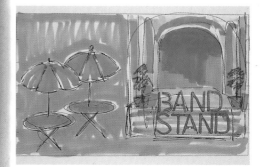

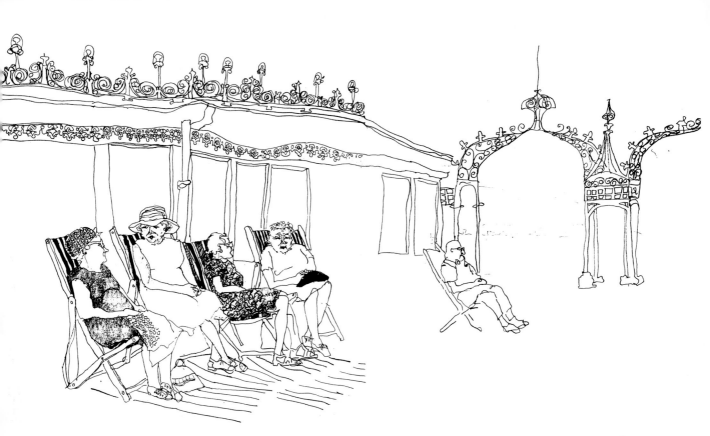

Moira Clinch
Pencil
11½″ × 16½″

This image (above) precisely captures, with sensitivity and humor, a typically English style of vacation. Part of the drawing's charm is its deliberate incompleteness, the area of white space contrasting with the intricate detail of the figures and pier architecture and isolating the right-hand figure from the comfortable group in the foreground.

John Elliot
Ink and Water-soluble Pastel
11″ × 13½″

This is a study (right) for a series of seascapes and although the figures give it a holiday mood, there is also a slightly bleak quality due to the flat horizontality and cool color treatment of the open sea behind them. The loosely spread pastel marks leave parts of the paper bare, creating white light on the page.

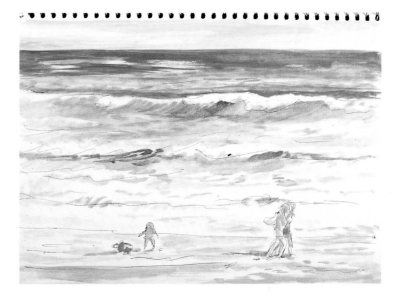

- You may find it useful to carry a small hardcover sketchbook at all times, of a size that can be kept in your pocket or travel bag. Stiff covers protect the pages while you are traveling and sightseeing, and sketchbooks of this kind are easy to handle when you are sketching outdoors or in busy locations such as a market or streetside café. Equip yourself with pencils, ballpoints, or felt-tip pens, depending on your preference.

- Think about the types of materials you will need to pack in your vacation baggage. If you are going to somewhere particularly exotic, you will obviously want the possibility to sketch in color. Take a watercolor box and pastels or colored pencils, together with monochrome media. Consider what is the largest size of sketchbook you might want to use, and that you can conveniently pack and travel with. Keep materials and equipment to the minimum, but try not to restrict your technical options too much.

- If you want your sketches to form a really comprehensive record of your vacation, consider making mainly quick reference sketches while you are out and about and allow some time to work on developing the views and subjects at more leisure in the privacy of your hotel room or vacation apartment. When reworking from sketch reference in this way, try to find time to deal with a particular subject while it is fresh in your mind, perhaps in the morning of the day following a sightseeing tour.

**Elisabeth Harden
Technical Pen
8¼″ × 5¾″**

While you are at leisure in an unfamiliar place, the local inhabitants are going about their work. This sketch (above) shows an archeological excavation going on under intense heat, supervised by the left-hand figure who is shaded by an umbrella. The workers took an interest in the sketches made and offered their names to be written into the record.

**John Elliot
Pen and Ink
9″ × 12″**

The beach in summer (right) affords an ideal opportunity to study informal figure poses and, as here, there are also interesting props that provide varied shapes and patterns. The diagonal arrangement of this composition gives perspective to the view.

Certain events and locations are of special interest for sketching because they are unique or unusual in your experience. These include places that have a particular function and atmosphere, such as a courthouse or theater, and one-shot events, such as a wedding or public celebration, that claim attention for their temporary but important status in the scheme of things. With some of these subjects, it is in their nature that the opportunity to

THEMES

Special events and locations

make sketches is relatively restricted by comparison with other situations. You may have limited time, a restricted viewpoint, or you may be a participant in the event rather than an observer of it, and therefore unable to stand back and take a detached perspective.

In these cases you may reap the benefits of a habit of sketching, given that long-term practice of taking quick but significant visual notes will have sharpened your observation and your ability to record what you see discreetly but in a way that can be useful to you as an artist. Usually your technical means must be kept simple and you can work only with a small sketchbook and a pencil or ballpoint. The quickest way to get an impression of a scene is in a line drawing, but you may wish to add tonal values to give the sketch more atmosphere, and you might also want to make color notes in writing.

The character of your sketch work also depends upon what you want to achieve from the experience. If the function of the sketches is just to be a record of particular aspects of the event, or if you are purely caught up by the immediate visual interest, you can keep your methods equally simple and view the sketches as mainly an interesting document of an unusual occurrence. However, you may be gathering material for further work, such as a painting or print depicting both the detail and atmosphere of the situation.

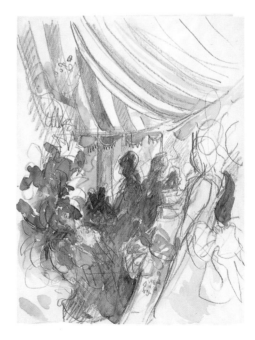

Elisabeth Harden
Pencil and Watercolor
(left) 13″ × 9½″;
(right) 23¼″ × 16½″

Both of these sketches are versions of an image made in preparation for a lithographic print, working out the tone and color balance. The artist's initial ideas came from the event itself, but because of the difficulty of sketching on the spot, the wedding video was used as backup reference for the sketches. The detail of the flower arrangement was taken from still photographs. Photography is sometimes a useful supplement to sketch work in certain circumstances.

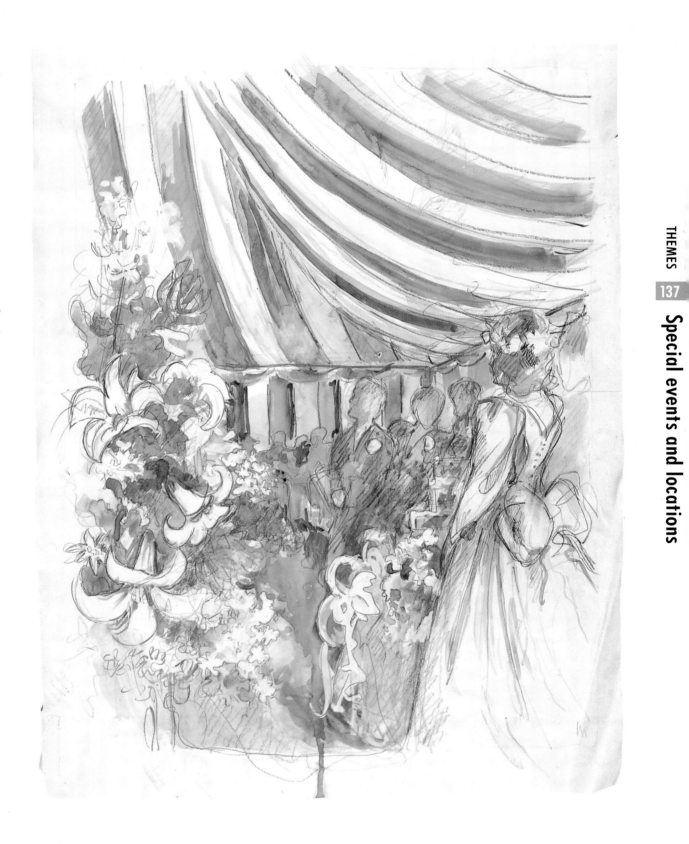

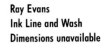

Ray Evans
Ink Line and Wash
Dimensions unavailable

It is an ambitious move to attempt a sketch of a scene so all-embracing as this (left), but there is also a particular sense of satisfaction if your work succeeds. The medium gives the artist quite a free hand; the figures and buildings are fluidly drawn with a sensitive line quality and then washed in tones that add depth and solidity to the image. A complex sketch of this kind can be allowed to evolve fairly loosely, but you might prefer to start by identifying basic shapes and proportions within the image that establish guidelines for positioning detail.

John Lidzey
Pencil and Watercolor
9″ × 12″

The fluid, translucent texture of watercolor makes it the perfect medium for setting atmosphere and mood by relatively simple means (below). This beautifully evocative rendering of a theater interior is described in low-key, muted hues and tones with the watery effect of the paint layers creating pools of lightness and darkness.

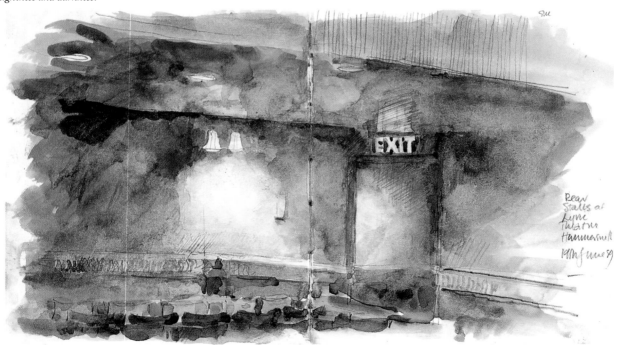

**Daphne Casdagli
(right) Felt-tip Pen
5″ × 8″; (below left)
Pencil 5½″ × 5¼″**

*Two images from a series
of drawings of an
orchestra rehearsal show
the artist responding in
different ways to the
stimulation of the event.
The ink sketch is
relatively precise,
showing the musicians'
concentration on their
work; the pencil version
is a vigorously noted
impression.*

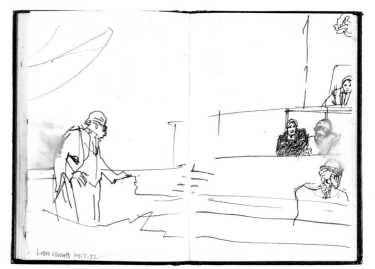

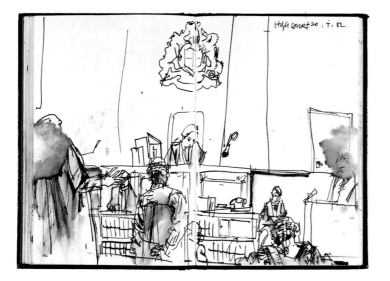

**Stan Smith
(left and above right)
Felt-tip Pen
each 9″ × 12″**

*Sketching in a
courtroom needs to be
discreetly done, and the
artist has chosen simple
materials — just a
sketchbook and black
felt-tip pen. The
drawings are worked
mainly in line, one
describing the open
space of the location
with a telling distance
between the figures, the
other focusing more
closely on a central view.
A little water lightly
brushed across the paper
surface has been added
to create some tonal
depth within the line
work.*

The nature of a subject and the character of your sketches of it can sometimes stimulate a broader idea for a specific image or a visual theme that then takes on its own life and goes some way beyond your initial observations. This might be in the form of a stylized interpretation, as when some aspect of a subject's character suggests a particular kind of treatment that is not purely naturalistic. Or it may become a completely abstract possibility,

Exploring ideas ✎
Working up different interpretations ✎

THEMES

The developing image

when the initial image is reworked in formal terms of shape, color, and texture and the techniques used in the reworkings themselves suggest new approaches to the theme.

The visual potential of an individual shape, or a group of shapes, can be worked out in a variety of ways that include simply using different media — so that, for example, in one interpretation line is important, whereas in another mass and color come to the fore — and the process of actually refining shape and form to essentials, or what seem to you to be their characteristic qualities and the best expression of them. Both of these approaches are in effect technical trials that generate new sketches from the original images. They may or may not lead to further interpretations and a definitive image — perhaps worked out in another medium as a painting, print, or sculpture. The examples of tree and garden studies in these pages show that this method of work can be contained in a way that remains close to the original inspiration, or may go quite far beyond it.

The idea of the developing image brings us into the realms of the artist's imagination. Often sketching is a way of fixing an image from the mind's eye, perhaps based on a sense of something real and seen, but given a special character that comes not from observation but from some other area of the artist's response.

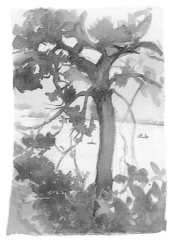

Elisabeth Harden
Pencil and Watercolor
(top and bottom left)
11″ × 7½″;
(right) 16½″ × 12″

Light is an important element of these three drawings. The same tree was sketched under different kinds of lights in an attempt to develop a free interpretation of the image. The varying approaches to the level of detail, treatment of the foreground mass, and depiction of the color moods give each sketch a distinctively different character, although the subject is recognizably the same.

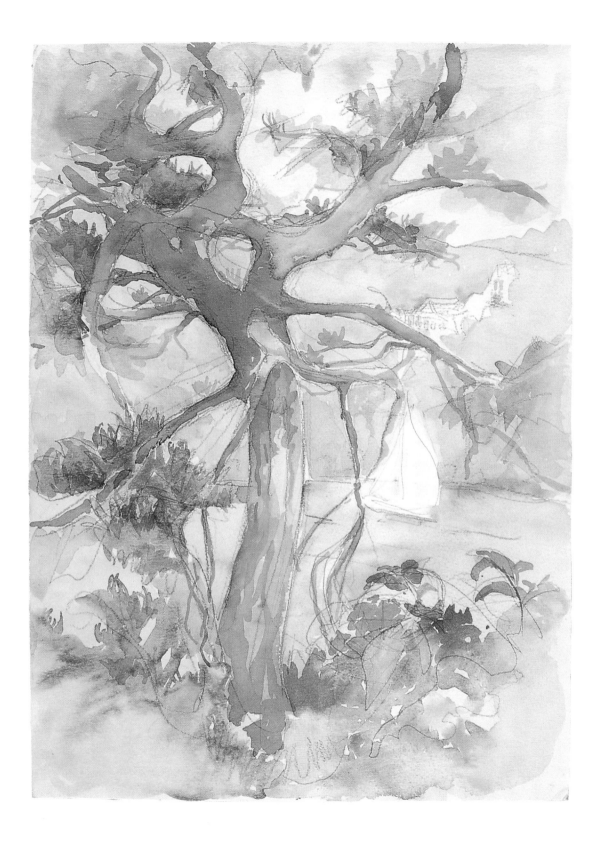

Neil Meacher
(far left) Ink and
Watercolor
8″ × 5¾″;
(left) Pencil 4½″ × 7″

The style of an artist's interpretation of a subject is one of the means by which the image is developed beyond its initial recording. Both these drawings demonstrate the artist's deep interest in shape and contour, which he has differently interpreted in color and monochrome. But the strong linear bias of the work gives it a special character and style.

Judy Martin
(above) Pencil
8¾″ × 11¾″; (inset)
Pencil and Pastel
13¾″ × 9″

These sketches reduce a view of dense woodland to the bare essentials of the linear structure. The drawings are both stylized and abstracted. The pencil sketch was made in front of the original subject, and the color detail is a studio reworking of the theme based on selected elements of the pencil version.

Judy Martin
(top) India Ink; (above
right) Gouache and
Collage; (center right)
Pastel and Collage;
(below right) Gouache
Various dimensions

*A small and oddly
shaped flower garden
growing in wasteland
became the subject of a
series of sketches
investigating variations
of medium and
technique. Both the
outline and internal
detail of the image
developed in different
ways according to the
mark-making capacities
of the materials used
and the ideas on color
and texture that
emerged almost
randomly throughout
the process of working
through the series.*

4

Applied
sketching

LOWES
LOWES

Applied sketching

Sketching as a record of individual experiences and observations is common to all artists at all levels of activity. But for some, sketching is a means to a different end, a method of traveling through imaginative possibilities to achieve a concrete visualization of something not yet in existence. Artists in all the various fields of art and design – fine art, performance, decorative, industrial arts, architecture, and graphic design – may use sketches to develop ideas that will be translated into entirely different media, through widely varying techniques and materials. The relationship of the sketch material to the end product exists in the artist's mind:

in some cases the direct visual links will be obvious; in others they will be far less apparent to the casual viewer, though perfectly clear to their originator.

COMMUNICATING A MESSAGE

One of the factors that influences the form of such sketches is the question of communication. The individual artist working on a once-only project primarily for his or her own satisfaction – this could be a painting or sculpture, an item of jewelry or ceramic ware – uses sketches as personal reference, whether recording an initial inspiration or representing the development of the idea. For artists and designers whose work is collaborative – in theater set and costume design, for example – the sketches are one means of communicating

Seymour Powell

Markers are widely used for rapid renderings in the design development stages of manufacturing consumer products. A quickly executed color drawing in this medium can create a solid visualization. The overlaid marker strokes model the form in broad terms of surface color, light and shade. Felt-tip pens, pastels, or colored pencils may be used to add linear detail and highlights.

The Horseman Cooke Design Agency

The sharp graphic imagery of product labels and packaging typically begins as a series of loose thumbnail sketches, which are gradually redefined and elaborated in more detailed forms until a close representation of the end product is reached (left and right). The designer uses drawing both to develop the visual possibilities and to communicate design ideas to the client for approval.

with other members of the design and production teams, and therefore must be more accessible. Where other craftspeople are involved in producing the object described in sketch form, there may also be practical details to be conveyed which the original artist must articulate clearly in the sketches.

The sketches in this section of the book represent the work of professional artists practicing their major skills, for whom sketching is one part of the process of composition or design. The materials and techniques that they use in sketching correspond to those described in previous chapters, but are directed toward particular purposes. And it must be borne in mind that the process of making the final object — whether a painting, a stage set, or a printed fabric — introduces technical variations and practical constraints that are not all reflected in the sketched proposals and often take the idea way beyond the original scheme. This is one of the particular fascinations of this area of sketching skills, in that much potential is suggested by the drawings that will be realized in other ways.

Cesar Pelli/ Olympia and York Canary Wharf Ltd

A detailed visualization is frequently required to project the impact of proposed buildings in their setting. The architect may produce concept sketches in the early stages of design; more complex renderings such as this prepared for the Canary Wharf Tower in London's Docklands are produced by specialist architectural illustrators.

Sketches for paintings are typically of two kinds — the location sketch that is a record of something seen, subsequently developed as a painted image, and the studio sketch that represents a further stage in the development of the image toward the painted version. Often the original sketch contains something of the artist's own style and vision that makes the work uniquely his or her own, but stylization may emerge more

APPLIED SKETCHING

Painting

emphatically through a series of preparatory sketches that gradually refine shapes, colors, the tonal balance, and the overall structure of the composition.

An important element of this process is the accumulated visual and technical experience that the artist brings to the work. This is reflected in the character of the sketch — the things the artist chooses to record and the degree of detail — but it is also worked out directly through the medium and scale of the final work.

Stan Smith

Sketch studies for a painting may be intended primarily as reference works, but often have a satisfactory completeness in their own right. The detail in this watercolor sketch is only briefly worked out, but the bold approach to color and the heavy use of white body color on the figure give the work a specially vibrant presence.

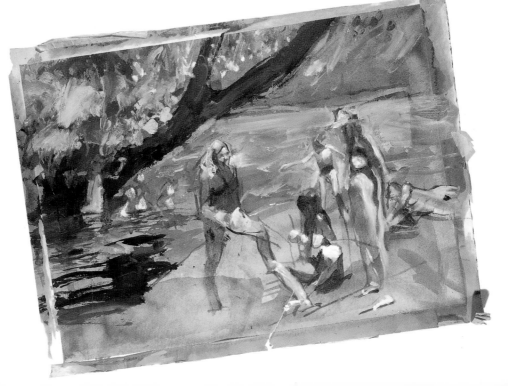

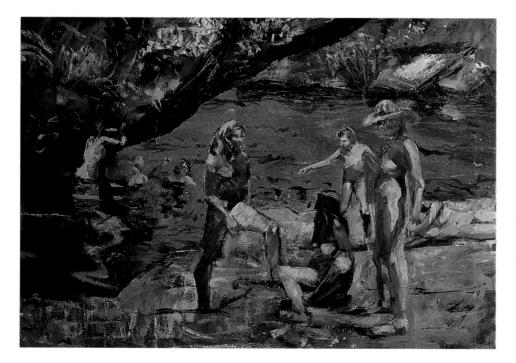

Colin Jellicoe

The pencil study for the painting investigates certain distinctive qualities of the image that appear in the final work – a strong tonal contrast, dividing the picture surface with the emphatic verticals of the trees, and a degree of stylization in the forms. In the finished image, the right-hand figure is worked in more realistic detail, while the left-hand figure has a more prominent scale.

Stan Smith

The painting relating to the sketch opposite is a faithful rendering of the composition, but colors and textures are suitably adapted to the dense oil medium. The figures have been rounded out in greater detail, and the light is conveyed with warm yellow tints rather than the cold blue-whites of the sketch.

John Lidzey

Both of these works are studio paintings, created away from the original location but with the aid of sketch references taken on the spot (right). Each clearly draws on both the composition of the pencil sketch and the artist's memories of the views, but there are subtle reinterpretations as the color medium contributes its own properties to the image.

John Lidzey

The oak tree sketch at first seemed unpromising and the wild location made the drawing process uncomfortable, but viewed later with a fresh eye, the drawing suggested an interesting watercolor. The lower sketch is a summer scene that had already been interpreted as a painting; the artist then decided to rework the theme as a winter landscape.

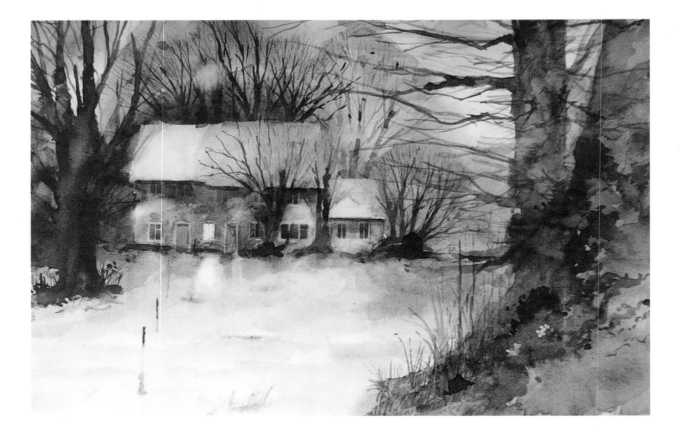

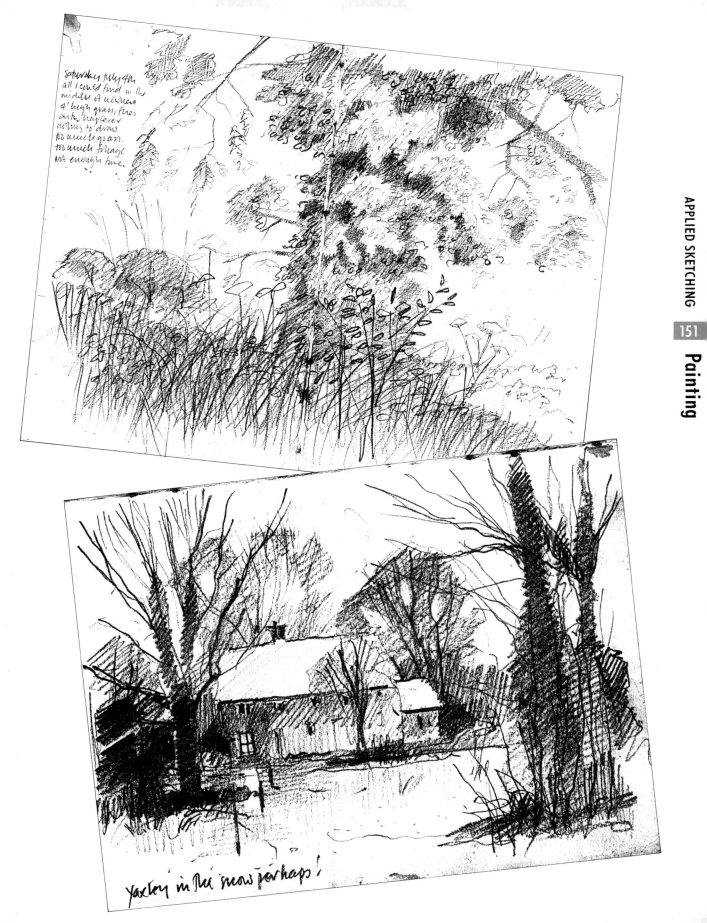

Saturday July 4th
all I could find in the
middle of nowhere
4' high grass, flies
out, hayfever
nothing to draw
too much grass
too much foliage
not enough time.

yaxley in the snow perhaps!

The difference between painting and illustration is sometimes only a matter of intention: whereas the painter may be working on images purely for his or her own satisfaction, the illustrator has a brief to work to and may be directed toward a specific subject, scale, and medium. Randomly made sketches will always serve as useful reference material – as subject records and technical experiments – but it may be

Illustration

necessary to undertake particular research for certain projects, some of which may be available from real models and locations while in other cases it may be necessary to use library and photographic reference. Since the brief for an illustration may also incorporate a tight schedule for the work, facility in sketching – using the materials and techniques to obtain precisely the right kind of visual preparation – can contribute effectively to the illustrator's professionalism.

Paul Hogarth

During a busy tour, the artist works very quickly with pencil outlines, adding detail in written *notes. Figures are sketched as and where seen for later insertion into the compositions.*

Paul Hogarth

The label on this sketchbook represents a worldwide tour undertaken for the artist's album of drawings entitled Graham Greene Country, *covering all the locations described by the author in his novels.*

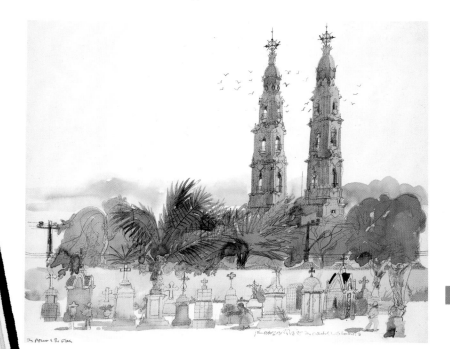

Paul Hogarth

The Cathedral of Tabasco relates to Greene's novel The Power and the Glory, *set in Mexico. The author's on-the-spot* sketch references and a storyboard treatment formed the preparation for the series of paintings presented in the album.

The collaborative processes involved in creating a performance work mean that the designer must necessarily function as part of a team. However individual the approach to overall styling, the result that is finally seen on stage is likely to have undergone some alteration due to the input of other members of the production team and is subject to practical modifications relating to various aspects of stagecraft.

APPLIED SKETCHING

Theater set design

Research sketches may be necessary to obtain true information on locations and objects relating to a particular period or style being used in the production. These also help to make the raw materials of the design very clear in the artist's mind, so that imaginative elements can be blended with the requirements of realism. From these visual research notes the designer can develop full-scale views of the set, taking account of other technical and visual elements of the staging.

Norman Coates

These sketches show initial design ideas for the first English production of the play Candlelight by P. G. Wodehouse. It was decided that the set should have a realistic period style, a decorative, popular 19th-century look. The artist undertook research in libraries and museum collections to obtain the necessary detail. Not only the general mood of the set design had to be discovered, but every element of the interior — doors, furnishings, ornaments, and surface decoration.

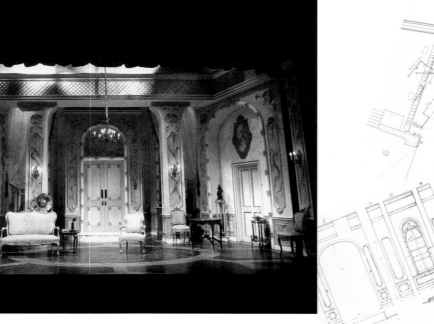

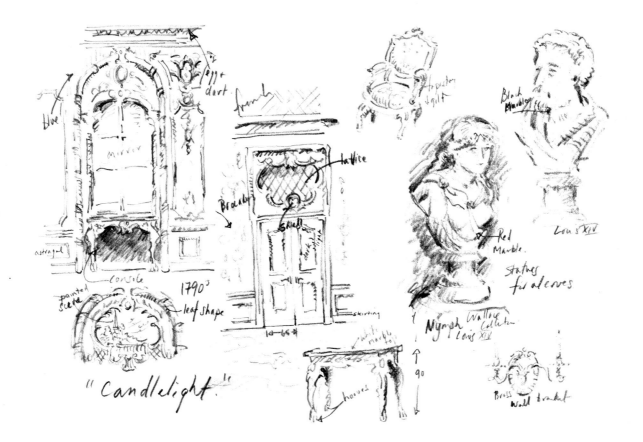

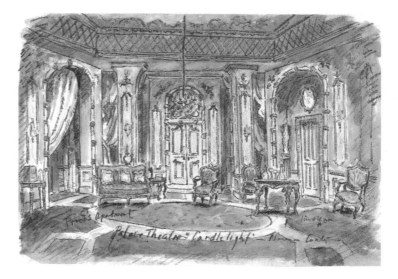

Norman Coates

This watercolor version represents a later stage of design, for approval by the play's director. The overall image of the set is established and related to ground plans of the stage (left), taking account of the areas needed for the actors' movement and the need for doors to "adjoining rooms."

Factors involved in designing costumes for stage productions are similar to those encountered by the stage set designer. Sketches may contribute to each step in the development of costume styling, from initial ideas and random jottings to detailed research, from an impressionistic sense of the visual presentation to detailed and descriptive sketches of the wardrobe of an individual character. The function of the

Costume design

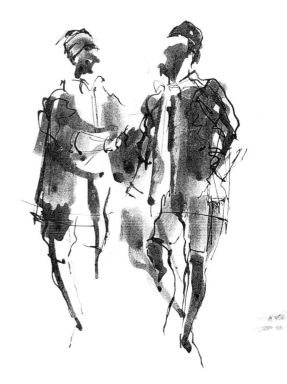

sketches is both creative and communicative – to allow the designer to work out his or her own ideas according to the initial brief, and to convey these ideas to colleagues so that conceptual and practical elements can be thoroughly considered. The sketches on these pages demonstrate how wide-ranging the demands on the designer's ingenuity and technical expertise may be, depending on the style and nature of the production.

Luciana Arrighi

This free line-and-wash sketch for a production of Otello *(above) achieves a sense of characterization through shape, form,* *and attitude rather than realistic detail, evoking a dramatic impression of the costumed figures.*

Michael Stennett

This design for costumes for Cleopatra and Julius Caesar for the opera Julius Caesar *has a detailed opulence well served by the free brushwork and emphatic tonal variations of the watercolor. Although some of the detail is loosely worked, the sketch achieves a highly descriptive sense of character and period.*

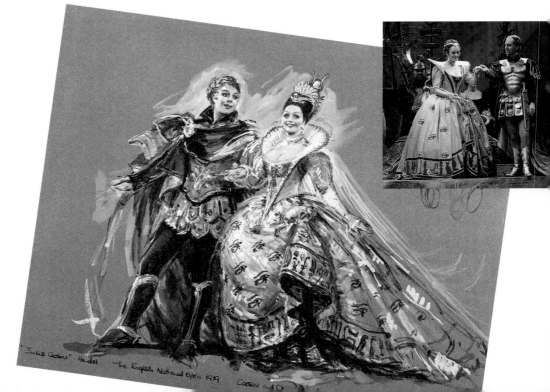

VOSS — sketch for
Australian Opera
pencil & w/colour

COURTIER MASK
— pen & wash + gold

UN BALLO IN MASCHERA

Luciana Arrighi

A character sketch for Voss *conveys a strongly realistic period flavor. Although freely drawn, the costume is precisely realized. Decorative masks for* Un Ballo in Maschera *(above and right) give freer rein to the artist's imagination.*

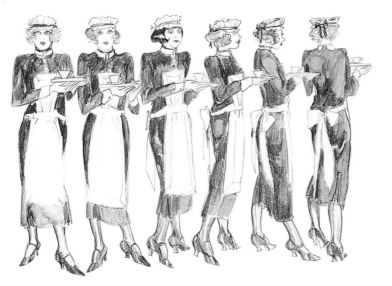

Sue Blane

A line of dancers crisply delineated in monochrome translates into a powerful black and white presence on the stage. These costumes for an English National Opera production of The Mikado *seem to combine a taste of austerity and frivolity reminiscent of early movie settings.*

There is a clear distinction between fashion sketches produced during the design process and illustrative sketches that convey the designs to a wider public, in fashion magazines, for example. But in both cases, it is often important to create a drawing that catches the mood and style of the clothes, rather than merely their physical detail. Because of the essential context of the work, fashion sketches can also provide an opportunity for inventive

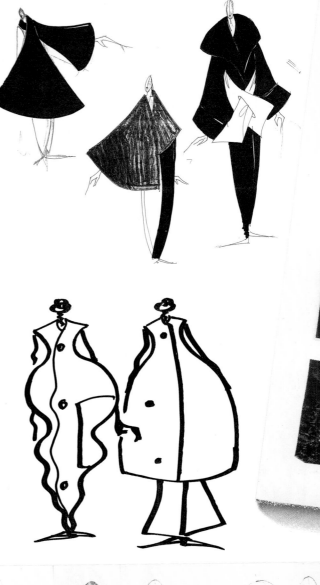

Fashion

interpretation of the human figure, often with witty and vigorous results. A great variety of techniques is utilized in fashion sketches, from simple line drawing to complex elaborations of color, tone, and texture. As with other design areas geared to specific processes of manufacture, concrete details that may be in the designer's mind right from the start become apparent in successive stages.

**Harrow College/
St Martin's School of Art,
London, Second Year
Students**

Fashion design drawings are often highly stylized (top right and center), not only to stamp the designer's "signature" on the work but also to present the ideas in abstract terms of shape, cut, and flow, giving the overall impression of the design without necessarily conveying the detail. A bold technique such as brush drawing (center) is particularly effective in this context.

Where detail is sought, a more sensitive approach to line drawing is appropriate (right). In this sketch, notes have also been made on fabrics to be used for particular designs.

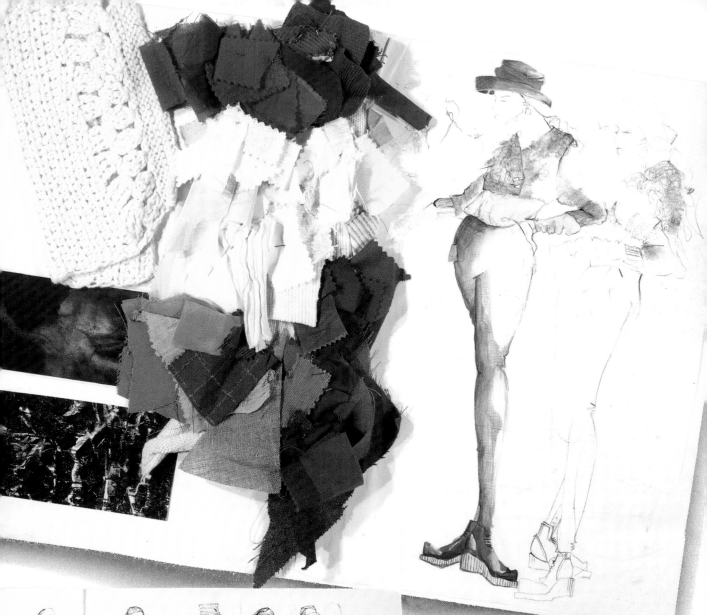

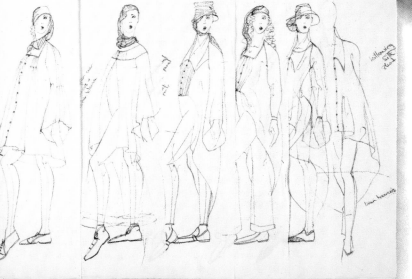

Harrow College, Second Year Students

A fashion sketch may primarily convey the style of the clothes, introducing only those elements of detail, tone, and texture that serve to illustrate the important contrasts or focal points. Real fabric samples (above) will be part of the information that the designer brings to developing the work and these may be supplied to accompany the sketches when the ideas have to be interpreted by other design professionals and technicians.

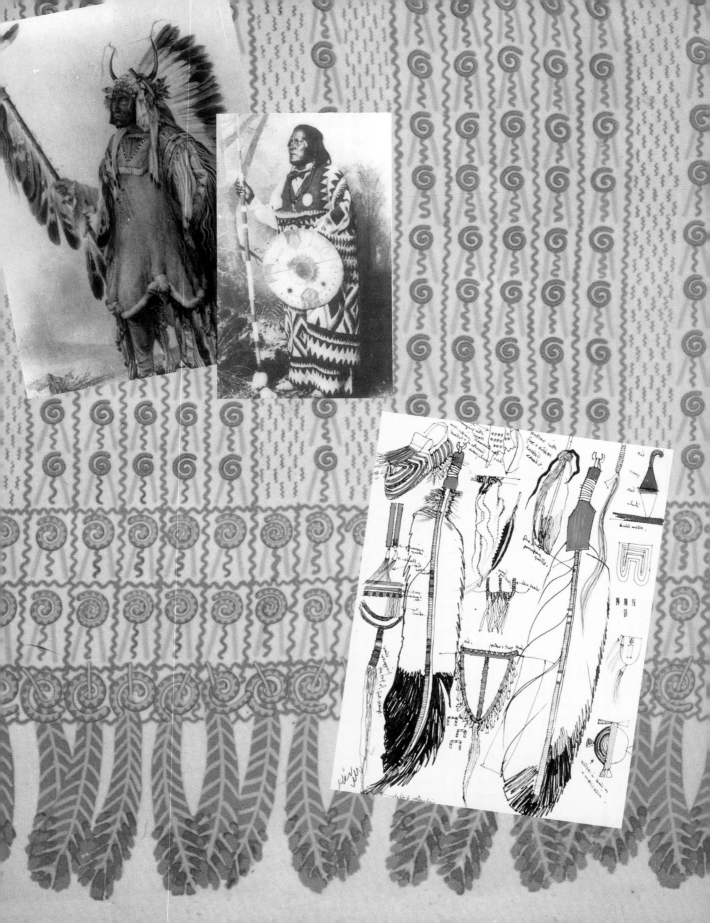

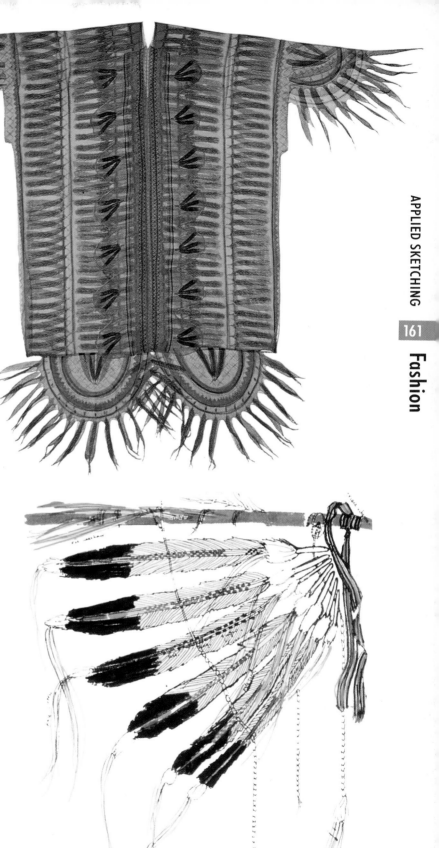

Zandra Rhodes

All of the images on these pages relate to Zandra Rhodes's Indian Feathers collection, directly inspired by a visit to New York's Museum of the American Indian, where the artist made many reference sketches (left and below right). These were developed into ideas for clothes as demonstrated in the fashion sketch (below), which incorporated both feather print fabrics and real feathers (right and below left). There was also a furnishing textile range developed from the same source.

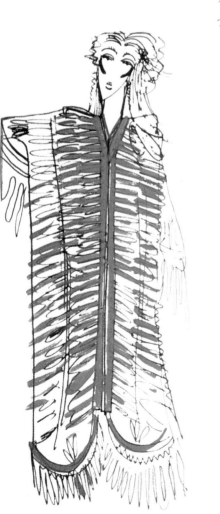

The materials of jewelry-making are so special in character that sketches toward designs for jewelry may bear only minimal relation to the finished product. As shown in the examples included here, the sketches are often inspirational rather than direct ideas for three-dimensional pieces. Certain shapes, forms, and colors that have been loosely established by the sketch drawings come through in the final work, but these may

Jewelry

have been considerably modified by the process of making the piece, acquiring new and distinctive qualities in the transformation. As with all processes of design and composition, the artist's expertise and experience is implicit in the sketches and made concrete in the final version. The manipulation of particular skills and material values is an essential part of the creative process, and each stage of production can introduce new visual elements inherent to the craft.

Zsuzsannah Morrison

Design inspiration comes from painterly sources, reflecting this artist's original training. Abstract works provide initial ideas which are then worked out in the materials of jewellery.

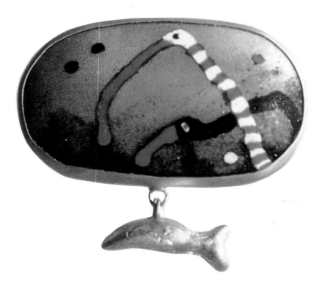

Zsuzsannah Morrison

The technique of enameling has similarities to painting that allow the jewelry designs to be described in a painterly manner. Transparent and opaque enamel colors are used in this series of pieces. Metals like 18-carat gold (far left below) may be introduced primarily for their color.

Zsuzsannah Morrison

Figurative drawings of birds provide an unusual starting point for an artist typically working abstractly. The drawings developed progressively into more abstract designs.

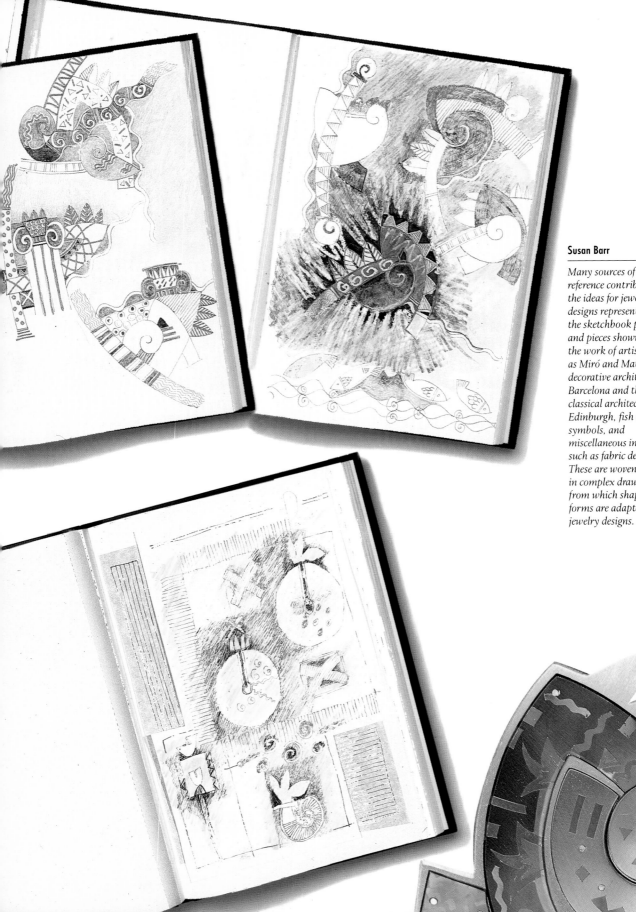

Susan Barr

Many sources of reference contribute to the ideas for jewelry designs represented in the sketchbook pages and pieces shown here – the work of artists such as Miró and Matisse, the decorative architecture of Barcelona and the classical architecture of Edinburgh, fish and bird symbols, and miscellaneous interests such as fabric designs. These are woven together in complex drawings from which shapes and forms are adapted for jewelry designs.

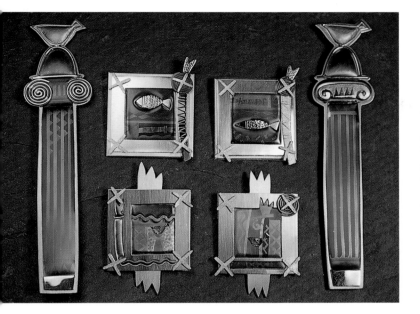

Susan Barr

The sketchbook drawings shown here represent a second stage process, the first being sketches that simply record different elements and are then reworked in the abstract designs and compositions. In the third stage, when motifs have been selected for translation into jewelry, the quality of the materials also comes into play. The pieces are made from the metal niobium, anodized to build up oxide layers that, by refraction, take on apparent colors in a limited color range. Three-dimensionality gives the motifs more definitive form than in the sketches.

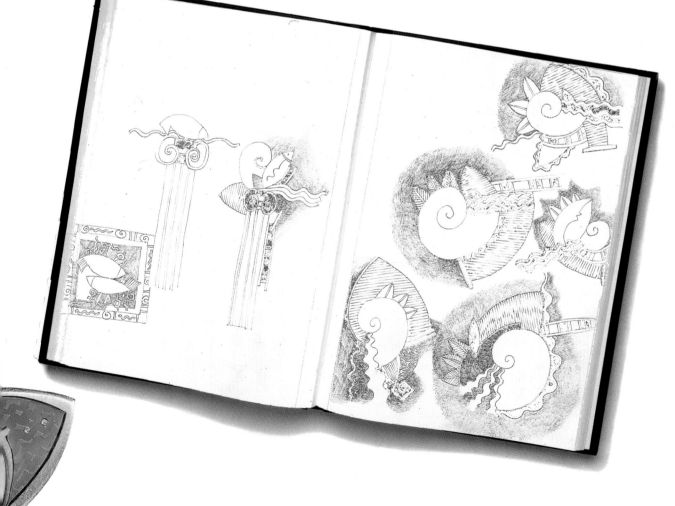

Sketches produced by ceramic artists have different functions and may take different forms. Sometimes the relationship between the sketch and the finished work is fairly oblique. As with any field of art and design, reference sketches may be made on a regular basis, noting interesting objects or details that may or may not ultimately contribute to an idea for ceramic work. Drawing and painting are also used as methods of exploring purely formal

Ceramics

Ewan Henderson

Landscape sketches (below left) provide a background of color and texture translated into the surface qualities of a stoneware pot. The association is strong but indirect — the techniques of creating and firing the pot have their own impact on the character of the finished work.

elements, such as shape, color, and texture. If such investigations suggest a particular approach to a ceramic piece, design sketches may be made relating the abstract elements to the artist's knowledge of medium and technique, gradually refining the idea toward its final form. The artist may also make maquettes — in effect, three-dimensional sketches — along with drawings in preparation for a full work, integrating elements of form and surface detail.

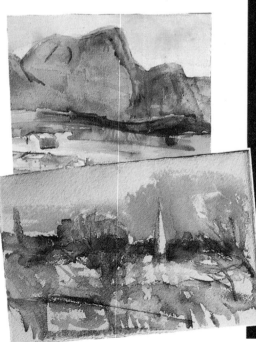

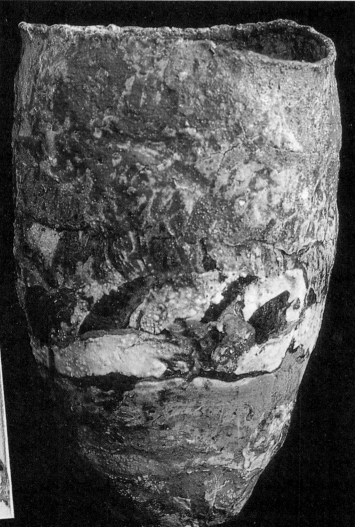

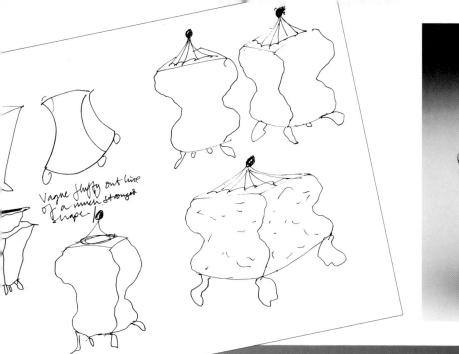

Vague fluffy out line
of a much stronger
shape

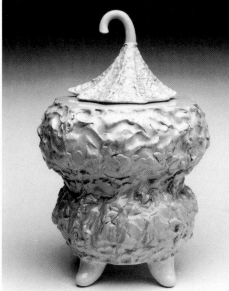

Ceramics

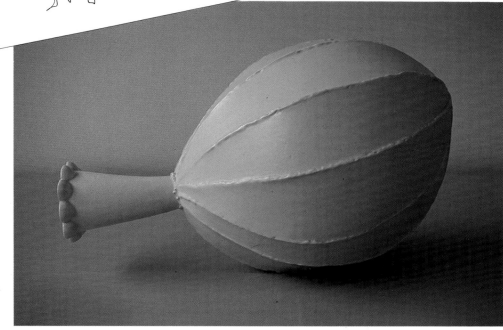

Richard Slee

A series of images for the lidded pot (above left) represent the historical inspiration of the Baroque period gradually taking a personalized, descriptive form. The artist's sketches for this and the pumpkin piece (below) are a way of relaxing into the forms so that the shapes emerge almost automatically. Felt-tip pen is a useful medium for rapid drawing – the sketches take seconds – as it moves easily across the paper. The ideas derived from the drawing process are considerably modified by the ceramic techniques applied to making individual pieces, but the intention is to preserve the spontaneity of the sketch versions.

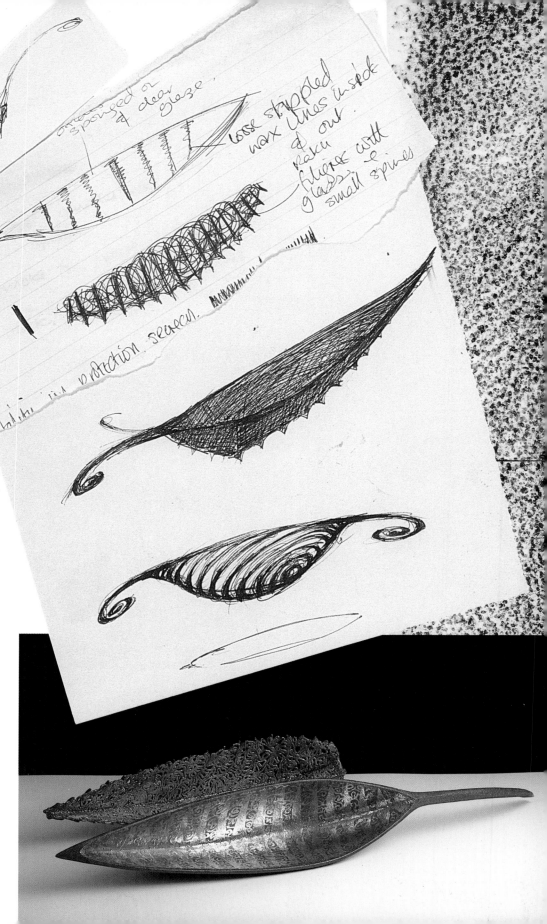

Christine Constant

This artist uses sketches very directly in the process of developing ceramic work, trying out ideas through drawing, then perhaps making a maquette, then sketching again to refine details of shape, form, and texture. Skeletal Cradle (below right) derived from earlier work based on boats and spoons, from which a hybrid form emerged, but this piece also refers directly to female anatomy — a vertebral structure forming a protective casing for a fragile object inside.

The artist had been working on things made in two parts, in particular the idea that one part contains another. In this piece (above) the hollow horn fits precisely over the rounded dial. The wax crayon sketch was made by a technique of building up color, covering it with black, and then scratching back the detail, in keeping with the idea of uncovering something concealed.

Christine Constant

The practical processes of design and manufacture of textiles mean that a successively more methodical approach to design is taken as the stages progress, relating early sketches to workable pattern repeats for printed fabrics, for example, and matching different elements of the design to appropriate color samples, perhaps developing alternative colorways for a given pattern. In the early stages, however, the designer is free to take an imaginative, even

Textile design

painterly approach, as in the color sketch shown opposite, which is a bold, direct brush painting that allows the floral pattern to develop fluidly. Textile design covers an enormous range of motifs, and while color is always crucial, good drawing skills are important in understanding elements such as individual shapes and edge qualities, and effective ways of combining them, that may be applied to figurative, stylized, or abstract subjects.

Sara Campbell

The images on these pages represent different stages in the development of a printed fabric, Collier Campbell's "Rio Rose." The design sketch (above) establishes the main elements of the flower pattern in a freely worked brush drawing. This is a painterly approach that allows the shapes and colors to develop loosely, although the character of a fabric pattern is already evident. The motifs are then reworked and devised in the form of a pattern repeat (right) with modifications to individual elements, such as the smaller blue and yellow flowers. This design also has enhanced color values and these are specified in color swatches (left), so that the artwork and swatches together form a detailed basis for the eventual fabric printing. One of the elements that needs to be taken into account in fabric design is the eventual use of the material, which has a bearing on the scale of the motifs. The relatively small-scale, busy, all-over pattern of "Rio Rose" gives it a wide range of uses for decorative items, from fabric-covered books to umbrellas (above left).

Index